MATERIAL *matters*

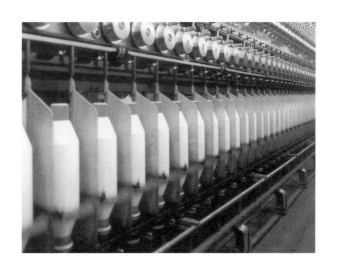

MATERIAL *matters*

The Art
and
Culture
of
Contemporary
Textiles

edited by Ingrid Bachmann and Ruth Scheuing

YYZBOOKS

Canadian Cataloguing in Publication Data
Main entry under title:
Material matters : the art and culture of contemporary textiles
ISBN 0-920397-23-9
1. Textile fabrics – Canada. 2. Textile crafts – Canada.
I. Bachmann, Ingrid, 1958- . II. Scheuing, Ruth, 1947- .
III. YYZ (Gallery).
NK8813.A1M37 1998 746'.0971 C98-931812-5

Design and Production: Michelle Teran
YYZ Publishing Committee Liaison: Kathryn Walter
YYZ Co-Director for Operations and Publishing: Melony Ward

YYZ Books is an alternative Canadian press dedicated to
publishing critical writings on art and culture. YYZ Books is
associated with YYZ Artists' Outlet, an artist-run centre
that presents challenging programs of visual art, film, video,
performance, lectures, panel discussions and publications.

YYZ Artists' Outlet is supported by its members, the Canada
Council for the Arts, the Ontario Arts Council, and the Toronto
Arts Council.
YYZ Artists' Outlet acknowledges the support of the Canada
Council for the Arts for our publishing program.

THE CANADA COUNCIL LE CONSEIL DES ARTS
FOR THE ARTS DU CANADA
SINCE 1957 DEPUIS 1957

*This book is dedicated
to the memory of Joyce Wieland
(1931 – 1998)*

Contents

IV. RECONSIDERING TRADITION AND HISTORY

Acknowledgments

An anthology of essays inevitably involves the resources and talents of a large number of people. We would like to thank all of our colleagues and friends who encouraged us in this project at its various stages. Special thanks to Lorne Falk who supported our engagement with textiles as a critical medium in a visual art context at the Banff Centre, to Kathryn Walter who lent her energy to the final stages of publication and to Michael Lawlor for his ongoing support and feedback.

We would like to thank the following people for their professional contributions to this volume: first and foremost the writers for their insightful essays and the YYZ Books committee for its support of this publication. We greatly appreciated the publishing expertise of Melony Ward and the organizational skills of Milinda Sato, the copy edit by Nicole Langlois and the inspiring design by Michelle Teran. In addition, we were helped by Petra Watson's thoughtful editing during the early stages of the project.

Finally, we gratefully acknowledge the financial assistance of the Canada Council through the Jean A. Chalmers Fund for the Crafts, the Visual Arts Section, and the Writing and Publishing Section.

Foreword

Where do we find literature on the subject of contemporary Western textiles? Like clockwork, *Vogue* magazine reports on this season's fabrics used in the fashion houses in London, Paris and Rome; do-it-yourself paperbacks offer advice on designing and making your own patchwork quilt, baby clothes and pillow covers; self-published dissertations on "back-to-the-land" natural dyeing are available at specialty book shops; architectural, medical and sports journals expound on the latest wonder-materials; academic papers put forth feminist analyses of the strictures of middle-class, middle-American life for women and men, making visible the cultural significance of private, domestic expressions such as sewing, embroidery and other needle arts; and European and North American exhibition catalogues and glossy art magazines offer artists' monographs and commentaries on the nature of art in textiles—and textiles in art.

Art helps us to isolate aspects of the world we live in. Steadfast and pervasive time travellers, textiles have steadily gathered rich and varied meanings. Mutating and evolving incrementally, textiles are now secured in (securely tucked into) the fluctuating cracks and crevices (folds and creases) of contemporary art and thought. Our collective imagination is informed by social, political, economical and mythological paradigms, and within these received models, textiles signify an engagement with their environments: hearth and home; the body; health and well-being.

The global presence of textiles (in pre- and post-industrial forms), and the adroit capacity they have to embody local and

personal meaning, lend the subject great currency. Many of the essays in *Material Matters* necessarily point out that textiles are all around us, all the time. Is it this very familiarity and accessibility (even though they are at times rendered invisible by their own ubiquitous nature) that reward the artist and the scholar who recognize the authenticity of daily life? The artists and writers in this anthology have positioned textiles as intimate measuring sticks of our time.

~ *Sarah Quinton*

Introduction

Material Matters developed out of a series of informal discussions regarding the marked presence of textile materials, processes and metaphors in contemporary art practice and discourse. Against a framework of feminism, structuralism and postmodernism, this collection of essays looks at the nature of materials in relation to contemporary culture: *Material Matters* refers specifically to textiles as a conceptual as well as a material field.

Textile is a unique medium—ubiquitous, banal, luxurious, celebrated and diverse—accessing a range of human experiences from the personal to the public spheres. We all have experiences with cloth on multiple levels: we are wrapped in cloth at birth and death; we wear it; we sleep between sheets of it; we pass on cloth heirlooms as carriers of family histories and traditions. In the public sphere, textiles perform in numerous ways: in museums as cultural artifacts; in art galleries as works of art and as the often unacknowledged physical foundation of Western painting; as a site of female labour; and in banners and flags as identification for national, civic and other group affiliations. In industrial labour, weaving technology has been at the forefront of both the industrial and technological revolutions as well as social organization and unionization.

In an age increasingly dominated by digital and virtual technologies, it is interesting to note that some of the world's most ancient and enduring technologies—weaving, spinning, knitting, sewing and braiding—associated with hand labour and tangible physical product, should figure so prominently

in contemporary art practice. This ability to move, function and reference within multiple sites simultaneously gives textiles a tremendous potency as a medium to comment on contemporary culture. This is evident in the almost iconic status that certain artworks incorporating textiles have achieved in this century. Examples include Joseph Beuys's *Felt Suit*, Joyce Wieland's *oh Canada* Quilt, Judy Chicago's *Dinner Party*, the installations of Christian Boltanski and the collective project of the Names Quilt which documents deaths by AIDS, to name just a few.

As a material, textiles have a complex and charged history in all cultures, making them an ideal field to deal with issues of gender, cultural identity, social status and allegiance, whether it be familial, cultural or subcultural. Their association with daily life, ritual and functional use, the scripting of textile work in the West as a feminine activity, and the role of traditional patterning in communicating and maintaining cultural and social identities, all affirm that materials do, in fact, matter.

In this volume we endeavoured to reflect different dialogues and points of view which constitute the broad range of production and thinking in contemporary textiles, by presenting competing as well as complementary points of view. This diversity in approach is also reflected in the variety of writing styles, which include scholarly and theoretical texts, as well as personal and anecdotal accounts. This was a deliberate choice, to reflect both the lively debate within the academic and artistic fields and to acknowledge peripheral voices that historically have constituted a large portion of textile producers. While a wealth of information exists on historical, ethnographic and anthropological textiles, a publication that looks at textiles within a contemporary context is missing. This anthology attempts to consolidate material that has previously been scattered in journals, exhibition catalogues and in the often limited confines of conference transcripts to fill a void in historical and theoretical scholarship in contemporary art and textiles.

The first section emphasizes material and process. Ingrid Bachmann traces the histories of textile media in the industrial

and technological revolutions. Her essay highlights the contra-
dictions between the material and physical conditions of daily
life and the promise of immateriality or transcendence advanced
by the rhetoric surrounding emerging digital and televirtual
technologies. A different approach to process and material is
presented by Steven Horne, who bridges feminist practices,
minimalism and craft traditions to explore the notion of an
embodied subjectivity. Based on the phenomenology of Maurice
Merleau-Ponty, Horne suggests hand processes as a means of
linking the social, the political and the personal. In her contri-
bution to the volume, Nell Tenhaaf examines the functioning of
representational practices through the work of Mary Scott and
her exploration of Lacan's reading of Freud: Scott's obsessively
bound objects, incorporating discarded clothing and old paintings,
explore a denied textile ground of painting in Western art.
Diana Wood Conroy combines the strategies of archeology,
anthropology and feminist criticism to create a framework for
contemporary tapestry work. Anne West proposes a very different
approach to process in her essay on the woven works of Sandra
Brownlee, whose poetic imagery, West argues, is rooted in the
process of weaving as a source of a regenerative, universal power
of symbols.

Themes of gender and identity are taken up by the writers in
section two. Textiles in clothing can communicate the wearer's
or user's ideological values, his or her economic status and his or
her group affiliation. While cloth functions as an identifier of
rank, class and social group, it also becomes a homogenizing
force or uniform which simultaneously signifies allegiance to,
or revolt against a dominant culture. This is evident in sartorial
codes ranging from the pinstripe suit, military uniforms and
religious habits to grunge. Renee Baert provides an analysis of
clothing as an instrument of cultural expression and as a means
to construct gender identity in contemporary art practice. The
issue of gender as social construct is also taken up by Robin
Metcalfe in his discussion of Robert Windrum's embroidery,
whose work blends traditional embroidery techniques with gay
tattoo imagery, transgressing gender boundaries and socially

accepted roles, and questioning assumptions about the status of the maker and the subject matter of embroidery. Janis Jefferies provides a feminist framework for discussing contemporary textile work within the writings of Derrida and Kristeva. She argues for the potential of textiles as a hybrid art form with the potential to dislocate and disrupt traditional language and gender inscriptions. Mireille Perron explores the idea of textile practices as social sites of ideological activities, which she proposes as rich sites to question assumptions about subjects such as women's work, femininity and domesticity and their relative perceived merit.

Textiles as sites of resistance have a long history within many political movements. The essays in section three explore these roles as carriers of social and cultural meaning. Sarat Maharaj crosses continents, cultures and centuries in his essay, foregrounding the simultaneous production of hand-woven cloth in pre-independence India and roller-printed industrial fabrics in Great Britain against the backdrop of Arachne's story. Maharaj uses this Greek myth as the basis for a comparison of cultural identities and power structures, combining it with a discussion of Gandhi's political strategy, which used the production of hand-woven textiles to radically alter Indian society. Jo Anna Isaak explores different modes of representation and the values ascribed to them through the work of Elaine Reichek. Reichek knits and embroiders diagrams and photographs from anthropological records, transcoding the images to reveal the bias of the original fabrications. In her essay, Debra Sparrow offers a personal account of her experience as a contemporary Salish weaver who places her work within the continuing tradition of her ancestors. Sparrow, who learned to weave as an adult along with her sisters, established a Salish weaving program that shows the seminal role of textiles in reactivating tradition and cultural history.

The fourth section examines implications of history and tradition. In the West, weaving often served as a language to assert the will of those unable to speak openly against a dominant power structure. Ruth Scheuing looks at the role of weaving

in Greek mythology as a women's voice through a feminist reinterpretation of the story of Penelope and other mythological weavers. In her contribution, Kiku Hawkes explores the language of textiles as a material form of oral tradition passed along matrilineal lines, in this personal account based on her experience as a mother and a daughter. Rococo imagery and its negative interpretations as decoration are compared with dominant attitudes toward gay lifestyles in an essay by Neil MacInnis. MacInnis contrasts the often violent objections to gay lifestyles by "straight" society with the actual violence done to gay men. Luxurious Rococo textiles, often described as decadent, serve as carriers for MacInnis' inquiry into these contradictions. In the final essay, Bruce Grenville examines the traditional role of textiles as markers of rites of passage. By focusing on Barbara Todd's quilts, which combine men's suiting fabrics with images of bombers, missiles and coffins, Grenville interweaves notions of death and sleep, comfort and brutality, in this meditation on death, war and patriarchy.

~ *Ingrid Bachmann and Ruth Scheuing*

I. MATERIAL AND PROCESS

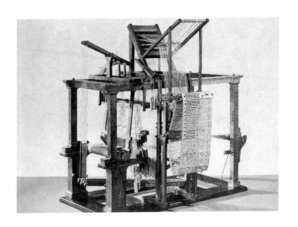

Material and the Promise of the Immaterial

Ingrid Bachmann

Imagine. A map, circa late eighteenth century, somewhere in the New World. The map begins to burn, from the centre out.

Scene 2. Vast plains, an expansive horizon, a fading sunset. Hold that image. From off in the distance, the sound of galloping horses, gradually approaching. Faintly at first, far away, you hear music. You think you recognize it, it has a familiar strain. Quietly, then at full volume, you hear the soundtrack from the 1960s television series *Bonanza*. Hum along if you like.

Jump cut. Scene 3. New image. Vast, black empty space... outer space—stars and planets, a shooting star, enormous silence... Out of this silence, a voice... Space, the final frontier. These are the voyages of the Starship Enterprise. Its continuing mission is to explore new worlds. To boldly go where no one has gone before.

Scene 4. Imagine. A large white boot descends from a silvery ladder and touches the surface of the moon. One small step for man, a giant step for mankind.

Scene 5. Fingers poised over grey plastic keys, shoulders hunched in dim light, an uncomfortable chair. The world reduced to a fifteen-inch square emanating blue light.

The rhetoric around digital technologies is infused with the utopian promises of deliverance and progress—the promise of another frontier, an original uncharted space, virgin territory, a clean slate, another chance to "get it right." This notion of the frontier has almost mythic proportions in the language and literature of the West. From the promised land offered in the Bible, to the lost Garden of Eden, from Columbus's arrival in the Americas, to the cowboy and Indian films of the 1950s and the space adventure films of the 1980s and 1990s, the notion of the frontier continues to engage the imagination of the West. This adoption of a frontier mentality toward the landscape and vocabulary of cyberspace provokes some interesting observations on how our visions of the future are predicated on the structures of the past.

At a time when resources are diminishing worldwide, when natural frontiers are disappearing, when outer space has not yet proven to be an hospitable and supportable environment for human life, cyberspace provides, however fallaciously, the last frontier. The frontier myth is an enduring one and its adoption into the rhetoric of the digital sphere has serious implications—myths of transcendence and separation between the mind and body, nature and culture, have a long and complicated history and their unacknowledged passage into cyberspace is a disturbing one.

I have titled my contribution to this text "Material and the Promise of the Immaterial" because it suggests to me one of the fundamental contradictions of our time (what we might define as late twentieth century, emerging twenty-first century, the postcolonial, postindustrial, postmodern era), namely, the contradiction between the material and physical conditions of our daily lives and the promise of immateriality or transcendence advanced by the rhetoric around emerging digital and televirtual technologies.

Technology is shaped by and is a product of forces that are deeply imbedded in economic, political and cultural structures. In this paper, I would like to examine the discourses and rhetoric around both textile and computer technologies (central

to this paper is the view of textiles as a technology), and to explore the ways in which these practices are scripted in contemporary culture and the values and attributes that are ascribed to them. What is the gap between a technology's apparent role, history, perceived use, its expected user, and its actual role, function and history? Why is weaving considered antiquated, artisanal, slow, gendered female? Conversely, why are computers considered fast, new, state of the art, virtual, gendered male?

The currency or, more accurately, lack of currency of textiles as a technology is rather pointedly illustrated in a recent advertisement in *Wired* magazine for an Internet provider. In the ad, a sexy redhead poses provocatively against a computer. The accompanying copy reads, "Let's just say that you won't find me on the knitting newsgroup." Clearly, knitting is for doddering old grandmothers, not for foxy cyberbabes or hip infobahn warriors.

Textiles as a practice is still quite firmly rooted in the popular imagination as an artisanal activity, a sometimes quaint, historical craft, one of the "gentle arts" usually associated with women whose site of production is historically the home, an antiquated process that operates outside the "real" economy of commodity goods and exchange. It embodies both the nostalgia and historicity surrounding many perceived economically redundant technologies. In a youth-obsessed culture with an almost pathological fear of aging, to be old is extremely undesirable. This scripting of textiles and weaving as both a feminine activity as well as an outmoded practice is not unexpected, but it is hugely inaccurate given the seminal role of textile production in both the industrial and digital revolutions of the nineteenth and twentieth centuries respectively. This romantic vision of textiles is further undermined by the global scale of contemporary industrial textile production and the ongoing and enduring presence of sweatshops in the first and developing worlds.[1]

After all, it was in the textile industry as well as the transportation industry that the Industrial Revolution was most strongly felt. The textile industry, including weaving and

spinning, was one of the first industries to be mechanized. This mechanization of textiles had an enormous impact socially, culturally and economically. The mechanization of textile mills involved the transfer of workers from the home to the factory, from the country to the city via the newly developed railways powered by the steam engine, and worsened the already deplorable conditions of textile workers. As Karl Marx wrote, "The hand-loom gives you society with the feudal lord; the steam-mill, society with the industrial capitalist."[2]

The invention of the steam engine, although uneconomical and inefficient to operate by contemporary standards, necessitated a consolidation of resources and machines. Textile machinery, whether a loom or a spindle, is comparatively light and uses little power. For steam power to be effective, the machines need to be assembled in large factories where many looms and spindles can be powered from one steam engine. The only available means of transmitting power in the mid-nineteenth century were mechanical, through the use of shafts, belts and pulleys. Later, with the invention of the electrical motor, machines were driven individually and no longer required mechanical and, by extension, spatial connection. But the desire for a consolidation of workers under one roof was not solely necessitated by technological requirements. It was reflected in the nineteenth-century management's desire to maintain discipline and control over workers, something easier to achieve when the workforce is localized and not dispersed. Twentieth-century labour conditions in the electronics industry are distressingly similar. The appalling work conditions of the multi-national electronics industry rival the deplorable conditions of the nineteenth-century textile mills. The shift in population from an agrarian life to an urban, industrial life necessitated by the Industrial Revolution is mirrored today in the large movement of people in the Third World—those whom Barbara Ehrenreich and Annette Fuentes have called the world's new industrial proletariat: young, female, Third World, their existence signalled by a label or imprint such as Made in Hong Kong, Taiwan, Korea, the Dominican Republic, Mexico[3]—

who are forced to move from countryside to city, rupturing social and cultural traditions. Ironically, in the developed world where computers are used but not assembled (with a few exceptions), computers have had the opposite effect of dispersing the population, allowing individuals to work anywhere a telephone line and modem can be hooked up.

Within the digital revolution of the twentieth century, the role of textile technology is equally seminal. One of the many ironies, as any first-year computer science student is well aware, lies in the fact that the forerunner of the first computing machine—Charles Babbage's *Analytical Engine*—was based on the early nineteenth-century Jacquard loom.[4] Joseph-Marie Jacquard's system of pattern punch cards to store and process information for his automated loom were translated into the first computer punch cards.[5] Weaving, after all, is a process of information storage, a binary system of interlocking threads, mirroring the 0's and 1's of computer programming. Yet the image of a weaver in nineteenth-century Lyon, France, let alone twentieth-century America, is strangely at odds with the image of the contemporary computer hacker.

This gap between a technology's perceived and actual function and history is well illustrated in artist Gwen Zierdt's *The Unabomber Manifesto*. It is a hand-woven textile, measuring two by four metres, consisting of horizontal woven strips that translate the first four paragraphs of the Unabomber's Manifesto into a pattern. Within each horizontal strip of cloth, grey and white squares in vertical blocks represent eight-bit binary numbers. These numbers correspond to the text as it is stored in computer memory. The Unabomber's text was downloaded from the Internet and represented by patterns that correspond to the 0's and 1's that are used to store text in computer memory. This pattern was then converted into weaving instructions and woven with a computerized dobby loom.

The Unabomber's Manifesto, also known as "The Industrial Society and Its Future" is, among other things, a tirade against technology and an exhortation for society to return to a level of technology similar to the one that preceded the Industrial

Revolution. By hand-weaving the Unabomber's Manifesto in conjunction with computer technology, Zierdt's work offers an ironic commentary on the location of practices in the popular imagination. That weaving, one of the most ancient technologies, a technology that has been at the forefront of both industrialization and digitization, the site of early labour exploitation and later labour organization, should be viewed with the romanticism of hand work inherent in the Unabomber's treatise is ironic. As Zierdt amply demonstrates, the discrepancies and distinctions between textile and digital technologies are not as distinct as they have previously been defined.

Zierdt's *Unabomber Manifesto* also questions the seemingly arbitrary nature of pattern as a collection of random decorative marks and units. *The Unabomber Manifesto* offers a striking contrast between the speed of digital telemedia against the slowness of hand production. The very visible labour of hand weaving is contrasted with the invisible labour of digital technologies, and points as well to the invisibility of the labourers who create textile goods and those who assemble computer goods. These seemingly disparate fields share the commonality of origins and a largely anonymous labour force.

In a 1995 collaborative project entitled *Fault Lines: Measurement, Distance and Place*, Barbara Layne and I explored the complex relationships and interrelationships between hand and high technologies. Our objectives were to incorporate digital technologies into material practices; to link disparate sites through electronic transmission; to reconsider boundaries, whether based on geography, philosophy or access; and to examine the contexts, associations and expectations of the apparently distinct media of weaving and telemedia technologies. The narrative traditions particular to both textiles and technology provided another interesting link in the *Fault Lines* project. Textiles have a very long tradition as a carrier of social and cultural messages: the Bayeux Tapestry, produced in the eleventh century, narrates the tale of the Norman Conquest; in the tales of Ovid, Penelope and Philomela tell their often horrific stories

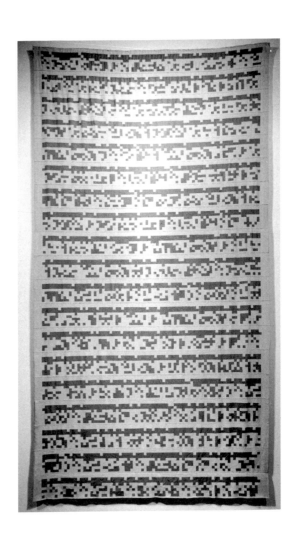

Gwendolyn Zierdt

The Unabomber Manifesto, 1997.

Cotton and silk, hand-woven, 300 x 180 cm.

Photo: James Prinz.

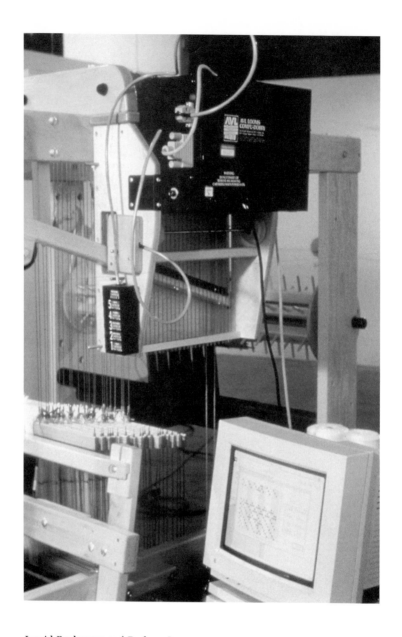

Ingrid Bachmann and **Barbara Layne**

Fault Lines: Measurement, Distance and Place, 1995.

Detail of computer attached to AVL loom.

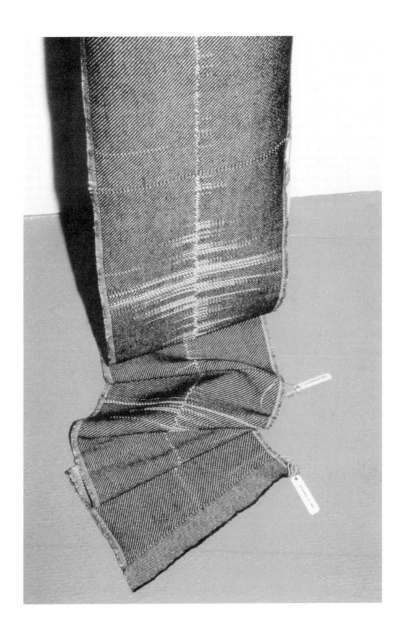

One of two computer loom woven cloths each 30 x 1675 cm.

through hand-woven cloth; and the contemporary Names Quilt documents the deaths from AIDS. Laurie Anderson has suggested that, "technology today is the campfire around which we tell our stories."[6]

Fault Lines involved the simultaneous production of two textiles in two distinct locations, Montréal, Québec, and Santa Monica, California, that recorded, measured and transformed the daily seismic activity of those cities into a woven record. Seismic data from Montréal and Los Angeles was uploaded daily by the geological labs at the Canadian Geological Survey in Ottawa, Canada, and the California Institute of Technology in Pasadena, California, to file transfer protocol (FTP) sites on the Internet. The data was exchanged from one site to the other via the Internet to computers attached to each loom. This information was then translated by custom designed software into a woven structure. For a period of one month, weavers at both sites operated the computerized looms and wove the daily seismic record of the other city, creating two continuous lengths of cloth that recorded the shifts of the earth as well as the gestures of the weavers. At the conclusion of the project, two bolts of cloth were produced. Each cloth was twelve inches wide and approximately fifty-five feet long. Woven in black and white yarn, the days were separated by shots of yellow or red yarn and tagged and dated. They were accurate renderings of the seismic data but their "truth value" was considerably diminished by virtue of their presentation in textile form. The information presented as a computer printout or a video still image has greater truth value to an observer today than the same data presented in textile form. The information itself had not changed, but its method of representation had. This called into question the seeming neutrality of various forms of representation. Clearly, all representations are mediated and information cannot be independent of the contexts and media in which it is presented.

Textiles are characterized by their haptic qualities and strong visual and tactile presence. The haptic quality of textiles reminds us of our own material origins and the often

problematic physical conditions of our daily lives. This tactility and materiality appears to be in direct opposition to the almost antiseptic sterility of the design of computer hardware. To note this is not an attempt to indulge in nostalgic longing for the loss of the haptic, nor to fetishize the labour intrinsic to most textile work, nor to make a claim for the superiority of the haptic. It is to examine the nature of materials and their location within a signifying realm. For what factors determine that textile looms are fabricated in natural woods and not in stainless steel? Conversely, what factors determine that computer hardware is fabricated in heavy duty grey or black plastic melamine rather than in wood? Why isn't fake wood grain an option? It would seem that the choice of materials to house these technologies is based on their associations as signifiers rather by any strictly functional imperatives.

What is at stake in the scripting of technologies as old, new, hot, cold, authored, anonymous? And what is at stake with the dismantling of the frontier myth of digital technology? The physical, the material, has an uncanny ability to remind us of our bodily origins, that messy, leaky terrain of wetware that the rhetoric of digital technology so desperately seeks to escape. We are reminded that even in our newest technologies we remain firmly rooted in the structures of the past.

NOTES

1. For an excellent resource on contemporary labour conditions in the textile industry, see *No Sweat: Fashion, Free Trade and the Rights of the Garment Industry*, Andrew Ross, ed. (New York: Verso, 1997).

2. Karl Marx, *The Marx-Engels Reader*, Robert C. Tucker, ed., (New York: W.W. Norton, 1978) p. 150.

3. Barbara Ehrenreich and Annette Fuentes, "Life on the Global Assembly Line" in *Feminist Frameworks*, Alison M. Jaggar & Paula S. Rothenberg, eds., (New York: McGraw-Hill, 1984) p. 280.

4. The abacus, it could be argued, is one of the first computing devices and its history has been traced back as far as ancient Greece and Rome. The abacus, which looks very much like a child's toy, consists of beads strung on rods mounted in a rectangular frame. As the beads are moved back and forth on the rods, their positions represent stored values. It is in the positions of the beads that this 'computer' represents and stores data. An individual is required to position the beads—data input—and is also required to observe the bead position—data output. But the abacus alone is not technically a computer, it is merely a data storage system since it relies on a human operator to create the complete machine.

5. See Sadie Plant's "The Future Looms: Women, Weaving and Cybernetics" in *Clicking In*, Lynne Herschman, ed., (Seattle: Bay City Press, 1996) for an in-depth look at the social, historical and cultural relationships between weaving, women and technology.

6. Laurie Anderson, *Wired* magazine, March 1994, p. 137.

Embodying Subjectivity

Stephen Horne

I perceive the wholeness of the world... to live perception, to be perception itself...
Lygia Clark

Automating processes open the work and the artist's interacting behavior to completing forces beyond his/her total personal control...
Robert Morris

Maybe if I really believe in me, trust me, without any calculated plan, who knows what will happen?
Eva Hesse

... it is the body of experience which understands the historical need for resistance. But I want to insist that, however much it may be brutalized, it is also the body of experience which bears the most uncompromised implicit understanding of the revolutionary possibilities that could favour us at the present historical moment with an opening up of the "healing dimension"...
David Michael Levin

Artworks provide paths to explore topics such as the self, work and embodiment. Lani Maestro, Mindy Yan Miller and Baco Ohama are three artists concerned with the relevance of "embodiment" to the project of linking the social and the personal. This essay focuses on works incorporating practices of the self: processes from which artworks emerge and bring the self back to the body, back to embodied subjectivity. Through these practices a wholeness of experience is recollected, and from this an empowerment arises which grounds the ideal of justice in the body of experience. Each of these three artists has incorporated aspects of the craft traditions in her development, and each positions herself within feminist practices and an art history that emphasizes a relationship to conceptual and minimalist styles.

This notion of justice in the flesh is located in the phenomenology of Maurice Merleau-Ponty as it has evolved in the current work of David Michael Levin. Levin proposes that the human body has, or rather is, an order of its own and that this order has not yet been recognized. The order he proposes is already social, geared into the mutual recognition of social interaction. The contemporary argument that "the body" is a social construct goes too far, however, implying the futility of any challenge to existing social order. Levin prefers to say that the body talks back. The work engaged in by these three artists focuses on rescuing the body from reification: social practices and cultural discourses that objectify the body and deny it the capacity to have meaning.

Minimalist art's repetitive dynamic can be found, and likely was found, in the practices of the craft tradition and in domestic labour, weaving, knitting, cooking, etc. The reintegration of these practices into art has a profound social and political significance, incorporating as it does a feminist revaluation of dominant cultural hierarchies. The processes, procedures and attitudes that I have in mind have to do with characteristics of embodiment, formlessness, invisibility, repetition and lack of closure. This tendency, which connects labour-intensive, repetitive, materials-based work processes offers a ritualized

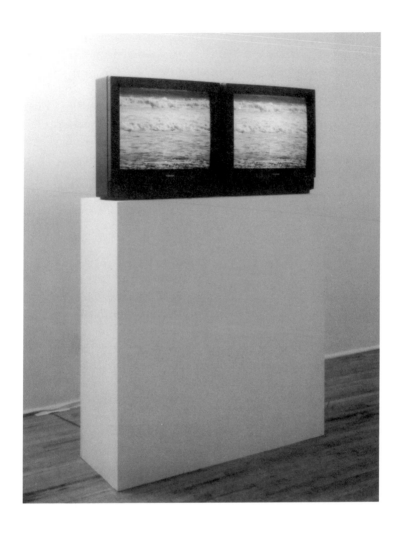

Lani Maestro
A Voice Remembers Nothing, 1988-94.
Video and audio recordings.
Photo: Lincoln Mulcahy.

recognition of the present through recollection, a theme to which David M. Levin has devoted several volumes. In his explication, recollection consists in:

> ... a retracing of steps in order to retrieve an understanding which will prepare us for new steps forward. Recollection is not a passive form of inquiry; nor for that matter, is its emerging body of understanding required to be docile, submissive and fatalistic. On the contrary, we need to realize that, first of all, recollection as a process of self-understanding, cannot possibly make contact with our history without interacting with present reality and changing its future course.[1]

Recollection, for Levin, is much more than a process of contacting and retrieving. It is also a process of developing our bodily awareness and cultivating its capacities. One effective way this process of recollection can be practised is through artistic activity.

In contemporary art writing the term "memory" has figured prominently as a kind of shorthand or summary device used by artists and critics to identify works and issues. The term suffers, however, when the psychological aspect is stressed to the exclusion of the physical; Levin's term "recollection" stresses embodiment. A few art writers have focused on the topic of memory, perhaps most notably Suzi Gablik and Donald Kuspit, who have often concerned themselves with "memory" in relation to the issue of "wholeness." Kuspit has argued that it remains necessary for the individual to have a sense of wholeness to survive emotionally and that the crafted object is a means of restoring the individual's sense of wholeness. In Gablik's view, wholeness is a sort of process-oriented framework with both self and world consisting of dynamic interactions and interrelational processes. This modifies the typical modern construal of the self as ego, an isolated and mastering centre, in favour of a self that exists as relatedness.

However, the issue of "wholeness" is complex. For example, by invoking wholeness we might mistakenly promote that

ideological construction which functions to mystify the fragmentation and alienation within technological culture. Levin claims that in fact there is a wholeness distinct from technologically constituted totalities and that it is through our bodily sensibility that we first become acquainted with a wholeness that radically differs from totality. He proposes:

> ... totality should refer to the wholeness metaphysics turns into an object, and that "wholeness" should refer to what cannot be totalized in this way... calculative reason only understands totality because it is grasping, instrumental, quantitative and disembodied. The heart understands a wholeness which cannot be totalized—a wholeness which is open.[2]

The repetitive processes occurring in these works of art are not indications of "memory" in the psychological sense of the term. They focus time and bodily action, integrate reflection, action and materiality in a process of embodiment, empowering the self as the investments of ego involvement diminish. In the case of these three artists this emerges through the development of artistic tendencies that embrace the unforeseeable through limited, repeatable operations and simple accumulation, and through which a meditative concentration is achieved, allowing a perceptual process in which a recovery of one's actions occurs. Such processes discover an empowerment in the unforeseeable aspects of repetitive, deliberate activity. They allow us to acknowledge the feeling that the meaning of our actions is determined by realities larger than we can perceive directly and to recognize that the culturally reinforced desire for greater and greater control over our selves, environment and persons is a project of patriarchal rationalism. I see these works as ethically concerned with the intertwining of the body and the self in artistic activities that constitute a reparative alternative to the metaphysical dualisms of action and thought, activity and passivity.

The suggestion being made here of an artistic practice as a recollective meditation finds a parallel in the spiritual practices

known as *mudra*. According to the Tibetan tradition of Buddhism, *mudra* is a form of embodiment that manifests the dynamics of enlightenment and functions as an antidote for too much thinking. In considering this relationship between embodiment and thinking (the work of language), Levin reviews the observations made by Martin Heidegger on this topic. In his 1954 essay *What Is Called Thinking*, Heidegger writes:

> Every motion of the hand in every one of its works carries itself through the element of thinking; every bearing of the hand bears itself in that element. All the work of the hand is rooted in thinking.[3]

David Levin suggests that the reverse is also the case, that there is a maintaining of thought which is rooted in the work of the hands. He is undertaking to define thinking not as cognitive process but as something bodily, something in the gesture rather than the distanced and controlling act of the Cartesian ego. There is a gathering of knowledge, habit and bodily effort in his characterization of thought:

> By virtue of patience, delicacy of touch, and gentle, careful motions, the (artist's) craft becomes an event of disclosing, a moment when the field of the gesture's encounter gives birth to, or makes appear, a "new thing," and the emotional depth of the field's reserve of enchantment is somehow itself made sensible for our emerging body of emotional understanding. Whenever this kind of skillfulness is at work, and wherever this kind of sensibility, this kind of reverence, is still handed down, as the gift of ancient tradition, there I think we will find a living response to the nihilism of our technological epoch.[4]

Lygia Clark, an artist whose concerns and works approximate those of philosopher David M. Levin, wrote in 1968:

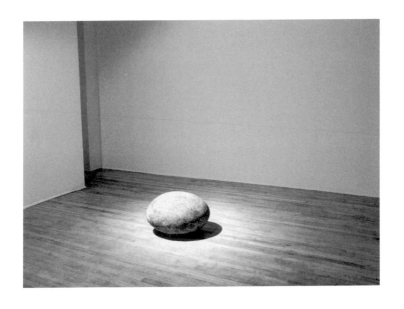

Baco Ohama

Stone, 1991.

Earthenware clay and ceramic,

underglaze, pigment, 60 x 48 x 33 cm.

Photo: Pierre Charnier.

Mindy Yan Miller
Template, 1995.
Pinholes, 181 x 43 cm.
Photo: Pierre Charnier.

When there is a struggle with the police and I see, in Brazil, a seven-teen year old killed, I realize that he dug a place with his body for the generations that succeed him. These young people have the same existential attitude as we, they unleash processes whose end they can't see, they open a path whose exit is unknown.[5]

Her statements continually focus on the ontological perspective of art making. Her sensuous manifestos, written in Brazil in the sixties, continually insist on the conjunction of the therapeutic and the political dimensions of artistic activity. She attributes this conjunction to art's potential for an overcoming of the western dualistic lifeworld and of the reifications imposed by the technological mode. Her statements manifest an intertwining of the body, time and space as erotic gesture:

... while watching the smoke from my cigarette, it was as though time itself were ceaselessly forging its path, annihilating itself, remaking itself continuously... I already experienced that in love, in my gestures. And each time the expression *trailing* wells up in a conversation, it gives rise to an actual space and integrates me into the world, I feel saved. (1965)[6]

In his writing on Lygia Clark, British art critic Guy Brett introduced the criterion of "efficacy" with respect to works of art, pointing out that efficacy is a word normally used in a medical context today. But, he says, the term has a profound history and meaning in relation to art also, since it refers to a time, or a cultural context, in which cultural artifacts were considered things that worked, when art and science were not split into two. In the case of the three artists represented here, the question of efficacy bears on the processes, necessarily subjective, that they have created in order to empower them-selves through artistic activity. The often minimal and sometimes meditative processes employed do so on the basis of an embodied awareness that emerges within their artistic activity and endures in the relationship we have with the works. This empowerment develops through an overcoming of self construed as ego. The

empowered self subverts the typical western conception of a justice that is based in the ego oriented will to power and provides a source of justice based on a redefined relationship between self and other in which self exists as relatedness.

NOTES

1. David Michael Levin and Kegan Paul, *The Body's Recollection of Being* (London: Routledge, 1985) p. 72.

2. David Michael Levin, *The Opening of Vision* (London and New York: Routledge, 1988) p. 177.

3. Martin Heidegger, *What Is Called Thinking* (New York: Harper & Row, 1968) p. 16.

4. Levin and Paul, p. 126.

5. Lygia Clark, October #69 (Cambridge: MIT Press, 1994) p. 107.

6. Ibid, p. 100.

Mary Scott:

in me more than me

Nell Tenhaaf

For a viewer familiar with Mary Scott's earlier work, the absence of any overt theoretical framework in her exhibition *in me more than me* goes counter to expectation. Similarly, the works in this show contradict an unmistakable psychoanalytic reference in their collective title: *in me more than me: schemas, diagrams, maps, knots, figures: stuck.* The five terms in the middle section refer to the system for representing operations of the psyche devised by French psychoanalyst Jacques Lacan, whose re-reading of Freud has been a key theoretical reference in Scott's practice. But if she seems to no longer be speaking "through the Father" in her apparent departure from theory, I discover that there is nonetheless a hidden entry into this work. I find out only after my first viewing that these paintings are made of Scott's previous works, complicating my impression that the work is more directly accessible than before. The highly mediated relationship of a viewer to Scott's work, involving research or access to information of one kind or another as the key to understanding, leads me to consider her current production as an evolution of epistemology, that is, as an inquiry into how we know what we know, rather than as a continuum of visual language. I'll begin by looking at naming.

The pronoun has changed since Scott's use of a very similar title for a 1991 exhibition, shifting from "you" to "me." But the most radical deviation of the current title from its predecessor is its final and seemingly prosaic claim: "stuck." This is a different kind of word from the rest of the title, at least a double-edged word, since these recent works have actually come unstuck, visually, from the Lacanian diagrams with which Scott had literally bound the drapes and billows of the works from 1991. With this word, she implies acceptance of the extent to which the Lacanian system introjects into her work and her thinking, reinforced by the pronoun shift to "me"; and/or, that she's caught at a point of stasis in that trajectory; and/or, that the word does not refer to Scott as a painter at all, but to an ordering principle in her practice that takes it somewhere else again.

Scott has never claimed to represent either her own self or any other body in her paintings. Yet throughout the decade of her visibility, her works have been identified with the body by writers, critics and viewers in general. Her works operate in a multidimensional field that suspends any usual objectives of representation, especially any intended reading predetermined by the artist. Her refusal of authority as author has been a con-sistent position, upheld within a rigorous quotation strategy for her iconography. Around the mid-1980s in the *Imago* works, this approach began to yield somewhat to an interest in the semiotic effects of highly charged materials such as unravelled silk, embroidery thread and gold leaf.[1] Nevertheless, body iden-tification has persisted in the readings of Scott's works, through two related tendencies in interpretation: as metonymic descriptions of a disturbingly threatened contemporary body; or, from the point of view of psychoanalytic feminism, as figurations of some less nameable psychic terrain that still speaks of a corresponding and necessary physical matrix. And now with the *in me more than me* series, the urge to identify the materiality of the works as touching upon the body is stronger than ever. But what kind of body?

For first, as touching the Cartesian Philosophy, this says that every body is a mere dead mass, not only void of all kind of life and sense, but utterly incapable thereof to all eternity; this grand error also is to be imputed to all those who affirm body and spirit to be contrary things, and inconvertible one into another, so as to deny a body all life and sense.[2]

How do we know that Scott's recent paintings refer to, even possibly stand for, the body? Given that they're made of silk, thread, clothes, conservator's tape and Scott's previous paintings, they hang on the wall as paintings, not as bodies, do. Clearly we intuitively sense a link with the body, through a feeling of "organic" form pervading the works. They look variously like chromosomes, truncated torsos, bundled babies, piles of brains, or some less-than-humanoid motile life form. For example, the paintings made of double-sided tape can become unstuck and creep down the wall to another spot. Sometimes the works read like an internal map of our own viscera, or as "data morphology," the shifting shape of coded information in the computer visualization of natural phenomena.

But all of this is only the surface, visual bites and obvious metaphors. The issue that emerges around the edges of these readings is not about somatic projections, nor is it principally about either a semiotic or an aesthetic effect. The sense in which a body is present in these works is rather an epistemological one, already implied in the name, *in me more than me*, which both conjures and refuses a physical self. The works read as continuously flipping between something that is revealed and something that stays hidden, holding those attributes simultaneously in deferral of a resolution. This indeterminate state of *in me more than me* leads to a body identification because it parallels how we paradoxically know and don't know our own somatic space. We have an immediate apprehension of it, and yet much of the time we can't grasp our body's messages very clearly, whether physiological, affective or psychological. We are, more or less, strangers in our relation with this

Mary Scott

in me more than me schemas, diagrams,
maps, knots, figures, stuck, 1992.

left: thread on blouses on painting, 40 x 71 x 15 cm.
right: thread on painting, 82 x 47 x 19 cm.

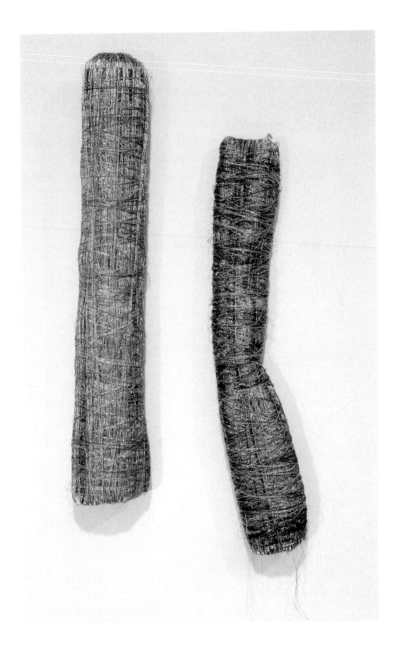

stuff that is us. This is how the idea of body in these works takes hold for the viewer, whether fully informed about their makeup or not.

As in Scott's previous work, a viewer's subjectivity is actively engaged. This engagement has a formal manifestation through gestures that seduce and mystify even as they reveal. The *Imago* paintings showed a preoccupation with the unfathomable dimensions of subjectivity; fragile images and materials alluded to how the sense of self is always provisional and in the process of being formed, never claiming to account for that formation.[3] There is an equally problematic subjectivity in the more recent works, a suggestion of the hidden spaces of psychic imprinting even without figuration on the paintings' surfaces or the quotation of imagery. All of that is now inside, contained within idiosyncratic homespun bio-spaces. These paintings, which contain earlier paintings, suggest that a bio-imaginary also forms our sense of self, that the implicit knowledge of oneself as an organism can become explicit. But this is neither a naïve idea of an essential self nor an especially theoretical proposal. Psychologizing is not pertinent to my observations, so I won't impute a motive to Scott's recycling strategy. Rather, I think that this work follows the logic of the particular representational trajectory that she is "wrapped up" in, one that is already deeply enmeshed in issues of bodily subjectivity:

> [O]f all the organisms on earth today, only prokaryotes (bacteria) are individuals. All other live beings ("organisms"—such as animals, plants, and fungi) are metabolically complex communities of a multitude of tightly organized beings. ... "Individuals" are all diversities of coevolving associates.[4]

These works contribute to Scott's highly personalized history of representational engagement with the limits of subjectivity, its ordering as well as its disruption. In the presence of these recent works, there is a strange reassurance about the continuum of inner life, the logic of one's discrete bio-mass and also that of

a common species life, largely inaccessible to everyone but specialists in biology. With her own psychic and material history bound up inside these unstable objects—threads come loose, shapes shift, fragments of words become recognizable, sticky surfaces transform over time from opacity to transparency—Scott makes life-forms that are as cohesive as any. But they are also transitory, only briefly adaptive as are we, always at a threshold of changing into something else. Scott's new paintings have swallowed her old, as life eats itself, taking in only what it can digest and incorporate, what nourishes it, and spitting out the rest so as to move on. If this seems a cruel process, certainly not a nostalgic one, it is nonetheless a powerful self-regulating dynamic. Within it, the artist's momentary intentionality could indeed be said to be "stuck."

The further parallel is unavoidable: painting tradition too has a life, an autonomous life and an evolution of its own. It can have a complex meaning for women: of co-opting the feminine within an ethos of masculine heroism and sexual prowess, of positioning women practitioners as "like men" so as to be adequate for the pursuit of its philosophical pro-ject.[5] Because Scott's practice engages with the question of self from the tenets of psychoanalytic thought, it does not admit to any project asserting a "true" subjectivity, feminine or otherwise. Her persistent divergence from "paint on can-vas" painting, although she calls all of her works paintings, is a corollary of this theoretical position. Yet this framework does not seem to have foreclosed in Scott's work a necessary interiority and internal ordering, co-existing with what remains unrepresentable, the ineffable of the deep ocean of the unconscious.

The feminist epistemology that I read in Mary Scott's practice focuses attention on the phenomenon of emergent subjectivities or identities, calling attention to the elusiveness and instability of processes of self-knowledge. Setting up a complex congruence, Scott discloses how representational practices, which enter into a fluid development of meaning from the moment of their inception through to their activation by a viewer, also acquire a

kind of "naturalness" that masks this process. In the recent works, these two different projects of knowledge are intertwined.

In the work composed of silk, sweat-shirts and five of Scott's earlier paintings, the rectangular framed paintings are completely hidden by a double layer of garments, covered first in ordinary sweat-shirts still visible in a few places, and then in sumptuous folds of silk which join one segment to the next. This work is intensely anthropomorphic, suggesting hierarchies of various kinds: of social status reflected in clothing, in the contrast between rummage sale cast-offs and luscious silk; of the historical significance attached to art media, especially painting as opposed to "feminine" fabric. The paintings here become disguised fragments of recorded consciousness, taking on variable outward form. If the dynamics of hierarchy and diversity in our political reality are habitually transposed into struggles for power, Scott's indeterminate typology speaks of a different, more fluid ordering, a different way of knowing.

These works offer a particular kind of pleasure then, an epistemological pleasure in considering the unknown not as a project for enlightenment, but as a condition to be approached with respect for its unfamiliarity, with deference toward its strangeness. Whether located outside or inside ourselves, we are "stuck" with approaching this strangeness by way of our best if not only means, through representation. Such a mode of inquiry offers an alternative subject position vis-à-vis the progress of knowledge, the project of the "new." If Scott indulges in the miracle of the new, what emerges in these works turns out to be a variation on the already known. Instead of engaging in the headlong tumble of evolutionary transmutation into what is construed, in our deepest cultural conventions and expectations, to be always more, better and improved, the pleasure effect here is one of suspension of form, accumulation, a holding pattern in time.

NOTES

1. Scott used French psychoanalyst Julia Kristeva's conception of the semiotic, which emphasizes the pre-symbolic period of understanding in early childhood prior to language use, as the basis for her representations of imaginary projections in the *Imagos*.

2. From *The Principles of the Most Ancient and Modern Philosophy, Concerning God, Christ, and the Creatures, viz. of spirit and matter in general, 1690*. Attributed to Lady Anne Conway, English Countess and noted vitalist philosopher. In Carolyn Merchant, *The Death of Nature: Women, Ecology and the Scientific Revolution* (San Francisco: Harper & Row, 1980) p. 258.

3. See Barbara Lounder, *Mary Scott: In You More Than You* (Halifax: Mount Saint Vincent University Gallery, 1991) n.p. Imagos, according to Lacan, operate like cliché images that stay with the child; they are also dynamic in their disturbance of aspects of the self and of intersubjectivity.

4. Lynn Margulis, "Big Trouble in Biology: Physiological Autopoiesis versus Mechanistic Neo-Darwinism" in John Brockman, ed., *Doing Science: The Reality Club* (Englewood Cliffs, N.J.: Prentice Hall, 1991) p. 221.

5. See my resumé of recent feminist discussions on painting in *Nameless, Named: Paintings and Works on Paper by Sheila Butler* (Toronto: Evelyn Aimis Gallery, 1992).

An Archeology of Tapestry

Diana Wood Conroy

I want to contextualize the practice of tapestry in order to extend its analysis beyond the blind wall of the art/craft debate, by interpreting tapestry through object-centred archaeological and anthropological approaches and through feminist research into language and the formation of a sentient consciousness.

As a practitioner, I would like to explore the hold that tapestry has on the imagination and its compulsive, if anachronistic processes. I have felt, throughout my working life as an artist, a dissatisfaction, an uneasiness, with the way flat-surfaced narrative tapestry seemed to be out of alignment, both with the craft world to which it is so connected through medium, and to the art world of painting and sculpture. In the Australian art world a tapestry is often interpreted through its ability to translate painted and drawn images, with an assumed separation of function between the weaver and the image maker. I therefore look beyond the hierarchical categorizations of "art" and "craft" in my interpretation of the art object within archaeology and anthropology, as these disciplines place objects within a whole range of material and social functions. But while finding many elements of value in archaeology/anthropology I also want to recontextualize their traditional, usually patriarchal, empirical application within feminist theory.

Archaeological interpretation is centred on analyzing patterns in material culture—that is, the things found in systematic excavations—to reconstruct patterns in associated human relations. Therefore a succinct definition of "culture" is a "system of shared meanings." The basis of archaeological research is the assumption that specific patterns in behaviour can be directly related to specific patterns in material culture. It could be said that archaeology focuses on the interaction between material culture and human behaviour and ideas, regardless of time and space. What we look at is not only fragmented objects of the past, but also residues of human behaviour.

The object is understood through the careful analysis of the context in which it was found. This is most visible in viewing objects during the process of excavation. The grid used in archaeology records not only the scattered detail of the site, but also suggests scaled-up tapestry cartoons.

Archaeology, through a scrutiny of objects, endeavours to reconstruct past societies, without judging or separating "art" or "craft" by categorization into particular mediums (i.e., the sculptured image as "art," the woven textile as "craft"). Sequences of objects from different sites are established within a chronological framework. Since knowledge of relationships and institutions of the past is often fragmentary or unknown, the object itself is subject to a detailed analysis of every aspect of the material it is made from, as well as its shape, decoration and imagery in relation to other similar artifacts found in related sites. Archaeology discovers the margins and peripheries of the past as well as the centres. "Putting in context" is the principal activity of an archaeologist: always placing the object in a network of similar objects through provenance, chronology, iconography and analysis of visual criteria. A nice touch for a tapestry maker who is also an archaeologist, is that the word "context" comes from the Latin *contexere* meaning to weave together or connect.

Tapestry is perceived to be a marginal art form, produced mainly by women, and archaeology, as I have said, is often concerned with marginal and peripheral conditions. Archaeology

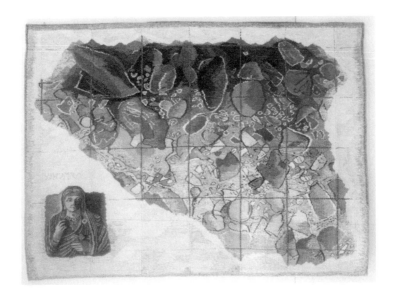

Diana Wood Conroy

Her only desire: Fragmentary site
with Lady of Palmyra, 1993.

Woven tapestry, 195 x 145 cm.

Private collection, Australia.

can then provide an approach to investigate the history of tapestry at a time when theories of history are under intense observation in current writing. The disunities, ruptures and marginal events in history, as opposed to the "master narrative," are now seen to be of equal importance to an understanding of the underlying structures of power. This insight underpins both archaeological and feminist discourse, as the methodology of archaeology, like that of feminism (and also postmodernism which is highly influenced by feminism), requires the placing of the object within a whole spectrum of social practices and hierarchies, as far as these can be deduced from the excavation of the site and examination of contemporaneous texts of all kinds. As image and form are viewed as inseparable, the stylistic analysis of minute visual criteria of images and patterns used in archaeology is a major tool.[1]

In recent archaeological theory, material culture is seen as not only reflecting the broader society but also as active in forming social relations. This leads to a new emphasis on the social, symbolic, ideological and functional aspects of art as an intrinsic part of our material culture. The subjectivity of the researcher is ever present: the observer as formed by the matrix of his/her culture must disclaim absolute "objectivity."

Feminist critiques, by revealing the masculine bias in western scientific "objective" method and theory, have called into question the very concept of objectivity. For feminists the personal, political and analytical are united in recognizing the subjectivity of such supposedly objective disciplines as archaeology/anthropology. The importance of the constant interchange between the person doing the discipline and the theory of that discipline, the intermeshing of theory and practice is not only recognized but is emphasized as essential.

In trying to understand how the subject, or person, is formed and thus constructs society, language is viewed by contemporary French thought to be at the heart of how we function as males or females. This thinking suggests a layering in the levels of language that reflect the layering of society. In contemporary tapestry there is a constant emphasis on the relationship

between text and textile (the Latin *textum* means woven fabric or web), and on the interconnections between narrative and tapestry. It follows that consideration of theories of language are essential in my research.[2]

Julia Kristeva, a contemporary French writer working within the philosophy of language, postulates an order of experience that is defined as the psyche's primary process in constructing meaning. She calls this the "semiotic" (Greek *semeion* meaning sign) and this area is the raw material, "the distinctive mark, trace, index, precursory sign, proof, engraved or written sign, imprint, trace..."[3] that precedes the acquisition of language in the child. Over this inchoate mass is imposed language, the "symbolic" order, which structures, gives system and syntax to the unformed "semiotic."

Both Kristeva and Lacan see this underlying, pre-linguistic area as being female, maternal, and the "symbolic" order imposed on it as being male, paternal. The "symbolic" male order continually represses and controls the maternal "semiotic." At certain significant historical moments, according to Kristeva, the symbolic control lapses, with the result that madness, holiness and poetry erupt into social orders. For Kristeva all texts and cultural products are the result of a dialectical process: the establishment of a unified "symbolic" system of language, and underlying and subverting this order is the "semiotic," a movement to break down and subvert these unities. This concept of the "semiotic" and "symbolic" can be applied to examine the relationship between textiles and the broader art world.

The association of textiles in our culture with the feminine, the domestic, the private rituals of birth, marriage and death, is indisputable. Coverings—curtains, carpets, quilts and blankets— soften our everyday lives, an almost unseen background for events and actions. These commonplace objects can be compared to Kristeva's "semiotic," as an underlying substructure separate from the recognized realms of dominant art practices. Dominant art practices may be seen as a patriarchal "symbolic" order that resists the intrusion of the "feminine" semiotic—the

craft practices bound to the senses—even though such sensuous references refresh and enliven the "symbolic" discourse.

The field of textiles is itself divided. The wider "semiotic" area of textiles pervades our everyday lives. Tapestry, by contrast, is a "symbolic order" providing a narrative of the great myths of western culture—heroic exploits as trappings of power for prominent public space.

Through examining textiles/tapestry in a "high art" context the woven medium is revealed as providing an unconscious, non-rational structure of form. Other meanings are presented within the woven tapestry.

NOTES

1. "Kay Lawrence's House: Self Considered as an Artifact," Bob Thompson, ed., *Forceps of Language: An Anthology of Critical Writing* (Sydney: University of Technology, 1992) pp. 112-120. Here, I applied an archeological analysis to contemporary tapestry.

2. Catherine K uses the text of newspaper as the constructing material of the tapestry, and the graffiti-like quality of the woven words form the image.

3. Elizabeth Grosz, *Jacques Lacan: A Feminist Introduction* (Sydney: Allen and Unwin, 1990) p. 154ff.

Weaving Out Loud

Anne West

Beginnings

> What is the impulse that compels an artist to bring the commonest
> of black and white threads into an intricate order?

For millennia, hand-woven textiles have provided a place for
recording information, memory and symbolic perception, and
the means to communicate social, magical and/or religious
ideas and values.[1] Especially important to the language and
meaning of textiles has been the association between the act of
weaving and the generative aspect of life. Since prehistoric
times, patterned cloths have served as a bridge between the
weaver (traditionally female) and the Creatrix (the universal
source of all life). One of the earliest known "messages" of creative
veneration is the kilim pattern design of the birth-giving
womb from Catal Huyuk c. 6400-5700 B.C.E. Through fields
of imagery and symbols of fertility, nurturance, continuity and
regeneration, life-giving designs (for instance, the diamond-glyph,
the labyrinth motif, or the birth symbol) were imbued with sacred
qualities.[2] Patterns laid out since ancient times functioned as an
"alphabet of the metaphysical."[3] They may be viewed as "an
endless incantation given visual form,"[4] like a poem or prayer
that gives sight and sound to the cosmos.

Symbols

> A true symbol (from the Greek verb meaning to "roll together, join, unify") always encloses two complementary poles; it is always ambivalent, ambiguous and indeed polyvalent...[5]

The visual symbolic language—the condensation of widely shared and deeply felt information and experience into primal nodes of truth—is at once universal and particular, dynamic and radical. For a visual symbol to communicate subtle, hidden life and function with spiritual grandeur and fecundity, it must be allowed to pervade all levels of reality, from the mental layer through to the mythic. Lamentably, in contemporary Western culture's tendency toward an ever-increasing, devitalizing fragmentation, few are in touch with the resonant, unifying power of a shared symbolic language. Vital symbols, once a treasure for constructing an understanding of our humanness and a means to further spiritual life, have been eroded by what communications critic Neil Postman calls "the great symbol drain" by technology: the trivialization of the symbolic language by advertising and entertainment enterprises whose sole interest in the visual is to further commerce.[6] Public myths and images circulated daily in the media make difficult the maintenance of a holistic perception of the world and the ability to establish relative priorities from the multitude of sensations that engulf us. Today we consume images, yet we do not know how to access their deeper source and meaning. Cosmic truths, with a grammar and syntax of a shared symbolic language, have been ignored or overwhelmed by technology and "progress." The opportunity for grasping the substance of our lives and a sense of rootedness and continuity has faded as the pace of activity has increased.

An Aperspectival Vista

In the exhibition *weaving out loud*, Sandra Brownlee layers history, myth and fantasy to show alternatives to the exclusive position given to technology by recognizing the sensitive layers of meaning that compose reality. For artist Brownlee, the delight in the ability to convey is based in a strong connection to tradition, and a desire to advance early pictorial conceptions alongside new elements from her visible and imaginary world. Brownlee's works reveal that symbols, and the narratives from which they are gathered, are spontaneous centres of action that may draw on specific non-spatial depths and meaning. They serve as bridges between the seen and unseen. If one sees beyond the hold of technological, disembodied habits of thought, one becomes aware of the living, regenerative power of symbols and their relation to time, the past, the forgotten, the spatially invisible; in other words, to the eminent, life-dispensing value of our age.

Patterned in black and white, Brownlee's work demonstrates trust and conviction in her relation to the world and to the idea of creation as a never-completely-new act. She is nourished through the making of vital connections to history; what emerges is a slow evocation of a world. She expresses and dramatizes an inherent respect for living symbols and a personal quest for meaning. The process of weaving allows Brownlee a focus, settledness and absorption. As with the concise, yet immense cosmologies of traditional weavers, she gives qualitative form to otherwise blind energies. Like the silent throbbing of a pulse, her works support an act of opening to a level of knowledge and experience that goes deeper than surface perception. Unlike the linear determinations of technological experience, her works generate a plenitude of time freedom: a tangible *durée*, a lengthening of time that is conceived of as a non-objective essence of being, a non-spatial reality. One experiences a tantalizing rupture in the conception of thought and life. One enters the beginning and the whole at once.

Making Cloth

Developed line by line using the technique of a ground weave with a supplementary weft pick-up,[7] Brownlee utilizes the inherent limitations of weaving to provide an essential, structured ground for the inscription of thought and feeling. She has entrusted her creative commitment to the straight line, creating a structure through interwoven linear elements. It is the intense continuum that gives form and structure to each visual element.

The vitality of Brownlee's work is conveyed through compositions that evolve instinctively, with little preparation and few sketches. Proceeding in this manner is not an aimless wandering. It requires concentration, play, a keen response similar to a child's method of expression, as well as thorough technical understanding. There is no changing, no altering, no opportunity for refinement. The potential for an image to evolve remains open. At any moment during the weaving process, only a partial sense of what the whole can become is visibly present. Yet this method also enables greater flexibility and spontaneity as the work develops, permitting an enthusiastic exploration of new forms and possible permutations.

Each woven cloth, with its markings drawn *alla prima*, reveals a pictorial world of ceaselessly mutating visual signs. The power of Brownlee's imagery, never clearly defined but endlessly absorbing, draws the viewer into a dense and delicate space where an intimate, personal, yet profound collective narrative is disclosed. The record is vivid and refined.

Notations of Being

Brownlee refers to her weavings as equivalent to the woven page. Messages... notations... records... fragmented glimpses...[8] Like the notebooks she constantly writes in, her weavings allude to the written signature and the emotion of handwriting. The weavings are drawings in thread as well as musings, a form

of thinking out loud. In some cases, the language that is formed surfaces as tiny murmurs, calibrations of movement, wanderings in time. They are an emergent language from a preformative substratum, rather than a composed text. Without finitude, these weavings do not set out to forge conclusions. The weavings are experienced as a felt, primordial, precognitive language. They are woven in the spirit of the first moment of discovering, and render shape to thought in a world that is forever becoming.

Brownlee activates the peripheral edges of awareness, stirring one to make connections between facets of life. She channels her view of the world within a global energy field. And thus, an immersion in her intimate spaces enables one to dwell in an expanse, a state of mind. The weavings offer shifting views of far and near, multiple perspectives and numerous viewing planes in which images are often magnified and superimposed. One becomes aware of a participation in the world based on empathy and identification.

Creation

> Creativity is a visibly emerging impulse of origin which "is" in turn timeless, or more accurately, before or "above" time and timelessness. And creativity is something that "happens" to us, that fully effects or fulfills itself in us.[9]

During the creation of her textiles, Brownlee weaves her heart into them as her story. She is receptive, open to the cloth, alive in every single intersection. Each line shapes the character of vital experience and of the spontaneous activity of living forms. Zoomorphic, anthropomorphic and fabulous creatures appear, tumble and dance. Historical references circulate in a wondrous, cumulative memory.

In her woven worlds, Brownlee's images form out of chaos as an energetic sea of dots congeals into meaningful sem-blances. In the *Creation Series* (1991), she evokes a sense of gathering, invention, and awareness of possibilities. Subtle

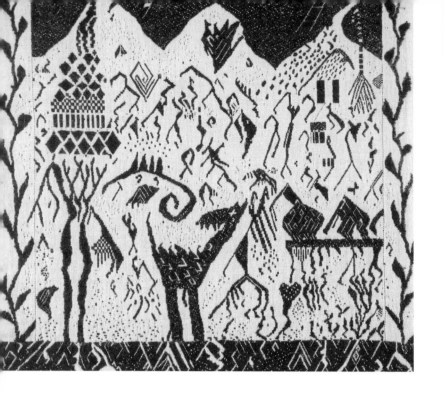

Sandra Brownlee

There's a World in My Mind, 1985.
Cotton sewing thread,
supplementary weft pick-up,
213 x 213 cm.
Photo: Jack Ramsdale.

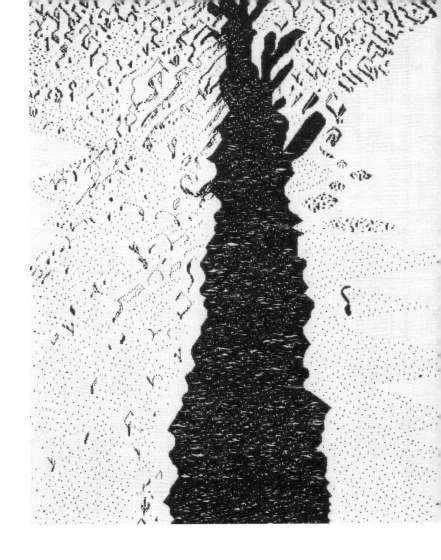

Woman, 1994
Cotton sewing thread,
supplementary weft pick-up,
213 x 275 cm.
Photo: Jack Ramsdale.

changes, repetition, rhythm, families of images built in unanticipated ways, dissolve, resolve and dissolve again. She is weaving in an activated field that is spatially alive, organizing and reorganizing according to its own laws. One feels the pulsing relationship to creation itself. Origin luminesces in the present, disarraying, transforming and liberating itself.[10]

Brownlee's vision is not solely contained within the woven form. The bookwork *GRRRHHHH: a study of social patterns* (1986), a collaboration between New York multi-disciplinary artist Warren Lehrer with chants and stories by Dennis Bernstein, is an example of a rich, intense and daring extension of Brownlee's *Unusual Animals*. In this bookwork, Brownlee's woven images have been interpreted and digitally transformed using the computer, giving them new life through pictorial and literary development. This convincing meeting of ancient and contemporary technologies speaks to the relevance of Brownlee's vision, and further challenges the narrow perception of the weaver as a current-day Luddite.

The Weaver of Images

In mythology, weavers have been often been represented as the Great Women of Fate.[11] They serve the Creatrix who weaves the web of life and spins the thread of destiny. Brownlee's work affirms this mythic role and embraces its position with a human dimension.

Like the mythic figure Arachne,[12] the celebrated weaver of images, Brownlee's fingers are expert at making refined cloth that expresses virtuosity, imagination and intelligence. Her works celebrate the experiences of a fully embodied individual through the process of weaving, thinking and telling. Following the long narrative tradition of textiles, Brownlee's open notebooks record woes and joys, hopes and visions.[13] The human act of weaving is positioned in relation to its primordial source as an impulse of creation embracing intricate

patterns and the perpetual expansiveness of the web of life. Her myriad threads demonstrate humanity and optimism, restraint and humility. And, like any true symbolic offering, they deeply engage the intellect and the heart. They "seize us and reveal us startlingly to ourselves as creatures set down here bewildered."[14]

NOTES

1. The sources for the thoughts expressed in this section are Buffie Johnson and Tracy Boyd, "The Eternal Weaver," *Heresies* 2:1, Spring 1978; Max Allen, *The Birth Symbol in Traditional Women's Art from Eurasia and the Western Pacific* (Toronto: Museum for Textiles, 1981); Ferdinand Anton, *Ancient Peruvian Textiles* (New York: Thames and Hudson, 1987); Marija Gimbutas, *The Language of the Goddess* (New York: Harper & Row, 1989); Susan Valadez "Patterns of Completion in Huichol Life and Art," *Uncoiling the Snake: Ancient Patterns in Contemporary Women's Lives*, Vicki Noble, ed., (San Francisco: Harper, 1993) pp. 145-154; Elizabeth Wayland Barber, *Women's Work: The First 20,000 Years* (New York: W.W. Norton, 1994).

2. Sacred qualities associated with cloth express sexuality and they also transmit notions of biological and social reproductive capabilities, all attributes associated with women. See *Cloth and Human Experience*, Annette B. Weiner & Jane Schneider, eds., (Washington: Smithsonian Institution Press, 1989) p. 25.

3. Gimbutas, p. 1.

4. From insights of art historian Douglas Frazer on "primitive art." Quoted in Allen, p. 8.

5. Jean Gebser, *The Ever-Present Origin*, translated by Noel Barstad and Algis Mickunas, (Athens: Ohio University Press, 1986) p. 221.

6. Neil Postman, *Technopoly: The Surrender of Culture to Technology* (New York: Vintage Books, 1993) pp. 164-180.

7. The supplementary weft skips over and under varying-sized groups of warp threads, creating the design row by row.

8. Conversation with the artist, December 1993. See in particular *1234 Series #1* (1980).

9. Gebser, p. 313.

10. Gebser, p. 314.

11. Allen, p. 10; Wayland Barber, pp. 238-256.

12. Many ancient myths revolve around textiles. I have referred to "Arachne's Tapestry," based on a retelling of the Greek myth of Pallas Athenae and Arachne by Ovid (42 BC-AD 17). *The Metamorphoses of Ovid* (Book 6), translated by Mary M. Innes, (Harmondsworth, Middlesex: Penguin Books, 1955). In this famous story, Athena, the patron goddess of weaving, is challenged to a contest by the self-confident young weaver Arachne. Unaware of her mortal limits, Arachne's arrogance and lack of wisdom eventually cause her downfall. Under the wrath of this divine being, she is condemned to become the Spider and weave webs forever.

13. Wayland Barber, p. 256.

14. Annie Dillard, "Write Till You Drop," *New York Times Book Review*, May 28, 1989, pp. 1, 23.

II. ARTICULATING GENDER AND IDENTITY

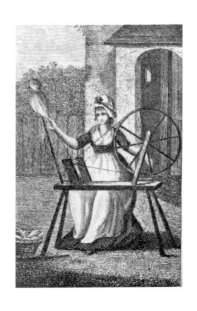

Three Dresses,
Tailored to the Times

Renee Baert

Clothing is a remarkably versatile and exact instrument of cultural expression. Formalized through dress codes that may extend as far as legislative decree—or that may be radically overturned by the more mobile decrees of fashion or by subcultural challenges to a culture's given mores—clothing constitutes a part of the social fabric at both its most general and most personal levels.

Dress is at once a social form and a surrogate for the body, a complex link between the private domain of the body and the public domain of the sign. In Nina Felshin's concise summation, it is "a dense coded system of signification that transmits psychological, sexual and cultural messages."[1] It is the visible interface of self and social—and not always in a tidy fit.

In recent years, numerous artists have taken particular notice of the potential of clothing as a means of figuring aspects of subjectivity. Often divorced from the body as bearer, and in excess of any function as dress, these garments serve to critically foreground fantasy, memory, gender, sexuality and history through the indirect depiction of embodied being.

Among the most immediate precedents for this work is feminist art of the 1970s, which utilized dress and related signifiers of the personal/domestic to highlight gender as social

construct. But there are also numerous antecedents in late nineteenth-century and early twentieth-century art practices for the engagement of artists with clothing. If current art practices typically depict clothing emptied of, yet standing in for, the body—or in performance works wherein clothing is altogether in excess of function—earlier art practices were no less engaged with the radical potential of dress as cultural sign, and as emancipatory vessel.

These include such instances as the pre-Raphaelite revamping of medieval clothing as artists' dress; the radical body politic of Italian Futurism (manifestos on clothing, streetwear of riotous design and colour, Balla's *Anti-neutral Suit*, costumes that mechanized movement); the Russian Suprematist and Constructivist art-into-life designs for a revolutionary social subject (Rodchenko, Tatlin, Stepanova, Lamonova among others); the Simultaneous clothing of Sonia Delaunay; the Surrealist alliances in the fashions by Schiaparelli (memorably her *Shoe Hat*, inspired by a Dali design). These adventures in clothing also extended to new visions of social subjectivity manifest in costuming for performance and avant-garde, anti-naturalist theatre in such movements as Futurism, Constructivism, the Bauhaus (famously Oskar Schlemmer's concoctions for dance and theatre); and Dada cabaret. Indeed, there is scarcely an art movement within the avant-garde of modernity that did not venture some activity in this realm, extending from the design of more "modern" fabrics or clothing to a more radical rethinking of the relation between clothing and the behaviours, body movements and social ideas it implied—or impelled.

In her important study *Seeing Through Clothes*, Anne Hollander has drawn attention to how the long tradition of figuration in Western art has itself shaped the visual codes through which we apprehend the body, whether dressed or undressed. Our visual self-awareness, as well as our shifting models of the look that is "natural" to any period, is itself purchased through these representational codes.[2] Whereas Hollander's book foregrounds the depiction of clothing in art from antiquity to the twentieth century, the avant-garde of

the early twentieth century turned to clothing as medium. Their remodelling of dress and costume constituted a means of rethinking subjectivity in modernity. The iconography of clothing also figures in later turns of twentieth-century art, ranging from Jim Dine's bathrobe paintings to Louise Bourgeois' body armatures to Betty Goodwin's vestworks to Andy Warhol's composite fashions to, most emblematically perhaps, Joseph Beuys' *Felt Suit*. It is the awareness of the imbrication of body, clothing, subjectivity and sociality that the post-modern "address" of clothing shares with these precedent projects.

Feminist art of the early second wave of the feminist movement was particularly influential in establishing the contemporary trend of divorcing clothing's status as function (dress) from its status as sign[3]—a sign which nonetheless drew upon the connotative dimensions of clothing. Though often worn as costume on the body in performance, film, video and other practices, clothing in women's art of this period also figured in usages abstracted from the body. Women artists found in dress and related materials a pertinent means of signifying and critiquing gender. The medium held the further allure of its association with "feminine" craft and domestic traditions which many women artists sought to valorize in new terms.

Early feminist art foregrounded the body as a fundamental ground of experience, incorporating clothing as adjunct to the depiction of gender and often utilizing the body itself as medium. In this, it was instrumental in undoing any notion of the "universal" subject (*qua* man) through its foregrounding of sexual difference and of the imprint of the social upon gendered experience and possibility. Among a later generation of artists, however, whose work gained particular prominence throughout the 1980s, many turned away from the body as source, drawing attention, rather, to the textuality through which it is invariably mediated. More concerned with undoing than propounding notions of identity, many of these artists have employed strategies that favour the deconstruction of the representational codes through which gender is (re)produced. Such works often

proceed through a reworking and destabilization of the imagery found within mass media or the canons of art history. The resurgence of clothing-based works in the 1990s suggests another turn, one that in many ways rejoins earlier feminist art practices in its paramount attention to embodiment and lived existence, even as it follows the deconstructive move in taking clothing itself as a culturally dense representational "sign" to be read—and rewritten.

Unlike the "body art" of an earlier generation of art practice, the exteriorization of the body through dress absents the immutable "real" of the body, sidestepping its literal representation to foreground, rather, its social sitedness. In divorcing clothing from the figure, a gap is created in the conceptual space between the body—on which prevailing gender, racial and other codes are inevitably mapped—and its second skin. Yet the absent body remains implied both through the contiguity of clothing and corporeality, and by the empty space within the garment. In the absence of the body, the social valence of dress as representation may be elaborated in new metaphorical schemas. The signifier of clothing is, further, a mutable one through which meanings are socially constructed, and this mutability of the sign enables a give and play with its codes and the staging of multiple theatres of identity. As a medium, clothing is a highly variable means through which to address a host of issues. Though its fit to the body—its social surface—privileges issues of embodiment, gender and sexuality, the cultural referentiality of dress enables clothing works to draw upon aspects of history, memory and the affective charge of popular iconography.

While contemporary feminist art practices have engaged issues across a broad spectrum of reference through the use, in whole or part, of clothing, the motif of "the dress" is itself a predominant, recurring means of doing so. Be it woman's or girl's, the dress is a quintessentially gendered garment, the very emblem of femininity. It is an external surface transmitting a host of cultural messages, in a variety of styles that constitutes a veritable theatre of roles and codes. Hence it is a potent symbol

and vehicle through which to reconceptualize and remetaphorize issues of identity as these circulate through bodies, social spaces and representational sites.

In the three examples of dressworks that follow, each proceeds from a very different vantage to figure, variously, a critique of rigid gender roles, a morphology through which to represent female sexuality and desire, and a revisitation of colonial history. The works interrogate cultural heritage through modes of symbolization that, like representation itself, turn on a play of presence/absence, but a presence/absence centering on the female subject. In absenting the female body from representation, retrieving it from its status as object, the clothing as presence stands in for the body to suggest a mode of subjectification. In this sense, clothing works may be seen to offer a privileged viability for conjoining poststructuralist theory's challenge to any notion of a fixity or innateness of identity with the wide-spread refusal in feminist theory to evacuate the category of the subject.

Mimicry and Mommy

Shawna Dempsey and Lorri Millan's *Arborite Housedress* might be seen as close in spirit to the feminist practices of the 1970s, in that it critically foregrounds the social construction of gender and the conscription of the "feminine" to a realm of diminished possibility. Yet their approach also has a rapport with the model of "mimicry" proposed by Luce Irigaray. For Irigaray, mimesis—the entering into and distantiated copying of the ideas and roles through which the "feminine" is artic-ulated in patriarchal thought—is a mode of revealing its structures and undoing its logic. "One must assume the femi-nine role deliberately," she writes, "which means already to convert a form of subordination into an affirmation, and thus begin to thwart it."[4]

Arborite Housedress forms part of an ongoing series of "unlikely dresses" that include *Object/Subject of Desire* (a ballgown of

Shawna Dempsey and **Lorri Millan**

Arborite Housedress.

Photo: Sheila Spence.

vellum paper), *The Plastic Bride* (a wedding gown of clear vinyl), *The Glass Madonna* (a body frame of stained glass) and *The Thin Skin of Normal* (a gown of clear plastic wrap perforated with out-pointing four-inch nails). Each of the dresses have been worn by Dempsey in performance works that examine, with sharp humour and from different facets, various emblems of feminine existence. Unlike most of the dresses, however, *Arborite Housedress* is also displayed as a free-standing object. Of a rigid geometric construction, made to human scale, it is a sleeveless summer garment of pink formica over a wood frame that stands squatly on the ground. The skirt of the dress is partly composed of an inlaid white apron, whose pocket opens out to reveal a drawer. The back of the dress features a row of buttons (large, round stainless steel knobs) that suggest the dress's opening. The work bears a certain conceptual affinity to Louise Bourgeois' 1947 drawing, *Femme/Maison*, a protofeminist icon in which a female body is figured with the head and bodice of a house. *Arborite Housedress* is itself built to the same process as house construction—a frame covered by walls then exterior finish.

The rigidity of the object conforms to the rigidity of gender roles in the post-war period in which this new "wonder" material became popularly available. Arborite was incorporated into the domestic realm as part of the extension into the household of modern models of rationality and efficiency. The material was prized for its ease of use, its durability and its simplicity of line, in which elements of adornment were incorporated into surface and function rather than as add-on ornamentation. It is at once decorative and efficient: an analogue for the role of the post-war housewife, confined anew to the "domestic sciences" of the household sphere.

The work is altogether an icon of a patriarchally defined femininity: woman as interminably mother, caretaker and subsidiary. Though quoting a 1950s iconography, the proffered image is not altogether distanced in time, given the persistence to this day of women's role as primary domestic caretakers. The work might also be seen to stand as a wry monument to the very model of womanhood that formed the basis for feminist disidentification

and rebellion by the daughters and the mothers themselves, with the rise of the feminist movement in the late 1960s. Through what Jan Allen has termed their "strategy of parodic literalism,"[5] Dempsey and Millan's absurd, rather bright and cheerful assembled object instantiates a mimicry of gender rigidity, an assumption so slavish of a model of feminine servitude that it "serves" to disassemble it.

The distantiation effect achieved through mimicry and play is yet more exaggerated in performance, where the dress is worn by Dempsey. Consider the apron's pocket/drawer, in its adjacency to the pubic area, already an invocation of feminine sexuality as receptacle. It is activated in staging as an object of much busy-work—opened to reveal a pencil, the tip of which is repeatedly licked, and a notepad on which chores accomplished are voraciously ticked, the tasks themselves (the "sucking" of dirt, for instance) a salacious displacement of "boxed in" sexuality, the drawer itself an hysteria of openings and closings. It is as if the very rigidity of the outfit functions to tightly contain the libidinal energies it houses. *Arborite Housedress*, upright and uptight, stands as a reprised emblem of domestic rigidities, built to a measure of quite different humours.

It is divine!

In Anne Ramsden's storefront installation *Dress!*, by contrast, the object of feminine apparel is a formal gown, an icon of wealth and glamour. Using to full advantage the "real" of the garment in its rich colour and sensuality, this "real" as mediated through the artist's modifications is itself founded on artifice and illusion. In deploying the dress as a kind of fetish object of displaced desire, Ramsden's dresswork accentuates the channelling of desire through the lures of commodity culture.

The site-specific work was installed in twenty-inch-deep display cases built into two windows on either side of the entrance to the Contemporary Art Gallery in Vancouver, evoking the look of a commercial storefront display of fashion

clothing—a reference pertinent to its location across from a community college with a fashion design program. The installation also drew upon the processes of urban renewal and gentrification transforming the neighbourhood, with their corollary influx of office workers and consumers.

In one window, draped in half over a gold-painted display rod, hung a cluster of unwearable accessories: a pair of black nylon stockings sewn together at the tops; a double-ended tie of a vividly coloured design (indeed, recalling the Futurist intervention into the drabness of male dress); a belt with buckle holes at both ends; and a pair of floral patterned evening gloves sewn together to compose one continuous arm. Laminated to the wall behind these objects stood a black-and-white photographic backdrop depicting these items at their unfolded length. The partner window held the eponymous object of allure—a form-fitting evening gown of emerald green satin, hung on a gold-painted rod, the base of the dress a cascading pool of fabric. Yet the appearance of the dress is deceptive: while seemingly of a classic design, it is of a narrowness defying any bodily fit and a length exaggerated beyond any possibility of wear. Like the accessories, it has no "use" value: it is an impossible object, a fetish object of/for irrational, excessive desire.

In Freudian theory, the fetish has little relation to female subjecthood, in that fetishism is viewed as a distinctly masculine perversion by dint of its relation to castration anxiety.[6] From the perspective of numerous texts, of which Laura Mulvey's classic "Visual pleasure and narrative cinema"[7] has been particularly influential, the dress as costume for woman-as-spectacle would be seen to play its part in the fetishistic displacement of male castration anxiety. Yet the object, through the trappings of visual display, is also enlisted in what Emily Apter has described as "the contemporary hypersensitivity to the sexuality of things. Objects are revealed as provocations to desire and possession."[8] Emptied of the body, it is the dress itself that is offered for imaginary possession. In this, the dress as commodity fetish—indeed, as image fetish—

windows: Anne Ramsden

enters into the chain of metonymic displacements through which the fetish secures its effects. The desire it provokes can be seen as a mode of female pleasure rather than as (only) the passive lure for the male gaze or as advertising's fetishization of the female body. In this, *Dress!* converts the fetish object from its disposition in masculine terms to that of a fetish/metonym of female narcissistic delight. Ramsden's deliciously yet perversely exaggerated *Dress!*, in drawing upon the fashionable, glamorous aspects of feminine wear, accentuates an imaginative relation to self-adornment along the axis of sexuality and pleasure. The physical body removed from the spectacle of voyeuristic looking is returned as the imaginative correlate of the spectator's identificatory apprehension.

The aspect of allure and visual pleasure in *Dress!*, however, is thwarted by the object's quality of unattainability. As an impossible object, the dress—and its companion pieces—may be seen to signify desire itself, desire that by definition is never fully attainable. In this sense, it is not only that the object of desire passes through the commercial commodity form, but that desire itself is on offer. It is a purchase ever-renewable in that its promised satisfactions can never be finally obtained, yet can ever be proposed in an endless stream of seductive image-products that move pleasure through the conduit of consumption.

As a lure for the female spectator/consumer, this sensuous dress is of an ambiguous register. It is an imaginatively potent source of female identificatory and spectatorial pleasure, even as it is also an elision of other possibilities—beyond spectacle and consumerism—for imagining the objects and movements of female desire. Propped upon a culturally available image repertoire of femininity, repossessing an iconography already culturally, sexually and phantasmatically invested, the ambiguity of *Dress!* does not resolve the complex predicament of the culturally "unrepresentable" female desire, but it appropriates these signs toward woman's stake in pleasure.

Colonial perfections

The little girl's dress in Buseje Bailey's *The Viewing Room*, hung lopsidedly from a misshapen wire hanger, is an arresting, disconcerting sight. A once pretty garment whose livid chartreuse colour seems to embody the vividness of childhood, it is emblem at once of innocence and its ruin. The bodice of the dress, made for a young girl, remains in almost pristine condition—a precious object for the display of daddy's princess, a dream dress. But its skirt has come apart, the fabric torn and hanging in clumps, its edges shredded with holes.

The distressed garment is hung within a large square window box, the frame of which is old, its weathered brown paint cracked and faded. A pair of transparent white mesh curtains, trimmed with a mesh floral pattern, fringe the wood frame and are drawn open with ties to reveal, theatrically, the centrepiece garment. The disused dress in its decrepit frame functions rather like a worn archival photograph: it is an imprint of the past, the representation of an absence, an inciting of memory, a field of projection. But a less mediated "real" than the photograph, its exact body scale and its material immediacy with the residue traces of time and human wear, lend it a compelling auratic power. At the same time, the frame itself initiates the dialectic between the positions of view from inside and outside.

Joined loops made of soft ribbon encircle the dress, passing from waist to neck and extending along the sides, like links in a chain. Wide bracelets and a deep necklace of brown satin also encircle the neck and wrists like soft shackles. The chain as signifier of imprisonment or slavery is here rendered as adornment for the absented body, evoking not a cruel repression, but the gentler bonds that command us, the subtler restraints to which we grow accustomed. This visual theme is reiterated in the curtains, the crisp mesh fabric recalling the pattern, in softer miniature, of a chain-link fence.

The original beauty of the garment, its persistent aura, invites an identificatory movement, a nostalgia for the charms of girlhood it suggests, but this is undercut by the satin chains,

the ravaged garment, the derelict frame. In Bailey's rendering, the once-perfect garment is a stand-in for what never was: the perfect girl, the perfect childhood. The dress in its ideal form is a garment for a pristine child, an immaculate girl on passive display. The ruined dress sets the limits to nostalgia, drawing attention to a gap—experiential, conceptual, temporal—between the ideal and the real.

While the scene—the dress, the frame, the dereliction, the display—is one that can appeal to many different cultural experiences of girlhood, the dress itself is a recovered mnemonic of the artist's Jamaican childhood.[9] Though less immediately expressive of its specific cultural reference than other dress works by this artist, which turn upon a more generic Afro-Jamaican "look," it is precisely not a traditional or ethnicized garment: it is an imported ideal, part of the trappings of a modern colonialism. The staging of the dress-icon can invite a recognition from highly various cultural vantages precisely because of the global dominion of a Western modelling of the world in its own cultural image.

If the artwork presents an object of divided meanings, this splitting also extends to the dress in its original form as a contradictory object of wear: it embodies a visible emblem of civility in a colonial context of derogation toward local culture and mores, yet at the same time it figures the imaginative centrality of Western cultural models as the exemplar of that standard. It is this imaginative hold, resonantly conveyed in the soft, constricting chains that suggest the displacement of a fiercer form of enslavement with a subtler one, that lies in ruin in the work. The aged garment, its allure in shreds, hangs on view as the transformed mnemonic of a past at once unforgotten and irretrievable.

Play of the sign

The postmodern is said to be characterized by the collapse of the grand legitimating narratives of science and progress

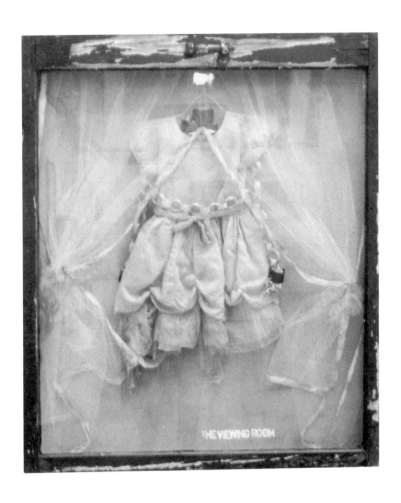

Buseje Bailey

Viewing Room, 1996.

Dress, wood frame, curtains.

Photo: courtesy the artist.

foundational to modernity (Lyotard). It is said to be an era ushering in the death of the author (Barthes), the disappearance of the subject (Foucault) and the end of history (Jameson). Corollary to the decentred idea of the subject is a postmodern aesthetic model: the fragment, the body in pieces, pastiche. Surface supersedes depth, and the free play of textuality—in the trope of a "feminine" indeterminacy—inscribes this surface. The body is a discursive field, marked all over by the traces of language and history, a volume collapsed to its surface plane.

While the works discussed above do not revert to a model of identity predicated on the notion of a unified, self-identical, "essential" subject, neither is their stance to be located in a poststructuralist dissolution of the self into textual play. While the feminist project might proceed against the subject/ aesthetic of modernism (autonomous, transcendent and free from the forces of the irrational), one feminist predicate of this analysis may be to align the "negative" deconstructive move— with its apt appraisals of the subject as "sign" captured in a traffic of discourses and representations—with a "positive" move to articulate, in new terms, the desires, anxieties, skepticisms and knowledges of contemporary existence and female subjectivity. The dress in these art practices is revealed to be a precise medium for enabling the depiction of the complex crossovers of the discursive and historical aspects of female existence with the elements of interiority, affect, fantasy and memory that constitute psychic life.

NOTES

1. Nina Felshin, "Clothing as Subject," *Art Bulletin*, vol. 54, no. 1, spring 1995, p. 20.

2. Anne Hollander, *Seeing Through Clothes* (Berkeley: University of California Press, 1975).

3. While there are other precedents of clothing divorced from the body, these are isolated incidents rather than the more generalized movement referred to here.

4. Luce Irigaray, *This Sex Which Is Not One*, translated by Catherine Porter, (Ithaca: Cornell University Press, 1985) p. 76.

5. Jan Allen, *The Female Imaginary* (Kingston: Agnes Etherington Art Centre, 1994) p. 15.

6. Sexual fetishism represents a compromise psychic formation through which maternal castration is at once recognized and disavowed via the fetish, which stands in for the missing maternal phallus.

7. Laura Mulvey, "Visual pleasure and narrative cinema," *Screen*, vol. 16, no. 3, 1975.

8. Emily Apter, "Introduction," *Fetishism as Cultural Discourse*, Emily Apter and William Pietz, eds., (Ithaca and London: Cornell University Press, 1993) p. 2. The citation appears in a discussion of the writings of Walter Benjamin. Emphasis is mine.

9. A family photograph depicts Bailey as a child wearing the dress, an image that has on occasion accompanied the display of the work, but is not integral to the piece.

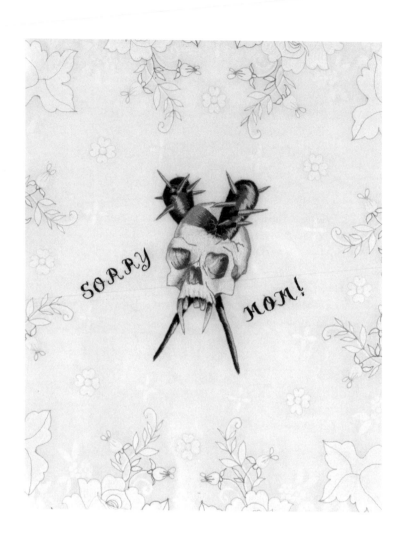

Robert Windrum

Sorry Mom!, 1992 (detail).

Commercially embroidered circular table cloth,
hand embroidered cotton floss, 160 cm diameter,
Collection: Nan Goldin.

Queer Stigmata:
The Embroidery Art of
Robert Windrum

Robin Metcalfe

He must have fixt aims and strong hand who hits decency and misseth sluttery.
Miss Lambert, *Church Embroidery* (1844)[1]

And those things that would have repelled most other, they were the very magnets that thus drew me.
Herman Melville, *Moby Dick* (1851)[2]

Like the eponymous hero of John Reid's 1973 autobiographical novel, *The Best Little Boy in the World*, Robert Windrum is the "nice boy"—the preacher's son—who has grown up to discover he's the sort of person his parents warned him against. His experience reflects the general collapse of normality that has brought both relief and confusion to middle-class life in North America during the later part of the twentieth century.

Born in 1963, Windrum grew up in a fundamentalist evangelical Christian family in Lethbridge, Alberta, where his father was a Baptist minister. He graduated with a BFA from the University of Lethbridge in 1985, including studies at the

Freie Kunstschule in Hamburg, Germany. Since 1989, he has lived in Toronto. Out as a gay man, he has been involved in AIDS activism in the arts community. He has several tattoos.[3]

Most of Windrum's artistic output is in embroidery, worked on fabrics that have direct contact with the body, such as clothing (shirts, underwear, scarves, a wedding dress) hand-kerchiefs or domestic linens (pillows, towels, bed sheets). The visual content of his embroidery consists of tattoo patterns or simple text. While he has sometimes quoted embroidery or tattoo motifs in works on paper or in photographs, Windrum usually grounds his art directly in the discipline of hand embroidery.[4]

In a 1992 work called *Summer Camp*, Windrum embroidered a pair of Calvin Klein underwear with images of paired phalluses spouting flames, and of a canoe pulled up beside a campfire. On the waistband, intermingled with the name of the designer, he worked the text, "This is Paradise."

Two fantasies collide in *Summer Camp:* the Norman Rockwell idyll of mothers stitching their sons' names on their clothing before they go away to camp, and the homoerotic narrative of Bruce Weber's advertising photography, which has elevated Calvin Klein underwear to the status of a gay male icon. The maternal tag, worn next to the skin, asserts the prior claims of family on personal identity, and evinces a certain anxiety that something might get "lost" in this extra-familial, all-male environment beyond immediate parental control. Appropriating and subverting the embroidered tag, Windrum plays on the double meaning of the word "camp" to evoke the world of erotic possibility that awaits the boy on this strange new shore.

Windrum's art directly reflects the dichotomies in his own experience: between normality and deviance, between masculine and feminine, between forbidden sexuality and the security of the familial domestic sphere, and between the paternal and maternal moral orders that preside over the socialization of boys and young men. The artist's queerness makes him an outlaw in both orders, even as he seeks to retrieve elements of each and to

combine them into a personal erotic and aesthetic language.

In an early series from 1990, Windrum hand-stitched tattoo designs onto commercial pillowcases that were already machine-embroidered in conventional floral patterns. The pillow slip in *Mother's Pillowcase/Son's Tattoo* is one his mother gave him when he first left home, the sort of household goods parents traditionally give their departing children, thereby maintaining a link with the familial. Onto this, the artist has copied the pattern of the tattoo on his own left biceps, a bright red heart above a pair of crossed wings, which he appropriated from a thirteenth-century Spanish manuscript.

Windrum respects and extends the symmetry of the original pillowcase design, but the vivid, bloody colours of the tattoo clash with the insipid blue pastels of the machine embroidery, just as the tattoo's image violates its bland normality. By introducing an emblem of his adult sexuality into the calm domestic order, Windrum dramatizes both the pathos of his wish for reconciliation and its impossibility.

Other pillowcases in this series bear mirrored skulls (in pink), a hand grasping a serpent that metamorphoses into an erect penis, and a bulldog with a spiked collar and a military helmet that Windrum copied from a tattoo on a model in a gay porn magazine. The content of Windrum's tattoo embroideries tends to be as defiantly "bad" as the images in tough-boy tattoos: skulls, daggers, serpents, flames, hard cocks, four-letter words. In a work for a 1992 exhibition, *Re-Dressing the Body*, Windrum embroidered the image of a fanged skull, pierced by two spike clubs, in the centre of a tablecloth embroidered in a floral pattern, together with the words, "Sorry Mom!" The gay child has fallen from grace, out of the protective embrace of the maternal order, but instead of being inducted into the patriarchal order, he has landed in no-man's land.

The contradictory yet overlapping identities imposed on gay men—the mama's boy and the sex pervert—confront one another directly in *Diptych-Mother/Fucker* (1991). On each of two pillowcases with scalloped edges, Windrum has added a small curved ribbon design that caps and embellishes the

original floral embroidery. The first ribbon, in pink, bears the word "Mother" in green letters, while the second, in reverse colours, reads "Fucker."

In 1992, Windrum moved from domestic linens to their industrial/institutional counterpart, when he created *Association/Revival*, a site-specific work for a group show called *Calisthenics* at downtown Toronto's Central YMCA, the largest Y in North America. In an exception to his usual rule of hand-stitching, the artist had over one hundred towels machine-embroidered with the words "Cleanliness" and "Godliness" distributed through the regular towel service. Six towels were exhibited in a display case for trophies and team photographs. The rest quickly disappeared as patrons nabbed them for souvenirs.

For years during adolescence, Windrum attended the annual youth recruitment weekend at the Prairie Bible Institute in Three Hills, Alberta. Within the YMCA display case, he placed a printed text referring to his own experiences there, and to his attraction to other young men playing basketball.

Association/Revival engaged the YMCA as a site on three levels: as a religious institution, as an athletic institution, and as an erotic institution where men meet other men for sex. This last function is implicitly celebrated in the 1978 disco hit by the Village People, "YMCA," which has recently enjoyed a popular revival and which serves as an emblem for the joyful hedonism of gay male culture in the years between the birth of gay liberation and the onset of the AIDS epidemic.

If the installation at the YMCA acknowledges the homoerotic subtext of a public institution, *In Sickness and in Health* (1991) situates homosexuality within the intimate space of the household, inscribing gay meanings on domestic linens. On a red bed sheet—the site of lovemaking, illness and death—the artist embroidered the image of a caduceus: a serpent twined around a staff. As the wand of the legendary doctor Asklepios, this device is associated with medicine and healing. It is also the attribute of the trickster god Hermes, the divine messenger who guided dead souls to the underworld and who was traditionally represented with an erect phallus.

Against this blood-coloured ground, Windrum has twined a ribbon around the staff bearing the words of the title, a line from the traditional marriage vow. One is reminded of the personal and physical consequences of AIDS for those who bear the disease and for those who love them, and of the recent focus of gay activism on achieving social recognition and support for same-sex relationships, through equality in spousal benefits.

As a common tattoo motif, the ribbon or scroll with text on it testifies to the bearer's loyalties: his romantic attachment to a (usually female) loved one or his allegiance to a (usually male) group such as a gang or regiment. Conventional male tattoos may express the most sentimental pieties of the filial, marital or religious varieties, or, alternately, the most aggressive impieties: assertions of irreverence, outlaw status and disrespect for authority. Both kinds often co-exist on the same body, even the same limb.

In trying to make sense of a body that is different from that of the mother, male children seek a structure to give meaning to their maleness. Most cultures offer male adolescents a ritual path to manhood, through initiation rites that enact a separation from the maternal order and a second birth into the masculine. Within the contested meaning systems of Western patriarchy today, however, men often lack spiritually compelling rites of initiation into the adult masculine order. The resulting masculine anxiety expresses itself in outlaw male subcultures that are tribal in form, such as motorcycle clubs and the gay leather community. Within these subcultures, scars, piercings and tattoos have functioned as both rites of initiation in themselves, and signs or records of that initiation into a numinous male identity. More generally, since the punk movement of the late 1970s, such signs of neotribalism have become for both men and women an expression of a cultural longing for a (literal) reinscription of spiritual meaning in the body.

The word "tattoo" is of Polynesian origin, with cognates in Tahitian and Marquesan. Although practised in many cultures worldwide since at least ancient Egyptian times, tattoos came

to be forbidden in the West under Christianity.[5] They were reintroduced to the West through sailors who had contact with the South Pacific cultures of Polynesia, societies whose attitudes toward sexuality were also at variance with the severe repression of the English-speaking countries.[6] In Aotearoa (New Zealand), tattoos communicated information about lineage and family history, and their later outlawing was an act of cultural genocide comparable to the suppression of the potlatch on the Canadian west coast.

Among the earliest references in popular culture to the art of tattooing is Herman Melville's 1851 whaling novel, *Moby Dick*. Queequeg is a fearsomely tattooed Pacific islander with whom circumstances require the narrator to share a bed in an inn. After their first night together, Ishmael awakes to find Queegueg's arm thrown over him "in the most loving and affectionate manner," hugging him in "his bridegroom clasp." At first frightened by the tattooed man, Ishmael soon finds himself "mysteriously drawn toward him" by "those very things that would have repelled most others." Queequeg takes Ishmael in an embrace of eternal friendship and declares that they are "married." They continue sleeping together on subsequent nights, "a cozy, loving pair."[7]

Ishamel is an outcast, as his name suggests, and his association with the tattooed man is a sign of his alienation from his society. In *The Scarlet Letter* (1850), an almost exactly contemporary novel by Melville's friend Nathaniel Hawthorne, the embroidery of Hester Prynne serves an analogous function to that of Queegueg's tattoos in Moby Dick. Hawthorne's heroine is condemned to wear the letter "A" (for "adulteress") embroidered on her dress. She applies her considerable skill at needlework to make the mark of her shame a thing of beauty, and in the process achieves a perverse freedom from the strictures of Puritan Salem. "It imparted to the wearer a kind of sacredness, which enabled her to walk securely amid all peril."[8]

Like other stigmatized groups, gay men have sometimes embraced their stigmata and transformed them into emblems of blessedness. Appropriating terms like "faggot" and "queer"

serves to blunt their edge and pre-empt their use as verbal weapons by our enemies.

In 1993, the Koffler Gallery in North York cancelled a planned exhibition of Robert Windrum's work, ostensibly because it objected to his use of an anti-gay epithet. In a work intended for the show, the artist had altered the wording "Born to be Bad" on a rocker scarf to read "Born to be a Fag." The incident reveals how the rhetoric of tolerance can disempower and silence those whom it supposedly protects. For Windrum, it comically evokes the image of "gangs of embroidering homosexuals."[9]

In 1990, Windrum worked the word "cunt" onto a piece of blue velvet in gold-coloured thread, using a simple satin stitch, and below it, much smaller, the name "Jeff." He then twisted the fabric around a long rod. The word "cunt," conventionally an obscene epithet of the first order, is in gold, the colour of purity, honour and incorruptibility, and set against a sumptuous velvet ground such as one might use to present a medal or a precious jewel. The subscript inclusion of a male name adds another layer of contradiction, evoking the seemingly nonsensical notion of a man who is, or has, a cunt. *Cunt-Jeff* provokes a kind of ricochet response as the mind attempts, in vain, to assign it a stable meaning.

The opprobrium with which Western patriarchy regards the vagina clearly demonstrates its contempt for all things feminine, particularly that which other cultures have regarded as the sacred source of life. The woman who is called a "cunt" behaves much like the man who is called a "prick"—obnoxious, selfish, unconcerned for the welfare of others—except that the female term has stronger condemnatory force. It suggests an assertion of an autonomous and explicitly genital sexuality that patriarchy deems more "natural" or appropriate to the male sex.

Cunt-Jeff illustrates a peculiarly intense form of gender-inappropriateness or perversion: a man who has taken on a supposedly feminine genital function by being the receptive partner in homosexual intercourse. It recalls the camp tradition of gay men referring to one another by feminine proper names and pronouns, notably the name of Mary ("Queen of the

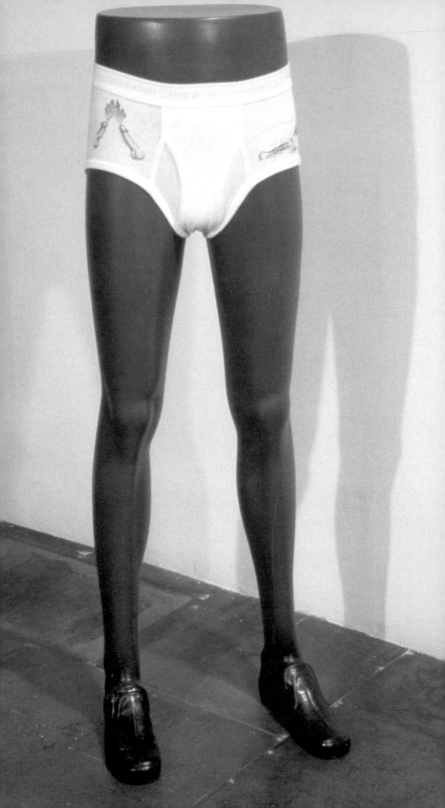

World"), the chief Christian derivative of the ancient Earth Goddess. Like much camp speech, this convention combines the qualities of a vicious put-down and an affectionate endearment and raises the possibility of degraded speech being reclaimed and revalued.

There can be a delirious pleasure in accepting an identity based on forbidden desires. The novels of Jean Genet—full of beautiful tattooed rough boys and sailors—revolve around notions of degradation as a form of sainthood. The tattoos of the criminal or biker are literal *stigmata* (the Greek root means "tattoo") that manifest a social stigma and transform it into a badge of honour.

Like tattoo, embroidery is a visual medium that has been consigned to the margins by modern art history, and both have become social markers of gender. They become metaphors for one another in Windrum's art, the embroidery needle interchangeable with that of the tattoo artist. The act of stitching, which we today understand as feminine, merges with another act of piercing that is read as masculine.

Embroidery, like tattoo, has often been a means of encoding one's status within kinship groups and social hierarchies. Matthew Benedict suggests that tattoos served in both Europe and Japan as a lower-class protest against sumptuary laws that reserved the wearing of rich embroideries for the rich. As visual traditions, tattoo and embroidery share some common motifs, such as the rose and the identifying monogram. Sheila Paine draws a link between the use of red thread in embroidery and the practice of sealing contracts in blood.[10]

Embroidery was an important narrative and ecclesiastical art in Europe during the Middle Ages. Both women and men practised the craft, first in workshops attached to households and religious institutions, and later in professional guilds. According to Rozsika Parker, it was the nineteenth century that constructed a "mythic history" for embroidery, marking the practice as inherently feminine. Both medieval nuns and Victorian housewives were accused of vanity if they embroidered for their own use, pleasure and adornment rather than

in the service of masculine domestic and religious authority.[11]

The social status of needle crafts, and Western notions of masculinity and femininity, have changed radically since 1520, when the meeting of the kings of England and France at the Field of Cloth of Gold was the occasion for a virtual orgy of embroidery. The surviving portraits of Francis I and Henry VII show men well pleased with the gorgeous maleness of their bodies, turned out in fine silk hose, sumptuous doublets and round, full codpieces.

By the end of the French Revolution, embroidery and the very notion of male adornment had virtually disappeared from ruling-class attire. Masculine clothing of the dominant classes changed from a celebration of maleness whose frankness verged on the lewd, to the anti-eroticism of the modern business suit, recalling the dour mourning attire of the Calvinist uniform from which it derives.[12] Windrum's phallic idyll in *Summer Camp* answers John Calvin with Calvin Klein, and returns erotic ornament to the male body.

Over the past two centuries, Western culture—particularly northern, Protestant culture—has largely withdrawn from men the capacity to experience their own bodies as a sensual field of pleasure. The male body has been reduced to the articulation and expression of power, corresponding to man's position as subject, while the female body is identified with the object of sensation and the occasion of (male) pleasure. The dominant culture defines primary narcissism—the capacity to experience one's own body as an object of pleasure—as a feminine trait. The ability to enjoy the touch of one's own skin is projected and transposed onto women.[13]

Homosexuality, by celebrating the erotic potential of the male body as an object of sensation, contradicts the modern Western construction of masculinity. Gayness, while characterized as feminine, in fact reveals the suppressed dimensions of male experience, the "other" masculinity, the one that is forbidden. Tattoos can serve, under these conditions, as a protest against the aesthetic poverty of the dominant masculinity and an assertion of its alternative.

Windrum produced a series of four embroidered handkerchiefs in 1991 named for the *Four Elements: shit/earth, piss/water, cum/air, blood/fire*. By incorporating bodily fluids into a system of numinous cosmological symbols, the handkerchiefs move to resacralize the body and its functions and to heal the split between spirit and flesh that plagues Western consciousness. More specifically, Windrum's handkerchiefs locate the sacred within the male body, particularly within the phallus and the anus.[14]

In 1990, the artist embroidered the word "homo" on the tail of a plain, white, man's shirt. Placed on a part of the garment that is not normally visible, it represents an aspect of sexuality that most men choose to keep hidden. It also locates that desire in relation to the body, in proximity to that secret gateway of male pleasures, the anus. *Homo* causes the shirttail to speak the name of its own homoerotic subtext to reveal that which it is intended to conceal. It reminds us that homosexuality is an identity that can be worn "out" or in.

Similarly, the title text of *We Move Freely Amongst You* (1991) is embroidered on the hem of an antique, child's chemise. It suggests the possibility of the child as a secret agent or alien, one who has infiltrated the family, but whose allegiances lie elsewhere.

By marking it with the tattoo, Windrum makes the fabric a metaphor for the human skin it is meant to cover. Formerly the instrument of concealment, it becomes in his art a means of transgressive display. Windrum's tattoo and text embroideries shift the meaning of the sign on the body, rupturing the process whereby it has served to reproduce the familial and patriarchal order.

NOTES

1. Cited in Rozsika Parker, *The Subversive Stitch: Embroidery and the Making of the Feminine* (New York: Routledge, 1989) p. 35.

2. Cited in Jonathan Katz, *Gay American History: Lesbians and Gay Men in the U.S.A.* (New York: Thomas Y. Crowell, 1976) p. 473.

3. Windrum says he never had to come out to his father, who is accepting of his son's sexuality and has left the ministry. Of his mother, on the other hand, he says that he "has to come out to her every year."

4. He executes most of his embroidery by first rendering the outline in split stitch, then using satin stitch to fill in the body of the form. The labour-intensive, repetitive action of stitching is meditative for him, something best done in silence, while thinking of something connected with the work. This accords with the common fibre tradition of praying with every stitch.

5. Interestingly, the other notable instance of a society in which tattoo has been socially unacceptable is Japan, where despite (or because of) this disapproval, tattoo has been elevated to an aesthetically sophisticated, if culturally marginal, practice.

6. For a discussion of this cultural encounter, see Katz's analysis of Herman Melville's novels *Typee* (1846) and *Omoo* (1847), pp. 467-9. The popular association of sailors with both tattoos and homosexuality is a durable one. Sailors are, for example, an important motif in the homoerotic novels of Jean Genet, particularly *Querelle of Brest*. Katz cites Melville's comments on naval ships as "wooden walled Gomorrahs of the deep" on pp. 469-70. Coincidentally, sailors on nineteenth-century whaling ships were also noted for the elaborate embroidered seascapes they produced on long voyages.

The persistent romantic fantasy of the pirate links the sexuality of all-male seafaring groups with the defiant deviancy of an outlaw culture, combining accentuated masculinity with homosexuality. B.R. Burg in *Sodomy and the Pirate Tradition: English Sea Rovers in the Seventeenth-Century Caribbean* (New York: New York University Press, 1984) argues that the freebooters of that period were almost exclusively homosexual.

I discuss the persistence of pirate imagery and sailor motifs in

modern gay mail-order fashions in my paper "The Mail-Order Body: Gay Mail-Order Fashions 1954-1993" presented at *Queer Sites, Bodies at Work, Bodies at Play: Studies in Lesbian and Gay Culture*, University of Toronto, May 1993. A shorter version appeared in the Toronto gay periodical *Xtra!* (no. 223, 1 October 1993, p. 27).

7. See Katz, pp. 472-3, for an analysis of the homoerotic subtext of *Moby Dick*.

8. See Matthew Benedict, "Tattoo/Embroidery: The Text of the Law upon the Body," *WHITEWALLS: A Journal of Language and Art*, (no. 30, 1992), n.p.

9. For an account of the dispute, see *Xtra!*, (no. 236, 12 November 1993), pp. 1, 13. The artist pursued a complaint against the gallery through the provincial human rights commission.

10. See Benedict (n.p.) and Sheila Paine, *Embroidered Textiles* (New York: Rizzoli, 1990), p. 7, as cited in Benedict.

11. See Parker, *passim*.

12. For a discussion of the social meaning of the suit, see John Berger, "The Suit and the Photograph," *About Looking* (New York: Pantheon, 1980) pp. 27-36.

13. I would like to thank Simone Vauthier for her comments on an earlier draft of this essay, which helped me to clarify my thoughts on the gendered body as a field of pleasure.

14. The resacrilization of the body is an ambition that Windrum's work shares with that of another Toronto gay artist, the late Robert Flack. Flack produced voluptuous photographs of the male body, projecting or superimposing on it colours and images suggestive of spiritual forces, with particular reference to the conventions of Tantric yoga. Some of the images Flack inscribed on the body, such as daggers and flames, are strongly reminiscent of tattoo designs.

Autobiographical Patterns

Janis Jefferies

When a female signature is assigned to authorship, autobiography, within the literary histories in the West, has been paradoxically named both as a mainstream writing genre and positioned as marginal practice. Traditional opinions on autobiography have usually been grounded within the idea of the "I" of self-identity as reflective self-presence and discussed within the terms set by the Cartesian subject; universal, singular and self-linked with the thinking, rational subject of eternal human nature. This has historically been codified as male. For women, autobiographical spaces have been profoundly fraught with tension, since the struggles to be the subject both of and in our own writing and speaking discourse, incurs problematic gendered readings. By challenging the universality of self-identity, women have cul-turally been identified as "other": exotic, unruly, irrational, uncivilized and different from the male norm. These classifica-tions established a hierarchy of naming and binary opposition that has had the effect of both legitimizing the potential of a female speaking subject as "other" to the limits of cultural practice and yet has, at the same time, fixed a conception of autobiography as the feminine, natural self-portrait par excellence.[1]

In another register, the coalescence between women and textiles has produced a fixity of identity in the West, which has named but has not always expanded or moved beyond a single definition of both terms.[2] This essay is concerned with this double paradox and ways in which I could begin to situate the self, subjectivity and the plurality of contemporary textile

practice as mobile entities, transgressing the old borders and boundaries of certitude and knowledge.

What is the cultural significance of the embodiment of this double dislocation and fixity: woman/autobiography and woman/textiles? Could Rosemarie Trockel's 1988 machine-knitted abstract of Descartes' *Cogito, ergo sum (I think, therefore I am)* be considered a signpost out of this double-bind, and claustrophobic restriction? Does it not parody the Cartesian subject referred to earlier? I speculate that the mimicking of the "pure" canvas of Kandinsky is played off in two ways. First, it is mimicked by knitting; and second by reinscribing the shaky signature of the hand-stitched, hand-written feminine "I" that transgresses its smooth surface of production. This idea of transgression, which ruptures both the formal properties of a discipline and the "proper" place of a gendered subject, is profoundly disturbing and unsettling to the body politic. Do Mike Kelly's failed power fantasies of dirty, messy, soft toys trash and transgress traditional forms of heroic media, including ideas of appropriate masculinity and false notions of domesticity? For me, each of these works speaks through an "autographics" of hybridity, encompassing both the textual configurations of subjectivity in language and the potential, performative role of practices that deploy textile processes in disturbing and unstable forms.

As Jeanne Perreault has remarked, one way in which autographics differs from autobiography is that it is not necessarily concerned with the process or unfolding of life events as reflective self-presence, but rather makes the writing itself an aspect of selfhood that the writer experiences and brings into being the possibility of playful, even wicked, self-invention.[3] Fictional manifestations may go beyond representation of the self, just as contemporary cultural practices may transgress the very naming of their gendered categorization to produce an infinite, undecidable set of contestations. These manifestations of throwing out of joint disrupt any notion of stable and definable subject or genre, and lurk at the very margins of mobile, fluid identities and subjectivities. Perhaps I/you/we

in the West can speak with some confidence about women's achievements in general, both in autobiographical writing and textiles, but I would argue that each category remains provisional as a tentative grammar of transformations and differences. I believe these are the new possibilities of both disciplines of writing and textiles in an ongoing relation, which provides an eclectically errant and culturally disruptive range of practices within an expanded field of cultural terms and definitions.

In earlier decades, the linking of the metaphors of pen and needle are re-told and re-called in a fragment of Elaine Showalter's own autobiographical anecdote, which denotes for me a hidden meaning behind the text and textile that forms the very intertextuality of its pages. A women's language is evoked as a social document of female experience. Piecing and writing are analogous to the process of quilt making which "corresponds to the writing process, on the level of the word, the sentence, the structure of the story or novel and these images, motifs or symbols that unify a fictional story."[4] As Showalter reminds me in a further essay, a number of women's nineteenth-century texts discuss the problem of reading a quilt, of deciphering the language of pieces like pages in an album.[5] A century later, Lucy Lippard's oft-quoted observation that "the quilt has become the prime visual metaphor for women's lives, women's culture" provided a situated knowledge for a version of feminist art practice that may now be seen as universalizing female experience.[6] Whereas, the "I" of the signature of Showalter is absent inside "Piecing and Writing," it is always paradoxically present in the writing as a controlling author of the text. Does Showalter not insist on a common ground between women's lives, women's writing and the reader/viewer who brings appropriate feminine sensibility to narratives that *any woman might know* (my italics)? However, this apparent coherence of the narrative and homogenization of experience is acknowledged and also mourned by Showalter as one who has "exaggerated the importance of women's culture" in order to find "a literature of our own."

To create a separate canon of women's writing through historical orientation and the specific characteristics of language, genre and influence is comparable to material counterparts in Lippard's search for a female aesthetic and Judy Chicago's revival of feminine crafts in *The Dinner Party*. Are we ruining our eyes, Showalter asks, in finishing a female heritage that may have become a museum piece? Who is included in the "we" here? Is this a nostalgic reminiscence for the past or a disturbance to the certainty of knowledge in an early feminist's traditional faith of the liberating effects of identity politics and women's rights?

Re-reading these texts in the late 1990s provides another train of speculation insofar as the decentred structure of a woman's text and textile fragment is re-figured in the processes of *écriture feminine*. In the "verbal quilt" of (an)other feminist text, Rachel Blau DuPlessis argues that there is an appeal to the voice of the female body which speaks itself as subject as "non-hierarchic... being hierarchical structures, making an even display of elements over the surface with no climatic movement, having the materials organized into many centres."[7] As practiced by Helene Cixous, *écriture feminine* becomes impossible to theorize. Cixous describes this practice of "writing from and of the body," as "feminine" in two senses. First, that it is *potentially* available to both sexes; second, that the new relations between the subject and "other" can be negotiated once the "feminine" subject position refuses fear and assimilation of the other's difference.[8] This way of writing does not claim unmediated access to the body since the body is figured metaphorically and anti-naturistically to create fictions of the self. Although, for the French writer and theorist Luce Irigaray, the conditions of women's subjectivity signals the "irrational feminine" as an enabling force within the symbolic order of language, Julia Kristeva provides a reading of the "feminine" which is not reducible to its verbal translation or biological naming.[9]

While I would not wish to remove women from history, economics, class or race, to "write" the body may allow for a

construction of the "feminine" against a fixing of identity within categories that deny the complexities of subjectivity and creative, gendered contradictions. As in the examples of work produced by Rosemarie Trockel and Mike Kelley, gendered contradictions encoded critically in the hybridization of textiles are disturbing and troubling to viewers.

Reflections on self, on writing, on textiles are unsettling. When I reflect on "I," what do I imagine it to be? Perhaps, "I" will only know myself when another is there? Is the "I" that makes a piece of the work the same "I" that will write its interpretation? How "I" move will be in relation to others and to the other in myself, as a subject-in-process tracking the psychoanalytical terrain of Jacques Lacan and Julia Kristeva.[10] The production of the subject, and the abandonment of the unitary subject-position required by the mastery of phallic language, permits us to adopt a number of positions simultaneously. This is also, primarily, a question of positionality in language that does not faithfully represent the already extant life. For many contemporary practitioners, like Trockel and Kelley, who mobilize critical ideas in relation to their studio practices, this positionality is indexed by placing subjectivity in process, where meanings and readings are staged, played off and multiplied. Therefore, a will toward the discursive and the reformulation of experience has consequences for the subjectivities of both women and men.

A critical use of self, of the "feminine" and of textile materials and processes, combine together as metaphoric signs of new autobiographical or "autographic" patterns with cultural practice. Together they operate as a lived tension between the "I" and other, the life of the text and "textile" and the terrain of the lived.

One of my favourite examples from writing is Carolyn Steedman's *Landscape of a Good Woman: A Story of Two Lives* in which Steedman's story of the "eye" and that of another "I," the "she" of her mother's story allows me, as a reader, to be involved in the places where what has already happened are re-worked to give events meaning. Steedman tells of her

mother wearing the "New Look" coat-dress of gabardine which fell into pleats from her waist at the back. On one level this is a literal image since, throughout the narrative, it figures as a very real and constantly present thing. Yet it also projects an image of desire as the "New Look" of her dreams, a common fantasy for white working-class women in post-war Britain. In Steedman's story, the coat-dress has a dual function: it not only refers to a specific moment in post-war Britain but also acts as a personal structure of feeling. This coat-dress is both an image and a product that represents several fragments of an autobiography written as "bits and pieces from which the psychological selfhood is made."[11]

Autobiographical references abound in the textile installation *We Knitted Braids for Her*, and explode in the many different voices and guises of identity that are played with by Austrian twins Christine and Irene Hohenbuchler and their sister Heidemarie. In their first UK exhibition, held at the Institute of Contemporary Arts in London in 1995, language, texts and textiles are interwoven to probe the conditions of subjectivity and autobiography in complex webs of chains of knitting, dream diaries and woven bundles of cloth.[12] A clue to their cultural practice can be found within the following extract from the sisters' audio tape transcript of August 16, 1993:

> ... what's actually happening with the 'dialogue' MATERIAL? Text-like surface conversational MATERIAL COMMUNICATION-DIALOGUE
>
> There-borrowing between articulated and textile
> language=exchange.
> Logo: woven chain makes chain
> Knitted: in lace chain knit fabric
> in plush chain stitching
>
> E... 'art' reveals a specific practice, CRYSTALLIZED in a mode of production with highly diversified and multiple manifestations. It WEAVES into language (or other 'signifying' materials) the complex relations between 'nature' and 'culture'... between 'desire' and the 'low,' the body, language and 'metalanguage.'

What we discover then, within the textile, is the function of the subject caught between instinctual drives, and social practice within language that is today divided into often incommunicable, multiple systems... while examining the meanderings between the 'I' and 'other'... is this desire within writing... to write is a mode of EROS."

Here, the position of textiles as a language is enmeshed, in my view, in the processes of *écriture feminine*. Textiles, as material processes and stuff, are both literally abundant in the installation and figured as a metaphor in a narrative flow of writing and speaking inseparable from the "feminine" as it meanders between "I" and "other."

To continue with the theme of eros I recall the work of Tracy Emin. In May 1996, this artist opened "The Tracey Emin Museum" for a month-long living autobiography to encourage people to tell their own life stories, which they would not normally disclose. With *Hotel International* and *Everyone I Have Ever Slept With* re-assembled in her living museum, a tent is covered with patterned fabrics made of all her old clothes and old household fabrics. Here, a comforting environment is denied as a hundred names of past lovers and friends, stories of abortion, suicide attempts and debt are revealed. While quilting and embroidery techniques are employed, Emin's gigantic patchwork-adorned tent refuses the first wave of a woman's celebratory experience, cited earlier through the example of Judy Chicago's *The Dinner Party*. Ideas of home and household fabrics are frequently inscribed in those earlier her-stories so meticulously recorded by Elaine Showalter.

Puzzle-picture scraps of dislocated and fragmentary lives created a unified pattern as in the overall texture of the quilt. But below these surfaces, as I know, the "monstrous feminine" resides; a place of sexual energy that is both dangerous and pleasurable, angry and "chaotic." This is not the "feminine," designated subject-position of patience and prudence, nurture and nature. As Tracey Emin explains in an interview with Anita Chaudhuri, "It's boring to say that confronting these

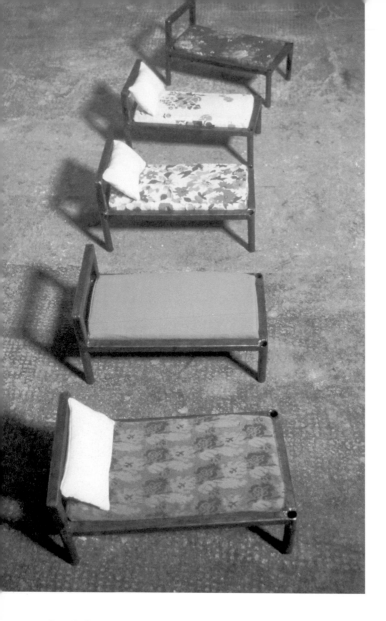

Permindar Kaur

Small Dreams, 1994.

Iron, fabric and foam.

Each bed 12 x 30 x 13 cm.

Photo: courtesy the artist.

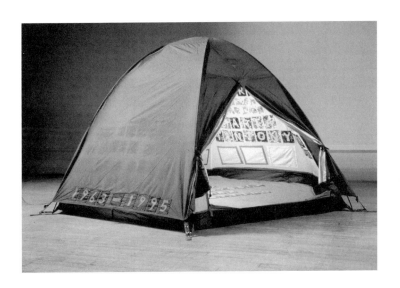

Tracey Emin

Everyone I Have Ever Slept With 1963-1995, 1995.

Appliqué tent, mattress and light.

122 x 245 x 215 cm.

Photo: Stephen White; courtesy Jay Joplin, London.

experiences and making beautiful things out them is something of a therapy for me... it's something much darker than that."[13]

I would argue that the repetition of unified patterns of experience pieced and patched into a coherent, overall whole are broken by a new wave of "bad" girl (and boy) scenarios such as those of Tracey Emin and the Hohenbuchler sisters.[14] In my view, their work ruptures the verbal and visual narratives of stereotyped femininity and autobiography to produce an autographics of hybridity. Stereotyped patterns of masculinity continue to be transgressed. For example, Neil MacInnis relates his experiences in a recent interview with Margo Mensing, "Both the domain of textiles and sexuality are informed by the conditions of habituated practice. Cultural artifacts and social interaction facilitate a meaningful history of use through sensory experience located first in the body rather than in the mind."[15] If MacInnis' use of Rococo French silks correlates with an immersion into gay culture and queer theory, then the "Home Boys" described in James Levine's essay of the same title critique ideas of any essential femininity or masculinity.[16] Frequently, staging the home is reworked through Freudian and Kleinian theories of childhood. I enter through a restaged "home" of cots, beds, mattresses, drapes, curtains, stuffed toys and chairs, mats and rugs that exceed their enigmatic forms by signifying future dysfunctional, autobiographical patterns.

The domestic, hybridized objects of English artists Chistopher Lee and Darren Caird, Permindar Kaur and Nina Saunders continue to disrupt familiar territories of place as rhetorical investigations of escape and fixed identity.[17] The question of who we are in terms of autobiography can be replaced by what "we" are as the self is understood as a moving line or thread that takes us toward becoming other than that which we may think "we" know. As these hybridized objects recede into a different sense of place, so the subject is destabilized; both the maker and viewer risk their status as knowing, complete subjects with calculable, gendered subjectivities neatly intact.

In conclusion, the unpicking of certitude, manifested in the works referenced throughout this essay, becomes further

metaphor for transience, transgression and the received models of selfhood in which possibilities of "autography" are yet to be fully rehearsed. This would include my own tentative excursions into invented identities as played in *Pretext: Heteronynms.*[18]

NOTES

1. Janis Jefferies, "Autobiographies, Subjectivities, Selves" in *Act 1, Writing Art*, Juliet Steyn, ed., (Pluto Press, 1995). Also, *Autobiography: Essays, Theoretical and Critical*, James Olney, ed., (Princeton, NJ: Princeton University Press, 1980) and Sidonie Smith, *Subjectivity, Identity and the Body: Women's Autobiographical Practices in the Twentieth Century* (Bloomington: Indiana University Press, 1993) provide useful, gendered accounts of this area.

2. Janis Jefferies, "Text and Textiles: Weaving Across the Borderlines" in *New Feminist Art Criticism,* Katy Deepwell, ed., (Manchester: Manchester University Press, 1995) pp. 164-173.

3. Jeanne Perreault, *Writing Selves: Contemporary Feminist Autography* (Minneapolis: University of Minnesota Press, 1995). In her critique of autobiography, Jeanne proposes that "autographics" is a kind of writing that evokes and suggests the flexible process of both *autos* and *graphia.* She proposes that, although an unwieldy generic term, autographics can just about encompass the complexities of contemporary texts by indexing the conventions of autobiography but resisting the monadic by bringing into being a "self" which the writer names as "I."

4. Elaine Showalter, "Piecing and Writing" in *The Poetics of Gender*, Nancy K. Miller, ed., (New York: Columbia University Press, 1986) pp. 222-247.

5. Elaine Showalter, "Common Threads" in *Sister's Choice: Tradition and Change in American Women's Writing* (Oxford: Oxford University Press, 1994) pp. 145-175.

6. Lucy Lippard, "Up, Down and Across: A New Frame for New

Quilts" in *The Artist and the Quilt*, Charlotte Robinson, ed., (New York: Knopf, 1983) p. 18.

7. Rachel Blau DuPlessis, *The Pink Guitar: Writing as Feminist Practice* (New York: Routledge, 1990).

8. Helene Cixous, *The Newly Born Woman*, translated by Betsy Wing, (Minneapolis: Minnesota University Press, 1986) and Susan Sellars, *Helene Cixous: Authorship, Autobiography and Love* (London: Polity Press, 1996).

9. For example Luce Irigaray, *Sexes and Genealogies* (New York: Columbia University Press, 1993) and Julia Kristeva, *Desire in Language: A Semiotic Approach to Literature* (Oxford: Blackwell, 1980).

10. Janis Jefferies, "Text, Textile, Sex and Sexuality" in *Women's Art Magazine* (no. 68) pp. 5-10.

11. Carolyn Steedman, *Landscape of a Good Woman: A Story of Two Lives* (London: Virago, 1986) p. 21.

12. Janis Jefferies, "Text, Textile, Sex and Sexuality" pp. 5-10.

13. Tracey Emin, interview with Anita Chaudhuri in *The Guardian* (January 24, 1996).

14. *Bad Girls* derives from the title of an exhibition held at the Institute of Contemporary Arts, London, UK, in 1993 and included work by English, Irish and American women artists, among them the late Helen Chadwick. This exhibition was a smaller version of a larger one held in New York in 1992 which also included work by men. It was an exhibition that proposed gender transgression in terms of traditional definitions of masculinity and femininity. While Tracey Emin was not represented in either show, her work nonetheless refers to an activity of practice which consciously deals with transgressing the boundaries of the "proper" name to produce a more raw, improvisational approach to art-making. Process rather than end result; deliberately low-tech methods are employed. See also Neville Wakefield's catalogue essay "Brilliant: New Art from London!" held at Walker Art Center, Minneapolis, 1995-96.

15. Margo Mensing, "Electronic Textiles: New Possibilities" in *FiberArts* (Summer, 1996) p.45. See also Neil MacInnis' essays in the pre-conference publication *Textiles Seismographes* and the post-conference publication *A Textile Identity* (Le Conseil des Arts

Textiles du Quebec, January 1996)

16. James Levine, "Home Boys" in *Artforum* (October 1991) pp. 101-105.

17. Christopher Lee graduated from Goldsmiths College, University of London, with an MA in Textiles (studio practice and critical theory) in 1994; Darren Caird graduated from Goldsmiths College, University of London, with a BA in Textiles in 1996; Permindar Kaur's exhibition *Cold Comfort* was held at the Ikon Gallery, Birmingham, and Mead Gallery, Coventry, in May/June 1996; and Nina Saunders' exhibition *Familiar Territories* was held at the Ferens Art Gallery, Hull, UK, from November 1994 to January 1996. For an interesting discussion around illusions of home against which a range of hybrid and illusory objects subvert familiar and gendered categorization, see Nancy Spector, *Homeward-Bound* (Switzerland: Parkett, 1991), pp. 80-89.

18. *Pretext: Heteronyms* was the title of an exhibition that took place in Clink Street studios, London, in November and December 1995. I participated under a different identity and practice with which "I" would normally be known. A catalogue, with an introduction by Juliet Steyn, is available through Rear Window publications.

Common Threads:

Local Strategies

for "Inappropriated" Artists

Mireille Perron

A language of resistance and co-optation

Several contemporary artists maintain the critical feminist agenda of the 1970s. They refuse to buy into the present neo-conservatist backlash against the social advances that were made by that previous generation of artists. As support for this project of refusal, these artists have access to a cornucopia of feminist and postmodernist practices and theories that have been accumulating since the 1970s, when women in the visual arts challenged the art world's modernist canon. The cornucopia is concerned with representation and signification.

By introducing analyses of the social practices of production and consumption into art, feminist and other postmodernist practices inflicted the *coup de grâce* to the Greenbergian tenets of truth to the material and the universality of art reception (like no-iron polyester, these tenets guaranteed the self-sufficiency of visual and aesthetic experience). Predictably, provocatively, the antipathy between feminism and modernism suggested a paradigmatic shift. Many of those who advocated the shift were linked by a common set of methodological positions: validation of collaborative attitudes over individualistic

ones, careful attention to audience response, use of personal lives and daily activities as sites of political struggle, reappropriation of the body and the redefinition of power. Many artists and cultural critics began to work together toward a creative revision of the status quo.

At some moment during the challenge to modernism, several artists realized that textile practices are rich sites to explore and question the assumptions made about subjects like women's work, femininity and domesticity. The oppressive constraints of the textile tradition were recognized and new ways of negotiating meanings through textiles were sought.

Early feminist art that explored textile metaphors involved women like Miriam Shapiro and Judy Chicago in the United States and Joyce Wieland, Inese Birstins, Mary Scott, Barbara Todd, Ruth Scheuing, Lise Landry and Michelle Héon in Canada and Québec. These artists reappropriated a feminine language of exclusion, a process of reappropriation that has continued into the present decade with other artists: "Do I embellish or hide? Decorate or camouflage? Deflect or deceive?"... The voice of Linda Anderson-Stewart is pressing... "I have had an ongoing struggle with my father. His name is Art." (She also had an uncle named Art—he was a priest, a "father" of another kind.)

Anderson-Stewart's work explores and tries to understand the decorative as a secret code, as a means to hide content that is not acceptable to the dominant fiction. This revisionist history looks at women as if they were members of a secret society and tries to decipher the meaning behind the politics of their resistance. In other words, it is a rewriting of the histories of their oppression. It is important in future research to compare the decorative impulse of textile works with, for example, the politics of the gay camp style. In both cases, oppression assumes the appearance of leisurely activities that act as a form of resistance: womanliness as masquerade, as camouflage, as a way to protect oneself from the dominant order.

Anderson-Stewart's work also alludes to the history of attitudes in textiles—a mixed legacy that speaks an ambivalent language

of resistance and submission. Even today, textile practices remain a violent paradox. Skills associated with textiles are *still* employed in the educational contexts of home and school to inculcate the male ideal of femininity in women. Sewing skills are *still* a source of exploitation of middle and lower class women. In the home, sewing is regarded as a hobby, while in the factory, it is viewed as industrial production—both activities, however, speak of submission to patriarchal values.

Textile work associated with embroidery and tapestry often connotes gender submission and class privilege. It takes a wife a long time to weave an elaborate tapestry to decorate the walls of the family home; the tapestry becomes a visual reminder of her financial dependence on her husband. Like the generic public sculptures used by corporations to symbolize their special economic status, domestic textiles symbolize traditional, patriarchal family values. They symbolize a family's "happiness" and serve as proof of a wife's devotion to the family's comfort, not to mention a guarantee that she is using her leisurely hours in an *honest* way. This symbolical world evokes the male stereotype of the good mother as virgin rather than whore. Try to imagine a whore knitting while she waits for customers. Or the silent embroiderer—the stereotype of femininity *par excellence*—taking a break to masturbate. The conflation of textile practices with infantile female sexuality (read: innocent and submissive) is an extremely resistant male metaphor. Any display of sexuality by women is provocative. Good mothers do not have lovers; they have husbands. They do not, as whores do, express their love sexually; they display it through artifacts of comfort.

> In women's novels the crucial interview between lovers is invariably marked by the moment when the woman drops her work—with her embroidery inevitably goes her self-containment and she surrenders to her lover.[1]

In the context of this loaded and complex history, when an artist uses textile skills (weaving, sewing, embroidering,

stitching) to negotiate the social constraints of women, the process of acquiring those skills is itself suspicious. This ambiguity often leads to dismissal, incomprehension or uncritical celebration of the artist's work. Granted, not all textile works are meant to be critical forms of resistance—some artists desire to achieve exactly what is expected of them by the status quo. But those artists who *do* transform textile processes and materials to produce meaning and provoke social discourse, deserve more than suspicion as a response. Their work should be attractive, if unusually challenging, to those in the art world who are committed to critical thought.

Ironically, when art criticism deals with media such as textiles, it is confronted by its own mixed legacy. It, too, has an uncomfortable language of resistance and submission. Like textiles, it oscillates between asocial formalist attitudes and renewed social interests. Consider the ease with which art criticism deals with the social content of contemporary practices like photography, video, film, installation and performance and the anxiety it reveals when it tries to deal with the social content of practices that were assigned lower class status by the modernist canon.

Resistance and submission; warp and weft. Before art criticism and textiles can weave their conceptual and historical threads together, they have to complete their examination of the effects of the guilt associated with their mixed legacies.

"Inappropriated" artists

Textile practices have been treated with disregard for so long it is almost inconceivable for some critics and artists to acknowledge them as discursive formations from which meaning can emerge. Artists who use practices that are not well understood have the complex task of repossessing social space (both inside and outside the artwork) and revising the politics of that space. They also have to modify existing networks, or build new ones, to diffuse the strategies, histories,

ethics and artworks that arise from these processes of reappropriation and revision. However, there are traps. The passion for reform threatens to swallow some artists down an essentialist well. The fascination with deconstruction can seduce others to play out the same nostalgic themes—an endless recording of discontinuous variations. It is often along the edges of such traps that many artists struggle to represent the contradictions that continue to characterize textiles' relation to the dominant art fiction.

Artists who deal with these contradictions can be thought of as *inappropriated* artists.[2] Their historical position does not allow comfortable relations with the self (textile practices) or the other (dominant art fiction). To be an inappropriated artist is to be in critical relation with one's practice. The inappropriated artist is committed to *tension*—she does not want to embrace and reflect the values of a practice; she prefers to diffract and displace them. Inappropriated artists live *in* the border.

Fortunately, they have more and more company. In this world of dislocated origins, there is a growing collectivity: artists who construct their practices outside the canons of authenticity. For example, when I asked the artists I am about to present about the logic of their relationship to various practices, they said they did not feel obliged to confirm a place for textiles within existing art discourse. Rather, they want to subvert the politics of why and how (a) practice becomes a proper form of knowledge.

Between 1991 and 1992, Joan Caplan and Mary Lou Riordon-Sello collaborated on a two-part project called *Current Connection—On the Elbow River and Current Connection—At the Deane House*. Caplan and Riordon-Sello posted invitations in rural areas around Calgary; written in five different languages, the invitations asked women who had lived in the region since the 1920s to participate in a textile project. Several elderly women responded and, over a period of several months, they met in the lounge of an apartment building for seniors called Murdoch Manor. As they shared stories about their lives, new

Joan Caplan and **Mary Lou Riordon-Sello**
Current Connection at The Deane House, 1991-92.
Photos: courtesy the artists.

Left: general view of the installation.
Right: detail of installation (crocheted flag).

versions of regional history emerged. At the same time, they were crocheting. Crocheting became a metaphor for the process of bringing to life women's history, a symbolic evocation of the collective efforts of women to build a regional community. They produced mountains of brightly-coloured crocheted strips.

The strips ended up on the banks of the Elbow River. Under the watchful eyes of the women, who were crocheting on-site what would be the last of the strips, Caplan and Riordon-Sello used domestic technology (clothesline pulleys and distaffs) to span the 175-foot width of Elbow River with no less than forty strips. The installation was strategically presented as a one-day celebration during the Fort Calgary Festival, a popular local event commemorating Calgary's history. At the end of the day, the crocheted strips were carefully retrieved for the second part of *Current Connection*.

The location for *Current Connection—At the Deane House* was an historical reconstruction of a Calgary courthouse, now a public site and tearoom. With a variety of traditional stitchery, the crocheted strips were assembled into the shape and size of flags. These crocheted flags were spotted around the courtroom, side by side with the official flags in situ—the juxtaposition became symbolic of a very different history. Video portraits of the elderly women recounting their lives also invaded the courtroom, occupying the benches normally set aside for the public. The electronic images of the women faced the judge's bench. On the wall above and behind the bench a framed chronology of women's slow progress toward legal rights was hung:[3]

> These rooms were chosen because of their significance to women. The courtroom was the seat of judicial authority where, until recently, women were described as "reasonable persons" (previously, many legislators and judges viewed reasonable persons to be male).[4]

It is important to point out that most of the elderly women, who had been involved in *Current Connection* from the first

group meeting in Murdoch Manor, were present the night of the opening at the Deane House. Like their performative presence on the Elbow River, their presence at the opening was more than a celebration: the exchange of stories continued.

The women involved in *Current Connection (I & II)* transformed clichéd notions of women gossiping while they crochet. They successfully let people know that their collective effort was necessary and worthwhile in the rewriting of women's history. More modest in scale, *Current Connection (I & II)* is reminiscent of the spirit of Suzanne Lacy's *Crystal Quilt* project.[5] In both projects, the artists paid careful attention to the process of empowering older women, to the politics of rendering them visible social subjects and to the intense negotiations with local as well as historical authorities. These are elements of a discursive strategy that allows rich critical meaning to emerge from the lives of older women. For Joan Caplan and Mary Lou Riordon-Sello, the empowerment of local women is the warp of everyday life. Those who take the time to understand the meanings that emerge from *Current Connection (I & II)* empower themselves, too, providing the weft that is needed to complete this regional social fabric.

In *Remnants: A Videotext, Part 1* (1992), Karen Elizabeth McLaughlin reproduces a videotape and displays it as a continuous paper strip on a wall. The enlarged "videotape" (sixty-four feet long by fifteen inches deep) is divided into three tracks: video, audio-one and audio-two. The surfaces of all three tracks are scratched with words. The scratches in the video track tell the story of a woman named Choral who is the collective voice of McLaughlin's matrilineal history: her great-grandmother, grandmother, aunts, sister and mother. Made of red panels, the video track is disrupted by a series of green editing panels, as if Choral's story was the script for an actual video tape. The two audio tracks sit above the video track. Audio-one, written in the third person, functions as a conversational dialogue with Choral's narrative. Audio-two, made of colour photocopies of the Nova Scotia tartan, displays excerpts of the same narrative.

Like previous work by Karen Elizabeth McLaughlin, these three components are stitched together with a sewing machine. Sewing becomes a feminist metaphor for editing in which the subversive stitch can be viewed as a motif that disrupts, or as a motivation to disrupt. But is the narrative really disrupted by the sewing? Or does the sewing make the story visible? The subversive stitch provokes many questions: Is Choral's voice disrupted by the voices of her past? Or is her voice constituted by them? The reinvention of the voices of McLaughlin's past becomes the material that allows her to sew her own story, to make her own videotape: "Choral unfolds the remnants and stacks them in piles of Mama, Cora, Nanny, Elenor, Joyce and Eleanor Michelle."[6] What becomes explicit is *her* concern with the formations of identity through fantasy; *she* is Choral *and* the artist.

What is most certainly disrupted in *Remnants: A Videotext, Part 1* is certainty. Common sense usually prefers not to consider fantasy and its cousin, fiction, in the context of a social and political inscription. The transaction (sewing) between the three tracks becomes the "in between space" of another scene: a *mise-en-scène* of feminine desire. One reads in the sewing (this desire to transact) the story of a woman who seeks to change (re-edit) her (and our) attitudes to her (and our) familial reality. Her (our) only certainty is the instability of the feminine subject in her (our) matrilineal history:

> Choral wants to remember the story Cora and Elenor always tell about the minister and the chickens in Ecum Secum. They always laugh so hard Cora pees. She doesn't think Joyce was there. All the laughing stories that could make you pee are with Cora and Elenor.[7]

McLaughlin has effectively deconstructed the dichotomy between the feminine fiction (the sewing and the writing) and familial reality (the videotape). The words scratched into the three tracks of the "videotape" acknowledge that there is no self-possessed lucidity in which the external world is simply

what it is. If the construction of the self as a social subject can parallel the construction of a videotape, both are mutable. Both are fictions to be constructed. McLaughlin/Choral is saying that the stories she has constructed from her memories may not be truthful, but they are still proper. Inaccurate yet necessary, necessary because inaccurate. Or, if McLaughlin/Choral was to paraphrase Roland Barthes, she would say, "I may know a photograph I remember better than a photograph I am looking at."

McLaughlin/Choral's storytelling is not a traditional narrative; lacking closure, it is constantly subject to rewriting. The members of her maternal family become privileged "families" of relational desires: desires that have a shape, desires that have a history. The Nova Scotia tartan, for example, is a mechanism of inscription that serves, not unlike a snapshot in a family album, to locate displaced desires. The tartan becomes a sophisticated device linking desires to a specific historical location. Meanwhile, the metaphoric representation of the "videotape" is a prop that stages itself as a scene. Just as the "videotape" stages its tracks, McLaughlin stages her selves through her fictive persona, Choral. Artist and videotape are a (in) *production*.

McLaughlin proposes a fiction where constant repositioning generates meaning. Like a Penelope without a Ulysses, McLaughlin/Choral weaves her life during the day and undoes (edits) it at night, not from fear of patriarchal reprimand but for the pleasure of trying out different patterns. Indeed, what better to do with all this matrilineal life footage then to sew it again and again, the next sewn narrative always just as intriguing as the others.

In the middle of a room, on a table, sits a large bowl of pungent pealed apples.[8] They are slowly browning. They are welcoming. On an adjacent wall, neat rows of preserves sit quietly on beautiful wooden shelves. Voices come from the far corner of the room, out of a video monitor. On the monitor's screen, a group of women are talking and peeling apples around a kitchen table. *i live there above a storage area of*

canned goods... shelves filled with glass mason jars... enough to feed everything... excess... canned... put away... suspended... arrested... preserved for posterity. A banal activity like peeling apples can be a metaphor for the process of constructing social meaning. Peeling and canning, like embroidering, sewing and crocheting, can be subverted. Transformed, they become discursive rather than submissive practices. *pears are dropped into an acidic solution to prevent darkening... hand-placed into the glass jars to be attractive... visually pleasing... not dark not me.* Women who are caught up in and formed by domestic practices have the power and the responsibility to construct new social selves. You know the faces; they are familiar. *on the periphery i rationalize my exclusion with my unacceptability.*

NOTES

1. Rozsika Parker, *The Subversive Stitch: Embroidery and the Making of the Feminine* (New York: Routledge, 1989) p. 166.

2. Minh-ha T. Trinh, "She, The Inappropriate/d Other," *Discourse*, (no. 8, Winter 1986–87).

3. For example, the Alberta Legislature only extended the right to vote to women in 1916.

4. From the didactic texts for *Current Connection—At the Deane House* (1992).

5. *The Drama Review: A Journal of Performance Studies*, MIT Press (vol. 32 no.1, Spring 1988).

6. From Choral's narrative in *Remnants: A Videotext, Part 1*, Muttart Art Gallery (Calgary, 1992).

7. Ibid.

8. The last paragraph is a description of an installation by Marilyn Love (Virginia Christopher Gallery, 1991). The italicized text is also by the artist.

III. CLOTH, COLONIALISM AND RESISTANCE

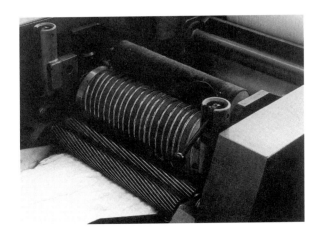

Who's "We," White Man?

Jo Anna Isaak

"When you name yourself, you always name another," Bertolt Brecht writes in *Mann ist Mann*. The inverse is also the case— when you name another you always name yourself. In a bus shelter in Vancouver I saw a poster proclaiming "*We* are the first world, *You* are the third"—a slogan particularly pointed in the context of Canada where Native people, realizing the importance "we" place on priority, especially in relation to property, have stopped calling themselves by Columbus's misnomer and now call themselves "First Nations." (Since the name change they have done much better on land settlements.) The poster, by Canadian artist Mark Lewis, points with economy and humour to the power of subject positions in our speech, to how dichotomies of "we" and "they" are established, and how commonplace understandings about others form our identity. In an exhibition entitled *Native Intelligence*, Elaine Reichek manages to sidestep the dated and divisive semiotic practice which for so long now has structured Western discourse. She engages instead in a paratactic style: nothing is fixed, all relationships are contingent, subject positions are constantly changing. Like the joke about Tonto, when the frantic Lone Ranger cries, "Tonto, the Indians have us surrounded—we're done for!" Reichek asks, "Who's *we*, white man?" Good question. What is the subject position of the second sex in the first world? Is it the same as the first sex of the third world... or is it the second world? It's hard to compute, and women are notoriously bad at math.

The installation begins with information (in the sense of the Latin *informis*, without form, "un-meaning"): postcards, snapshots, magazine spreads, film stills, wallpaper, fabrics, even flour sacks, as well as various ethnographic and anthropological material culled from the Library of Congress and the Smithsonian in Washington, and the Museum of the American Indian, the Natural History Museum and the Metropolitan Museum of Art in New York. These vast storehouses of photographs, documents and artifacts were accumulated in the wake of the encyclopedic urge that so preoccupied the First World at the close of the last century. The burgeoning museum culture ostensibly grew out of the desire to preserve a record of peoples and customs before they vanished, but what was really at an end was the era of colonial expansionism: these are fragments we have shored against *our* ruin, not theirs.

Adopting the presentational strategy of the museum exhibition, *Native Intelligence* postulates an information-processing circuitry that is intended to generate intelligibility, but the vast flow of data is kept moving too long. Metaphors compound upon metaphors without ever settling into the substantive. In a photocollage entitled *Red Delicious* a reproduction of a painting by Wright of Derby from 1785 is inset with smaller, circular photographs that lead, by a process of free association, to other romantic heroines of the Wild West—Lola Albright in the Hollywood movie *Oregon Passage*, the blonde captured by Indians in *Unconquered*, the abducted brunette in *Comanche*, or that really feisty gal in *Red River*. There is a moment of Brechtian distanciation in each of Reichek's photocollages; in *Red Delicious* the "device" is "bared" in a photograph taken from behind the scenes of a movie set, revealing the cardboard canyon into which Indians chase the stagecoach.

The operations that the information undergoes, the associations that are made between disparate data, the continuities that are recognized become too profligate, suggesting a problem in the processing system. The metaphoric connections that once provided a reassuring sense of cosmic togetherness begin to unravel under the influence of signals from so many sources

and now seem only coincidental. The activity of classification and categorization—the whole drive to stabilize, organize and rationalize our conceptual universe slips into irrationality, chaos and fragmentation; we are brought too close to the margins and the marginalized, too close to what the museum has always promised to keep at bay.

Reichek's work is not about the failure of the museum to produce "truth," or an objective account of other peoples. Nor is it about First World culpability. Rather, she is accumulating texts about textuality, about fabrication and about our imbrication in our own fabrications. Reichek reads our documentation of other peoples for their symptomatology, for what they tell us of our needs and desires. Finding two different versions of Roland Reed's 1915 photograph showing Blackfoot Indians in Glacier National Park, for example—one in the archives of the Smithsonian, and the other in the Museum of Natural History—she also discovered that Blackfoot Indians never lived in Glacier National Park: Reed had taken a group of them there and had given them props and costumes to create scenes of the picturesque. Reichek gives us four versions of this same photo, and manipulates them in various ways, inverting them, colouring them and giving them various formulaic captions like "The Indian Suns Himself before the Door of His Teepee," "After the Hunt," and "Shadows on the Mountain." These multiple misrepresentations are not made to expose the fraudulence of Reed's photojournalism, or the credulity of the curators of the Smithsonian and of the Museum of Natural History, or even the pretension of the positivist vision which photography has supported for so long. If these targets are hit, they are only collateral damage in a search-and-destroy mission against anything that is already culturally determined. Reichek is not the Ralph Nader of a museum culture, demanding correct consumer information.[1] She is an eccentric and generous reader who finds herself constitutionally alienated from divisions like "fact" and "fiction" and does not hold the text or the teller accountable for the misinformation they generate.

Instead, "errors" become cracks that provide the opportunity to look behind seemingly transparent texts at the culture that requires them. Read through Reichek's methodology, Margaret Mead's *Sex and Temperament in New Guinea* would be the story of a young American girl who writes a book that becomes enormously popular, about her desire for a more sexually liberated culture, one in which women were not linked to property exchange.

There is a flagrant and funny feminism weaving in and around Reichek's reworking of ethnographic, anthropological and museum practices. It is manifest most overtly in the female-identified medium of knitting, which she uses to reproduce documentary photographs of native peoples and their dwellings. Knitting is an "inappropriate" tool for this purpose—so unscientific, one of those typical feminine misunderstandings, as if some dotty old woman had gone on an anthropological expedition equipped with wool and knitting needles instead of a camera and notebook; or one of those comic cross-cultural misperceptions, like the moment in the film *First Contact* when a New Guinea aboriginal puts on a Kellogg's Corn Flakes box as a headdress. The culture that Reichek is misreading is her own, but her misrecognitions mark her distance from it and, at the same time, her deep familiarity with the machinations of its codes. It is as if she had taken literally Barthes' metaphor of the textuality of the text: "*Text* means *tissue*, but whereas hitherto we have always taken this tissue as a product, a ready-made veil, behind which lies, more or less hidden, meaning (truth), we are now emphasizing, in the tissue, the generative idea that the text is made, is worked out in a perpetual interweaving; lost in this tissue—this texture—the subject unmakes himself, like a spider dissolving in the constructive secretions of its web."[2] Barthes' metaphor almost seems a reworking of a story told by Jimmie Durham in his catalogue essay for Reichek's exhibition—the Cherokee fable of Grandmother Spider, who sits unnoticed in the corner weaving, yet is the most powerful, for it is her activity that makes the yarn.

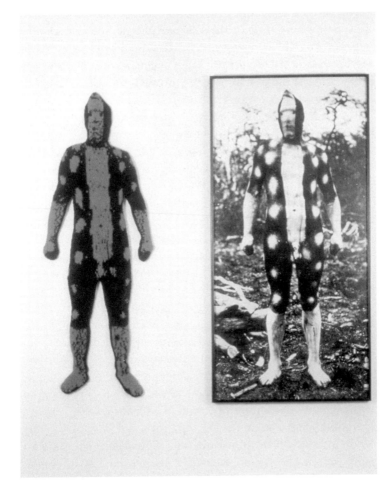

Elaine Reichek
Red Man, 1987.
knitted sculpture and photo,
162 x 178 cm.
Photo: courtesy the artist.

The knitted men in *Native Intelligence* are derived from Edward Curtis's turn of the century photographs of *Apache gaun* or "devil" dancers and a Mandan dancer. The three-dimensional knitted versions hang beside large-scale versions of the original photographs. The knitting reproduces the information in the photograph in a way that is at once precise and quite *un*signifying. It is not just that knitting, as "women's work," is out of place in this context, but that as a discourse knitting is not "*endowed* with the author function."[3] Without the author as proprietor, a discourse also loses its possessive case, what Lacan calls the "*belong to me* aspect of representation, so reminiscent of property... as soon as I perceive, my representations belong to me."[4] By miming and thereby undermining those more well-endowed discourses that claim to provide significance, these knitted versions reveal the tenuousness of the web of lexical or indexical certitude that secures our confidence in the world.

The process of transcoding or reweaving of texts reveals the bias of the original fabrication, what in fact the anthropological and ethnographic accounts have tried to cover up—the body of the text or, rather, the bodies of the Natives. Narratives of exploration and discovery are about nothing if not the human body. They habitually describe Natives' bodies as monstrous, riddled with all manner of libidinal excess—naked, sexually licentious and commonly engaged in every form of Western taboo from incest to cannibalism—a people *sans roi, sans loi, sans foi*; in short, just what the Europeans unconsciously wanted to be.[5] The agenda of the narratives of discovery was to inscribe these people in Western systems of representations, a project that had something of a missionary aspect to it, as if the very act of encoding them would bring them into the realm of "normalcy."

A significant side-effect of this inscription was that Native peoples could then be made to disappear at the will of the author. Early explorers of the Americas invariably described the land as "wilderness," unoccupied space to be claimed for some European monarchy; yet the central enigma of the

wilderness was always the body of the wild man. We still have trouble seeing him. A photograph in the *New York Times* of September 18, 1990, shows in the foreground a row of three men. The identifying caption reads, "Napoleon A. Chagnon, left, American anthropologist, and Charles Brewer-Carías, Venezuelan naturalist at Konabuma-teri." But the man at the left wears a loincloth and feathers; the two white scientists stand centre and right. To the *Times* editors the native is "not there," even though *his* is the body we are really interested in; his body is the reason for the scientific study and for the newspaper's story. "Is it not precisely because desire is established here in the domain of seeing that we can make it vanish?"[6]

The bodies in *Native Intelligence* take on a presence, stand three-dimensionally, cast a shadow, have human stature (though they are a little short, like the artist). "Does the text have human form, is it a figure, an anagram of the body? Yes, but of our erotic body."[7] *Our* erotic body is exactly what *Native Intelligence* invites us to explore. Instead of the detached, fetishistic pleasure to be had from viewing a photograph, the knitted bodies offer the pleasures of texture and proximity. They have a plenitude, a warmth, a sensuality. In this tactility we are given an implicit invitation to touch or rub these nude or semi-nude, dark, fuzzy bodies, compelling ambiguities of cuddly life-size doll and dark, enigmatic, even slightly threatening Other. There is a *frisson* to the encounter. For those who accept the invitation to transgress or regress, this work will make you laugh.

Everything presented in this exhibition is familiar to us, in fact we are awash in the comfort of the familiar. The final installation in *Native Intelligence* is redolent with nostalgia. We are returned to our childhood, and to the childhood of our grandparents, when little girls laboured over embroidery samplers and, in the process of learning their ABCs, learned homilies of constraint, a constraint perhaps more anxiously imposed on women during pioneer times because of the proximity of "savages" on the frontier. Here, however, instead of those stultifying adages by which we are taught to pattern

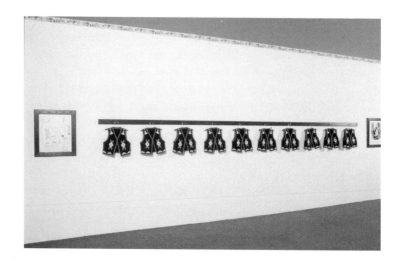

Elaine Reichek
Ten Little Indians, 1992.
Paint on felt, photostats,
64 x 700 cm.
Photo: courtesy the artist.

our lives, other voices speak through. Where the original samplers contained maxims such as, "She walked with God and He was her support," or, "Religion should our thoughts engage," now Mahpwa Luta (Red Cloud) says, "When the white man comes to my country he leaves a trail of blood behind him." Or Yellow Wolf says, "Only his own best deeds, only the worst deeds of the Indians, has the white man told." That these voices have infiltrated embroidery samplers suggests a deep defection. If women, occupying a marginal position within the symbolic order, have come to represent the necessary frontier between man and the supposed chaos of the outside, there is always the disconcerting possibility that they will identify with the marginalized. It looks now as though the patriarchy's worst suspicions are confirmed—Big Eagle, Yellow Wolf and Red Cloud came to tea and chatted!

While little girls embroider their ABCs and learn their position in the symbolic order, little boys learn the same lesson playing cowboys and Indians. Childhood is the time of the great divides—between *he* and *she*, between *us* and *them*. A remark by General Norman Schwarzkopf embroidered on cowboy-patterned curtain material shows just how formative these years were for him: of the Gulf War, he says, "It was like going into Indian country!" An old poster reproduced in another work depicts one little boy's quest to find out "Why Don't We Live Like Indians?" The poster is in French, attesting to the internationality of this fascination with Native Americans.

Ironically, this is a shared childhood: even Indian kids play cowboys and Indians. My childhood playmates were Kwakiutl and Comox Indians, though I didn't know them by those names then and I doubt that they thought of me as Caucasian. One Halloween we all dressed up as Indians, making fringed buckskin jackets and skirts out of burlap potato sacks. I remember this not because any adult pointed out the absurdity of our choice of costumes, but because a firecracker landed in my skirt and the whole burlap outfit instantly caught fire. Our childhood was divided when they were sent to the Indian school in Alert Bay and I had to stay home and take correspondence courses.

Many years later, when I was a student at the University of British Columbia, Claude Lévi-Strauss gave a series of lectures on the kinship relations of the Kwakiutl. As he spoke, at times in rapid French and at times in an almost impenetrable English, of "Native conceptions" that were clearly to be understood as something other than his and the audience's own, the divide seemed to grow into an abyss.

This last installation in the exhibition offers a sense of reparation, of some amends having been made. Perhaps it's those ten-little-Indian vests hanging on the wall, perhaps it's the care with which they have been stitched together from the patterns in an Indian craft catalogue, perhaps it's the offer of another chance at childhood, another chance to do it again and get it right.

NOTES

1. As I was writing this essay, I happened to hear a report on National Public Radio about the problems natural history museums were having in dealing with the obvious and embarrassing gender and cultural biases of their exhibits. One director explained that there simply wasn't enough money to "correct" all the mistakes in displays like dioramas. Instead, he has invented what he calls the "dilemma labels" for incorrect or misleading dioramas. For example, a diorama showing a lioness at home with her cub while the male lion is off hunting a zebra would be given a "dilemma label" explaining that it was the female lion that did the hunting. The male, he said, "was usually just a couch potato."

2. Roland Barthes, *The Pleasure of the Text*, translated by Richard Miller, (New York: Hill and Wang, 1975) p. 64.

3. Michel Foucault, "What is an Author?," *The Foucault Reader*, Paul Rabinov, ed., (New York: Pantheon Books, 1984) p. 107. Italics mine.

4. Jacques Lacan, *The Four Fundamental Concepts of Psycho-Analysis*, Jacques-Alain Miller, ed., translated by Alan Sheridan, (New York: Norton, 1981) p. 81.

5. I am indebted, in this discussion, to Lennard Davis's unpublished essay "'No Fable in Their Case: New World Explorers and the Problem of Narration." I am also grateful to Lennard for bringing to my attention the photograph from the *New York Times*.

6. Lacan, p. 85.

7. Barthes, p. 17.

Robyn and **Debra Sparrow**
Joshua wearing a blanket made
for traditional wear, 1990.
Woven wool blanket, 180 x 120 cm.
Photo: courtesy the artists.

A Journey

Debra Sparrow

We did not plan on being weavers. We started off on a journey not knowing where we were going. I have gone out many times over the past few years to share the direction and inspirations that we have had as weavers. I have found it interesting to listen to others talk about the worlds they come from, their heritage, their traditions, often a world I know nothing about, a world very far removed from the one I live in. It is not to say that I have not been influenced by contemporary mainstream society, but where I come from is the land of the Salish weavers, and we, in this world, are doing exactly what you were doing in your world in the seventeenth century. I am not a reader and I am not a traveller. As weavers engaged in a process of learning skills, we searched within ourselves, and our own culture, and I am going to explain how it all began years ago. Then I will return to the weaving that we do now.

We all want to know who we are and where we fit in the world. As Aboriginal people we had to assimilate into a society that we felt very afraid of and very threatened by. The education system failed us, religion failed us, and we had failed ourselves because we lacked belief in ourselves. And we didn't know why this was happening and why we felt a gaping hole in our soul. So we searched, feeling that we were not going to think with our minds, but that something in our spirits was calling for us to pay attention.

My sister, Wendy Grant-John, the woman who started the weaving program at Musqueam, and I had many talks about the absences in our life. Then we heard about a Salish weaving program and I said to her, "What's Salish weaving?" and she said, "I guess its some kind of weaving." She had heard about the Sardis weavers in Chilliwack. My grandmother came from that particular area, but she never discussed weaving. I used to sit and watch her knit and periodically make a basket. I thought that I would really like to learn to knit one day, but I didn't because I was too busy being a rebel, too busy sticking my head out the door and looking out into the world and getting absorbed by the power of mainstream society.

But every once in a while I felt the gentleness of my grand-parents' life. I knew they had something to offer and that eventually I would need it to complete my own life. I would spend hours talking with them, but when it came to talking about my life, I felt frustrated and let down. I wasn't inter-ested in the outside world anymore; I decided the only place I could look was within myself. My older sister and I had many conversations that revolved around the lack of visual reflections of our people. We looked in awe to the north, the south, the east, the west, to all the Native Aboriginal people. Our lifestyle and reflections could not be shared with the outside world because it meant too much to us; it had a spiri-tual value that could not be seen by the public. As we sat during the ceremonies in our winter longhouses, we knew that this was where we needed to be to start to redefine who we were as Indian people, as Indian women, as Indian children. The rest of our time we spent watching TV, going to McDonald's, and going so far away from ourselves that we would almost forget who we were. Visiting the longhouse every winter, we began to share a small part of what was left of who we were as Aboriginals.

About two years later, I heard about a program on Salish weaving offered at the Vancouver Aboriginal Centre. My sister and I jumped at the opportunity, but to our disappointment they would only accept one more person. Because my sister

knew this fellow very well (sometimes it's not what you know but who you know), she argued that there should be at least one Salish person in the Salish weaving program. She got her way and I left Vancouver to return north where I lived at that time. While she was weaving, I taught myself how to engrave and carve on silver jewellery. I came down to visit her once or twice to see what they were doing in the weaving course.

When the program was finished we moved back to the village of Musqueam. This village is part of what you would call Richmond; here the Musqueam people live on the shore of the Fraser River. We decided to start a Salish weaving program and we sent out flyers to all the people in the village. Approximately twenty people applied, and nine, who we thought could best help start the program, were chosen. Some of the women already knew how to spin wool because they were knitters. We began a weaving program that was the beginning of a wonderful experience.

The nine women selected for the program knew nothing about weaving and so we referred to a book written by Paula Gustafson on Salish weaving. Paula had spent many years cataloguing blankets and working with museums to create the book that would mean so much to us. We really have to thank Paula, because without that book we could not have gone forward. We bought sheep's wool from Birkland Brothers and began to learn how to spin and dye. Most of us didn't know how to spin or dye and many of us thought that this was the last thing that any one of us would do. And I thought, what am I doing here, I shouldn't be doing this, I should be doing something else. I made sure that I was the slowest, that I spun slowly so that it would take longer. When I learned how to warp the loom I pretended that I forgot how so I could waste more time. And I did everything so that I would not really have to learn it, because I was only there because it offered a good wage.

I think that a lot of the women felt the same way, but we didn't know that something was taking us by surprise. As I learned how to spin with much more coordination, I felt something

within myself stirring, I felt that I could relate this spinning to another world. I can see that now but I could not then. But could I spin myself from this world to another? Could we as a group use these tools to help us understand how we got to where we are today? We became an individual family unit that didn't really care too much what was going on elsewhere. We just wanted to know who we were through our family meetings. We all wanted something to elevate ourselves in our community but we could not relate this, at first, to anything specific.

We developed from spinning to making two-bar vertical looms. We warped them with much difficulty and used our wonderful, fat, spun wool, some of it dyed and some of it with stinging nettles still stuck in it. We started to learn how to do just the plain weaving and just a little bit of tabby, and began putting these two things together. We started to sense the identification of the Salish weaving and started to relate to it, to think very seriously about the women who made the original blankets and tapestries. We wanted to connect with them, to be a part of them. We started to gain self-respect again and respect for our people who existed before us, and I started to ask, why did we think that we weren't worthy of ourselves or that we weren't worthy of society? When I looked at the tapestries and weavings in Paula Gustafson's book and thought of the women who wove them, I wanted to be one of those women. I had a role-model. I had a reason to exist and now there were ways of bridging the past to bring forward an understanding of what was happening in the present and how things might work in the future. We realized that weaving was teaching us as Aboriginal people to regain what was very seriously lacking in our community: patience and understanding what our people represented to each one of us. We had lost knowledge and important wisdom that our people had passed down from generation to generation. So there was a long dormant period. I call it dormant because it was not dead; it existed in each of our spirits and was waiting for the right time to emerge.

My sisters and I are very passionate about Salish weaving.

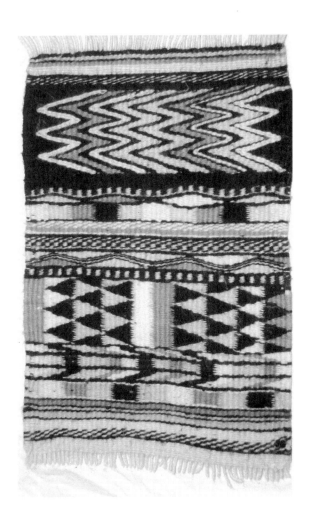

Debra Sparrow
Blanket, 1994.
Woven wool blanket, 60 x 90 cm.
Museum of Anthropology,
Vancouver, British Columbia.
Photo: courtesy the artist.

Through weaving we have tried to understand what it is that we need as Native people and how we might right some of the wrongs that have been done to our ancestors. We need to reintroduce, through weaving and tapestry, a message that can be read by society as a whole. I have this belief—and I've heard other Native people talk about this too—that each blanket, each tapestry, has a message within. If I have to use my hands to reflect a message to people then I will do that, but the messages do not belong to me individually; they belong to all our people. And we are willing to share, willing to go forward in time and be political, to some degree. We are not trying to make people feel bad about what has happened in the last two hundred years; we want to make sure that our people who lived thousands of years ago will be able to feel justified in their existence by the work that reflects them today. That has been our goal: to be able, on a large scale, to share and reflect with the whole region and the world, the integrity and intelligence of the people who existed in this land prior to the arrival of the Europeans. We were a functioning people with skills and intellect equal to any other.

I think that our search is meaningful to other Aboriginal people throughout the world. If people have to see to believe, then we now have our weavings to show, something to share with you. It has been the most exciting journey some of us have taken in our lives. The most important thing is that it has brought a sense of success to our people. As we go about our business and community politics, the weaving represents a success equal to anything that others are doing. It is our saving grace, it is our education system.

The discussions that I have had with my ninety-five-year-old grandfather, who was the last person to see any weaving in Musqueam eighty-five years ago, are part of this education process. I will never forget the time, six months after I began weaving, when I sat with him and had a cup of tea. He said, "So you're learning this weaving," and I said, "Yeah, I'm actually starting to like it," and he said, "That's good, that's good." I said, "Do you know anything about weaving, Grandpa?" and he said,

"Yeah," and I said, "Why didn't you tell me? What do you know?" He said, "What do you want to know?" and I said, "Anything you know. Why haven't you explained it to me when I've been here before? You've said nothing." And he said, "You didn't ask me." That put a knife into my heart, to realize how much I had to learn. Weaving has done that for me, it has made me realize how important he is, and how important it is to know who I am through him. Then he told me, "When I was a little boy just come to my senses, about five years old, I used to go to the house where my grandmother and the old ladies were weaving. They had wool, coloured wool, big balls of wool. I used to play there, there were boxes stacked up and they were standing up there weaving. They were about seven or eight feet high and there were two bars and I remember my grandfather going to help them move the weaving over to the other side." I thought things must have changed by the time Paula wrote the book or maybe they wove differently up north. He said, "I remember that, and how the old women would sit together and have tea and talk about their weaving and I'd play under their warps." My grandfather has that memory.

He remembers the women working for quite a few months to weave a hanging in preparation for a naming ceremony, which was his own! Native people from the lower mainland came together, from the Island, Cowichan and Musqueam. People gathered in the longhouse, sixty feet long and twenty feet wide, and the weavings ran from one end of the longhouse to the other. At the entrance to the longhouse were boxes covered with weavings. They put a weaving on him and gave him his name. He had not known that this was what the women had been preparing for. The last time he saw weaving it was being done by his grandmother eighty-five years ago, and the next time he saw weaving it was done by his grand-daughters. All those years we were waiting to be connected through time.

Every time we stand in front of our looms, working with our wefts and our warps and mastering the tabby, we know that our ancestors used this same weaving. What were those

women thinking about? Why did they weave this kind of geometric design? We don't know that because it has not been documented. We are happy weaving and we don't need to know. We will be respectful though. If we have to copy to get the influence and the inspiration that we need, then we will. We will pay attention as closely as we can, listen closely in quietness, without a radio sometimes, paying attention to the messages that are being sent to us through our spirits and through our souls and our thoughts. And that hole that I had in my soul about my existence, has now been closed.

I would like to close by saying that I think that no matter how any one of us weaves, it is a very significant and important part to play in society. I think that one day, as it has been for us, you will be the saving grace for your society. We are the hands in which our ancestors weave.

I dedicate this article to the memory of my grandfather Ed Sparrow.

Arachne's Genre: Towards Inter-Cultural Studies in Textiles

Sarat Maharaj

"Do" and "Do not" says the law of genre.
Derrida

Arachne or Athena? Who ends up the more wronged, the more shabbily-treated in the fateful contest to decide who is the better textile-maker of the two, "the champion"? The question is not easily shaken off—something of it unsettles even the most clipped, zero-degree renderings of the Arachne story. The more we feel for Arachne the more we seem to stop short of taking her side altogether: at the same time, we become less and less sure about Athena's wisdom.

It is this ebbing double movement which Ruskin strives to counteract in telling the Arachne story, part of his Address on prize-giving day, 13 December 1870, to the Woolwich section of the Art and Science Department.[1] He does not simply run through the story start to finish. He cuts into his own narration just before the climax to make a special plea for Athena and to caution his audience: they should not be taken in by the fact that everything appears to end quite disgracefully, demeaningly for the goddess. To set things in her favour he paces his audience through a reading of the fable.

Why the desperate need to shore up Athena's reputation? What clues does it give about how we have come to think of textiles and textile-making and the world of idea and imagination associated with it? To explore this we might perhaps recall the bare bones of the myth.

Arachne, a Lydian woman renowned for her needlework, sewing, and stitchery, challenges Athena, goddess of the crafts, to a contest of textile skills. Athena, disguised as an old woman, tries to dissuade her. But Arachne persists with her challenge. The text begins, Arachne's hands fly across the taut loom-netting with the shuttle as swiftly, as ably as Athena's. Athena inspects the completed piece, finds it faultless, as lovely as her own. The dénouement is best left in Ruskin's words, "She loses her temper; tears her rival's tapestry to pieces, strikes her four times across the forehead with her boxwood shuttle. Arachne, mad with anger, hangs herself; Athena changes her into a venomous spider."

Ruskin's staging of the myth projects a norm for textile-making and womanhood, for "proper" textile work, and "proper" sexual identity. "Athena" serves as the device through which this feminine/textiles norm is constructed and dramatized. He justifies her wrath by presenting her as a corrective, sobering force exercised in the name of the law, the norm. How she enforces it—the matter of her aggressive jealousy, her violent fury, the all-too-final punishment meted out to Arachne—is side-stepped.[1]

Athena, figure of the notion of "proper" genre and gender? Arachne, at the opposite pole, sign of everything improper, deviant? The opposition is summed up in their embroidery. Through the "trim-leaved olive of peace" motif the former signalled a sense of poise, control, restraint. The latter's imagery of ivy leaves, as Ruskin puts it, "in their wanton running about everywhere" spoke of wild abandon, of Bacchus—disruptive forces of a topsy-turvy world of tabooed desires, unchecked longings, feelings quite outside "the law."

Athena had embroidered the council of the gods—a serious, weighty theme. It celebrated order, reasoned exchange, measured

discourse. The composition touched on the sense of civic manners, virtues, morals, on the civilizing force, the laws of men. What Arachne had pictured might be called "the unmentionable." Ruskin describes it as "base and abominable." It demystified the lives of the gods—exposing their trickery, the devious means to which they stooped to get their way. Arachne had driven home the point by depicting the "Rape of Europa" and twenty other episodes involving the gods' abduction and violation of women.[2]

For Ruskin, Athena's idiom and imagery are at one with the established order of sensibility—bringing together ideas of "needlework within the bounds of good taste" with those of "the decent, respectable woman." How he constructs the "textiles/feminine" is underscored by the fact that the goddess had sprung fully created from Zeus's head—something of a male-centred projection of the feminine? At odds with this order, Arachne's work seems unbecoming, lewd, in poor taste. It smacks of the shameful and licentious. Athena was "legitimately" provoked into curbing, as Ruskin puts it, "her fault of a poisonous and degrading kind, sensual, insolent, foul."

His address seems fine-tuned for the women in his audience, at times as if for their ears alone. A confessional mood is evoked. "Do young girls still sew samplers?" he asks in an aside. Let's hope they have not let such sound, Athena-work lapse. It would amount to courting Arachne's fate. The intense terms in which he describes her transformation into the "meanest and most loathsomely venomous of creatures" impresses, repels, instructs. With allusions to Penelope, faithful at her loom, and to "the Queen of our own William the conquerer, maker of Bayeux tapestry," his model of "proper needlework/womanhood" is rounded off and heightened—against any temptation to stray onto the reckless path Arachne had taken.

What Ruskin subsumes under the term "textiles" seems surprisingly all-embracing, "good stout clothes to knit and weave but also to make pictures on them." It seems to take in the spectrum of textiles genres, cutting across all its modes and effects—everything from production of cloth, through com-

modities and goods, to textiles as art practice, as something which may be read as fine art statement or object. Should we take this, in the spirit of Barthes' "endless garment,"[3] as a seamless, unending textile text worthy of attention at any of its countless points?

Ruskin, however, privileges and validates simply one site of this vast textile text—Arachne's genre. He sees its force as essentially institutionalizing—at the four corners of her tapestry she had embroidered "admonitory panels" depicting the dreadful fate of those who dare question the established order. He favours its capacity to replay received imagery and iconography, to cite and re-cite an approved, accepted system of attitudes and values—a logic encapsulated by the notion of "sewing sampler."

He excludes Arachne's space, subordinates it—sensing in it a swirling stream-of-consciousness energy, the destabilizing force of tinkering at will with elements of received representations, playing them off and turning them against themselves. What he is denouncing is its potential prising open a gap through which other versions and voices, other inflections and differences may appear. It is on this drive towards such an exploring, experimenting sensibility—on a questioning, independent creativity—that he comes down heavily toward the end of his address.

The genre of Athena as repetition; that of Arachne as resistance? The former as sheer production, as prescribed representation, as saying the same thing again, as "naked repetition"; the latter as expressive, self-reflexive practice, saying it again with a difference no matter how apparently small, as "clothed repetition"?[4]

These may serve as signposts in mapping textiles today. We may see Arachne's space as a metaphor for avant-garde textiles practice—in which handed-down notions of art practice/genre/gender come to be cited and overturned, displaced and played out. A space on the other side of Athena's male-order decencies—one shot through with a sense of the obscene, orgasmic?

Arachne—Exotic Embroideress?

To the blonde goddess's eyes, Arachne's tapestry border of ivy leaves was "faultless": she tore it to shreds. To Ruskin's eyes it is "exquisite": he condemns it as signifying everything "wanton, foul, abominable." It suggests something not unlike that split in the gaze which constructs the exotic object— between irresistible attraction to the thing and a sense of revulsion for what it is taken to mean—the split of the Eurocentric gaze.

Arachne is a Lydian needlewoman, "a poor little Lydian girl" for Ruskin. Lydia, in Asia Minor, stands as part of "the Greek world." But it is also too much at its edge, at that dangerous point where "the Attic" must meet and tussle with whatever it constructs as other than itself, as different. The word "Lydian" connotes a sense of the voluptuous as against "Attic" restraint, self-control. As a musical mode, against the latter's manly, robust clarity, its strains are orientalizing, effeminate. It serves as a metaphor for the exotic, the Oriental Other—impossibly necessary and unacceptable in one go.

The Athena/Arachne poles, in various guises, have tended to underpin modern versions of the Eurocentric gaze in art and design history and theory. "When the Attic migrates eastwards," Winckelmann, founder of the discipline's modern career, observes, it risks "lapsing into Asiatic luxury, becoming voluptuous, wanton."[5] The artistic norm, the idea of the beautiful in "the Greek" he counterposes to the wayward extra-ordinariness of "the Eastern other"—grotesque, non-manly, excessive.[6] For Hegel, too, "the bizarre extra-ordinary" signals the exotic other; he situates it in Indian art, which he constructs with formidable consistency as the split sign—at once shamelessly sensual and sublime.[7]

Ruskin's split view of the Lydian as the exquisite or foul is not separate from this tradition of looking. It is tied to his own distinction between the Greek ideal, "Daedalus work," and what he sees as Indian art's excess and moral inferiority.[8] Indian textiles, design and craftwork count as exquisite in his

scheme only because he hives it off from the distasteful content he finds in Indian art.

The pattern persists even where we would have expected change. Fry attempts in the 1930s, under the impact of modernism and primitivism, to dethrone the Attic norm. He ends up constructing Indian art in terms of exotic excess, as a sign riven by lush lifelikeness and pornographic content—summed up in what he sees as its "provocative dehancement of the female figure."[9]

For inter-cultural studies the concern is not only with how the Eurocentric gaze constructs itself historically. It is with the fact that it is the inescapable factor in analysis.[10] Athena's piercing eyes dart across the Lydian's embroidery—scanning, scrutinizing—till she lashes out. How do we go beyond the relations of power and domination of the Eurocentric gaze which constructs the "otherness" of non-European cultures— beyond the violation following on Athena's gaze?

But could she have made sense of Arachne's embroidery as a Lydian might have? The possibility of an epistemic barrier needs to be admitted. To speak of cultural orders whose ways of patterning and picturing experience are "radically at odds with ours" is to face up to incommensurable elements of systems which cannot be decoded one to another. There is no "common idiom" in which to do so, hence their "radical difference."[11] Foucault highlights this by reference to the "bafflingly fantastic way" in which animals are classified in Borges' Chinese encyclopedia:

> (a) belonging to the Emperor, (b) embalmed, (c) tamed, (d) sucking pigs, (e) sirens, (f) fabulous, (g) stray dogs, (h) included in the present classification, (i) frenzied, (j) innumerable, (k) drawn with a very fine camelhair brush, (l) et cetera, (m) having just broken the water pitcher, (n) that from a long way off look like flies.[12]

Its impact on "our own" logic of representation is to show it up as only one of many ways of arranging things. It makes us rethink the view of inter-cultural studies as simply stepping

out of "our" ways of knowing and feeling into those of another culture. It is more likely we are thrown into tussling with "radical difference," with an epistemic barrier we might never quite pass. The more we strive to get under the skin of another system the more we find ourselves glancing over our shoulders to see how "our system" is reshuffled. By the inter-cultural stance we would need to understand something like this anxious, two way, self-searching process—scene of never-ending exchange.

The view seems not unrelated to post-war economic and cultural developments.[13] It is not easy to see how we could continue to speak of cultures as discrete entities, separate worlds of life and living closed in on themselves. As Clifford notes, the forces of post-war communications and internationalization, of global economics, cultural centralization, of "entry into modernity," have produced what may be spoken of as a world-system. The exotic, once tantalizing far-away, is now increasingly part of our local, everyday; at the same time, we stumble over the familiar in the most unexpected, "exotic" of places.

It suggests a breaking down of differences between cultures, a levelling out of those distinctions, oppositions, contrasts, on which received ideas about culture were based. At least, of notions of clear-cut, essential forms of difference centred on stabilities and continuities such as tradition, roots, clothing and custom, language. The breakdown of the "old orders of difference" might be understood as a process of loss, of homogenization. Or as an opening for creating new, critical statements of difference and identity. Neither seems to tell the whole story. Each undermines the other and slips out of the privileged grasp of a totalizing account.

In this setting we might think of culture less in terms of a final, enclosing identity, more as an unceasing activity of unmaking and remaking. It stages itself as a stalling, a perpetual putting off the point of arrival. We might see it as play of inflections of difference, images of self rubbed out even as they are written up. By the idea of post-imperial identity we thus grasp something not unlike "a fable of our Caribbean

selves"—metaphor for a sense of self as a process of uprooting, grafting, copying.[14] It makes itself up as it goes along out of the dizzying mix of elements of the late modern world.

But it remains arguable whether this breathtaking spectacle of diversities amounts to a realm of expressive liberties or to one of repressive tolerance. It is not unlikely that what we gain on a micro-level in terms of expressing difference through dress, fashion, clothing, style, we lose on a macro-level to tighter, intensified standardization and corporate uniformity.

It suggests an interplay of liberating and imprisoning forces—or even perhaps their stalemate. What sense should we thus give the claim that the Eurocentric gaze has been met and scattered?[15] Does it persist through this scene in the guise of fashion-textiles up-to-dateness, the "Ethnic Look," or is the latter a travestying of Athena's gaze, turning it against itself?

Textiles' Primal Scenes

The Arachne Story or *The Tapestry Weavers*—is Velasquez's *Las Hilanderas* on a mythological or historical theme? For all the hard evidence now in the former's favour the verdict remains open because so much in the picture does not fit the case made out by either side. Ortega suggests that Velasquez turns myth "inside out": he does not let it run away with representation into make-believe, he draws it into the real world, he historicizes myth. "He finds the root of every myth in its logarithm of reality."[16]

The view echoes the long-standing counterposing of the mythic to the historical—the former as representation on an imaginary, timeless plane; the latter, as in specific time and place. The one an order wrought out of idea and concept, the other out of sticking to the empirical facts. Myth as running on the spot, replay—as "naked repetition"—how textiles tends to be written about. History as cutting through myth in steady advance toward progressive enlightenment, a chronicle of bursts of originality and creative leaps—the way fine art practice is written.

Rubens

Fable of Arachne, c. 1636.

Panel, 27 x 38 cm.

Collection: Virginia Museum of Fine Arts.

It loses its force as we grasp the complex ways in which myth intertwines with enlightenment, metaphor with unembellished historical fact.[17] Historical writing may thus be seen as a "white, colourless light" spun *out of* the colour spectrum that is epic and myth, rather than as something entirely separate from it.[18] The force of metaphor in historical writing, in what stages itself as a meticulous representation of "things as they actually happened" seems inescapable. We rarely, though, see anything of the machinery, the figures and tropes, with which it pulls off the effect.

Such metaphors are not unlike worn-out images on coins, defigured through use and rendered "invisible." Drained of their lifeblood, a "white mythology" they figure forth representation which has the look of a flat, factual, "historical" account of things, of "literal meaning."[19] We would have to think of textiles in the spirit of this interleaving, beyond the "reassuring opposition of metaphor and proper meaning," myth and history. It would be to alert ourselves to metaphor's and myth's force in language—how it shapes the social, political, institutional discourses in which textiles are imagined and made.

The myth of the primal scene serves as a device for imagining that "origin" through which the textiles world comes to be decisively carved out. At the same time the idea of an "originary moment" is cancelled, for we reach back to more than one scene, more than a single "origin"—to the high modernist avant-garde, to ancient Greece and India, to the *Odyssey* and the *Mahabharata*—to Penelope in the former and Draupadi in the latter—epics in which textiles function as pre-eminent signifiers.

For much of the epic we have a portrait of Penelope, drawn by a male-order placing of the feminine, as patient, prudent, adamant. We witness her highly praised loyalty to Odysseus who has not returned from the Trojan war. She waits faithfully at her looms as the years pass, managing to keep at bay the suitors who lodge themselves in her home and who refuse to leave till she has chosen to marry one of them.

It is at odds with how she is portrayed in the final book, the Hades section of the epic. There the suitors, recounting the events leading to their slaughter by Odysseus on his return, see her as deceiving, double-dealing. They complain of the calculated way in which she misled them into waiting. She had promised to make up her mind about whom to marry when she had finished weaving her husband's shroud. But she had only pretended to be doing this. All day she would weave at the loom. By night she would sneak out to undo her day's work.[20] She had devised a delay tactic, a way of stalling for time.

The ruse stamps something of the motif of the guileful, weaving woman, the notion of feminine craftiness across the textiles scene. Penelope herself seems to come through largely unscathed in literary, artistic representations. As we have seen, Ruskin invokes her image as the "good needlewoman" and endorses it. But the point is not that we rarely, if ever, see Penelope herself cast as the cunning "bad needlewoman." It is that "good or bad needlewoman," they amount to two sides of the same male-order coin of feminine images.

In the *Mahabharata*, Yudistra stakes himself, his brothers, even Draupadi, their collective wife, in a game of dice he loses to his greedy cousins. She is dragged by her hair, out of the seclusion due to her at the time of menstruation, into the assembly hall as the Sabha Parva section of the epic notes, "trembling like a platain in the storm."[21] The victors try to disrobe her in public. The final humiliation they wish on her, however, does not quite come off.

For every yard of her sari her tormentor manages to pull off another seems to add itself on. He ends up in a tangle of cloth. Draupadi asks, "has the house of the Kurus sunk so low that women are not respected?" Draupadi's violation mirrors the even more ancient figure of feminine hurt, Amba, whose name means "the womb" and who haunts the epic's events. Both voices counterpoint through the epic a complaint which is never silenced against male-order and its power.

Penelope's suitors, Draupadi's husbands; Penelope's unending

shroud, Draupadi's endless sari; a weaving and a denuding which never reaches finality, a stalling tactic, a perpetual deferring which encapsulates something of their "recalcitrance," the sense of feminine resistance. The motifs come to be echoed and inflected in the avant-garde, in the Bachelors' attempt at disrobing the Bride which is part of the turbulent narrative of desire in Duchamp's *Large Glass* or *The Bride Stripped Bare by her Bachelors, Even.*

In the *Large Glass* drama the Bride's "intense desire for orgasm" leads her to take charge of her own undressing. That is, even when the Bachelor machine—"9 malic moulds, a cemetery of uniforms and liveries," as Duchamp describes his cross-section of the hierarchy of male stereotypes—assumes the initiative in her stripping, in which she aids and abets. But she backs off and rejects his brusque offer. Frustrated, the bachelor turns to auto-eroticism, "grinds his own chocolate," culminating in its own spectacular splash.[22]

Against this Duchamp sketches the Bride's struggle to go it alone, to work out and achieve climax under her own steam. Her desire springs from a voluntary stripping imagined by herself. Duchamp pictures her effort in terms of a motor car climbing a slope in low gear. "The car wants more and more to reach the top while slowly accelerating. As if exhausted by hope, the motor of the car turns faster and faster until it roars triumphantly."[23] It dramatizes something of a sense of independent feminine desire, activity and achievement.

It is not without significance that *The Large Glass* is subtitled "A Delay in Glass." We might understand it as a holding back in a double sense—in terms of the work's theme and its genre. The encounter between the Bride and the Bachelors is fraught, incomplete. It puts off the idea of some final coming together, a moment of total erotic fulfilment—metaphor for the notion of the inundating, full presence of meaning? The search for such a moment is left open-ended.

But *The Large Glass* as "delay" also refers to holding back from identifying with any particular genre. Duchamp conceived the piece as a resisting of the "painterly visual," of its

mindless excess, in favour of the conceptual. His notes on how to render the orgasmic cloud—Milky Way imagery in the topmost part of the work—recoils from a full, grandiose fine art treatment of pigment. A lush, expansive painterliness, smeary impasto flourish and facture is cited but held at bay by more reserved, laconic, "taste-neutralizing" forms of marking and imprinting based on varnish, dust-breeding techniques, on lead-wire thread and threading.[24]

The work stops short of the genres of fine art statement, holding them up for as long as possible. The painterly institution of the canvas as window on the world, its perspective conventions are played *ad absurdum*. Our sight passes from the glass surface, through and beyond it into the extra-pictorial. The piece is not a "painting on the wall"; if it is a free-standing object it is not quite so in a "sculptural sense." It has a craft dimension to it, a sense of meticulously-calculated design set off against ready-made, manufactured elements. The myths of a painterly genre, the sense of free expressivity and its flourish are detoured and side-tracked.

A genre which cuts across genres—which seems both less than painting, the ready-made, sculpture, the craft-design object, visual and conceptual statement, and yet more than them. A genre which keeps itself at play between them, eluding them, not unlike the Bride's "going it alone." With this configuration of genre and the sexual identity do we begin to approach Arachne's space?

The historical moment of Duchamp's *Large Glass*—from 1915 to 1923—saw the opening of two discourses grappling with "the cloth famine" from opposite ends of the world system of textiles: in England, a discourse centred on the new journal *Textilia* (1918–20)—trade and corporate interests searched for the way forward after the Great War, to recover imperial normality "without delay."[25] In India, Gandhi's views and debates on textiles addressed to Indians struggling to shake off British rule "without delay," centred on the paper *Young India*, collected and reprinted in the thick of the independence movement as *Wheel of Fortune* (1918–22).[26]

Textilia: 1919–20

> Never was a time more inauspicious than the present, it would seem, for the publication of a new journal—when all the great nations are engaged in the greatest war ever waged, when industry and commerce are plunged in difficulties hitherto never dreamed of and new anxieties appear on the darkened horizon almost every moment.[27]

Textilia was launched with these words in July 1918—a monthly journal but published quarterly because of wartime economies. It embraced some fairly long-standing journals and bulletins acting as the mouthpiece of the spectrum of established textiles trades.[28] They grouped under the Textilia umbrella to speak with one voice, a common front in the face of an important element of the wartime crisis—buyers at home and abroad felt that the trade was taking unfair advantage of war shortages to push up prices; there were allegations and suspicions of outright profiteering.[29]

It was a prime factor in *Textilia's* original reasons for appearing at what seemed an inauspicious time. It saw its purpose as "created by the exigencies of the present and writ large on its pages," "to tell in the language of truth the real position of the Textilian and allied industries of Great Britain and Ireland at the present time, their struggles to maintain output in the face of the gravest difficulties which have ever beset the trade and their loyal services to their country in its hour of peril." It set out to reveal the facts behind "abnormal prices, the vital details of which are perhaps not fully grasped or understood."[30]

"Vital details"—a sustained commentary on them. That is how we might look on *Textilia*, a "fair-minded" defence of the trade's views on the rising textiles prices, an issue which dogged it to its final number in 1920. With an eye on the big South American market, it resorted to quoting a Brazilian minister on the trade's bona fides: he vouched for the fact that Britain's name was synonymous with "reliability, sound

workmanship and good faith, punctuality and straightfor-wardness."[31] The testimonial unwittingly spotlights the very problems which made for the textiles crisis!

The journal sought to dispel worries about inordinate rises in prices, the future of the trade given the cloth famine and bleak world-wide shortages. It aimed at boosting morale—at encouraging colonial buyers who were fighting shy of placing firm orders in the hope that prices might come down. Against crashes, breakdowns, distortions in the wake of the govern-ment's diverting of massive textiles resources for the war effort, it sought to inspire confidence in the trade, in a return to something like pre-war normalities.[32]

To restore trust, to reaffirm old alliances and contacts— *Textilia* embarked on a robust publicity drive on the trade's will to weather the crisis. Its advertising campaign promised "business as usual" after the war. For "textilian entrepreneurs and tradespeople" it was not unlike a pep talk, a barometer of market fluctuations. For the British public, colonial buyers, new consumers—it saw itself as an exercise in persuasion and propaganda to stave off growing competition.

"Vital details"—the issue of rising yarn and cloth prices— which *Textilia* tried to account for so tirelessly so "that nothing might besmirch that fair character attaching to British production" thus comes to signal two conflicting desires. The wish to go back to "familiar prices," stabilities and normalities of the pre-war imperial textile system at odds with the awareness that there was no going back, that "abnor-mal prices" had come to stay. The desire to restore the old order plays off against the desire to move forward, the pull of the traditional against that of modernity and change.

Textilia discourse structures itself in this double movement. On one plane it is a narrative of past enterprise, achievement and success which runs as a series of tales on specific sectors of the trade: each becomes a mythic, heroic saga of determination, skill, triumph.[33] Against this, on another narrative plane, run reports on the actual, contemporary condition of the trade— glimpses of hardship, loss, adaptation, grappling with modernity.

In this sense, it structures itself as "representation of representation." The textiles narrative it constructs is through other narratives on the subject. We have a heightened sense of the mode with the "Great Trade Novelists" series.[34] The textiles world is depicted through citing other depictions. Literary/historical, fictive/documentary, statistical/imaginary—the lines between them blur in the journal's representation of the trade.

The visual representation of textiles it constructs is, in not dissimilar mode, through representations of art works related to textile-making. Pieces by great masters build up into the sense of an unbroken, grand tradition.[35] What is evoked is a textiles culture at one with fine art masterpieces and the world of high culture—sign of traditional order, wholeness, stability of value.

That the journal should been subtitled "Argosy of Informative Textilian Commercial Industry" takes on some significance in this context. It seems to connote little more than a formal, literary convention as we might understand in a "treasury" of stories and reports. But against the background of crisis, the desire for "the homecoming" to stable values and prices, the framing power of the Odysseus myth is not far away—ideas of survival against all odds, sacrifice and ordeal, of adventure and exploration, even conquest and colonization. Audley Gunston's cover design pictures a berthed, textile-laden argosy to dramatize this point—an inspiring image for the trade striving to make it through the stormy times.

As if to stress the homecoming theme, the April 1919 issue featured, at a dark hour of the crisis, Bernardino Pintoricchio's *Scenes from the Odyssey*. It entitled it *The Return of Penelope to Ulysses* which, though not inaccurate, tends to inflect our reading in a more positive, affirmative register. We see Penelope at her loom and Ulysses (though it is more likely Telemachus) as striking figures in their prime—not, as the epic text might have led us to imagine, somewhat aged and ravaged by testing years of separation and exile.

Through the window we catch a glimpse of the "argosy" safely in harbour (though it is more likely a snapshot of the tormenting Sirens episode). In the journal's context, the picture comes to be projected as an idealized sign of reunion—at any rate, a shorthand image of homecoming as a sense of completeness and reprise which mirrors the journal's narrative of the trade weathering the crisis back to the productive fullness of its heyday.

As Renaissance art work, the Pintoricchio itself stands as a sign of "the standard of value" as opposed to its breakdown in the contemporary avant-garde. *Textilia's* projection of this version of the myth may be contrasted to two other avant-garde uses of it around the time. In Joyce's *Ulysses* (1915–23), the heroic myth is at every turn punctured by the mundane, the contemporary everyday. Bloom's return is to a "cold, cuckolded bed": Molly is modelled on the tradition of the "disloyal" Penelope who was said to have chosen to sleep with her suitors rather than to have saved herself for her husband. Joyce holds back on the notion of a grand reunion—everything is left open-ended, in flux.

His language would not permit otherwise. Meanings slide across other meanings, a perpetual staving off save arrival at some enclosing finality of meaning. It is not unlike the Vorticist language of William Roberts' *Return of Ulysses* (1913); angular, jagged forms keep at bay the sense of organic totality. They discourage and interrupt build up of sentiment and feeling associated with the reunion theme. Swerving, dissonant juxtaposing of planes and perspectives, a terse, speeded-up idiom break up the received regularities of our ways of seeing and picturing things.

Textilia's inaugural number signalled the idea of "the homecoming" both as a return to the pre-war imperial order of textiles and as a reclaiming of the "essence of British identity." The trade's resilience, its capacity to fight and win back its pre-eminence is tied to grit and determination, "the characteristic of the British race." Its capacity to prove its strength and resolution against all odds, in the darkest hour

Textilia cover by Audley Gunston.

of crisis, is presented as "an axiom" of the national identity. The tenacity which brought its military captains such success is linked with the spirit of its industrial and commercial adventurers who managed by "their indomitability in penetrating to the uttermost parts of the earth."[36]

The journal noted a year later that the portrait it had penned had not been unjustified. It sprang from "the sure record of our national history, where there is no instance to be found of our defeat, when to the world it seemed inevitable."[37] But, from the October 1918 issue onwards, there was growing awareness that it had become less easy to speak of Britishness in terms of the received grand myth: other voices, of textiles workers and the public of consumers, now cut across it. If the lead article, "Renascens Britanniae," continued to couch Britishness in rather grandiose figures of the fifteenth-century revival, the imagery was also deployed to dramatize the possibility of regress, of "lapse into decadence and decline."

The concern was that despite the forging of a new sense of Britishness—"pulsating with new aims, new hopes, new visions of the future"—injustices, vices, evils of the industrial past[38] would linger on. The inflection it was adding sought to appeal to both ruling and subordinate elements of society. The search was for an identity built on a spirit of cooperation and togetherness. In a rather laboured tapestry metaphor the lead article, "Dawn," was to speak of the "Great Design that now had to be woven," of "New units in a harmonious whole," of unity through interdependence.[39]

The corporatist overtones of this vision of Britishness, centred on an organic unity of "head/hand, brain/brawn, capital/labour,"[40] were not uncoloured by the period's new order political ideologies. It reflected its classic oppositions: keenness to thrust into the industrializing future set off against the wish to reaffirm what was seen as the human, personal quality in pre-industrial work relationships. As its scan of Britain's historical development reveals, *Textilia* favoured an idealized model of close, individual contacts, family–community bonds of workers associated with the era of artisanal labour.[41]

If the age of machinery had created great manufacturing concerns, workmen's combinations, and federations, it had also unleashed bureaucratizing forces—"a maze in which the individual is lost," a wounding division between "soulless corporations called employers and soulless combinations called employees." The journal held out little hope for schemes of betterment for workers until the "old relationship could be restored without being attended by the old evils"; a restorative and tranformative desire in one go—not the first time we see this pattern in its discourse.

The "Britishness" *Textilia* pondered was understood as forged within the network of Britain's relationships with the colonies—national identity as something defined through "other worlds" against them. "Lancashire," textilian symbol of Britain, was seen as both tied to and set off against India, sign of the colonial world. The latter 's purchasing behaviour came in for anxious scrutiny—sustained speculation about whether Indian dealers would follow up price inquiries with commitments to buy. If Lancashire was to be baled out of the slump this was crucial. What is unwittingly conveyed is that India—portrayed as Lancashire's special dependent, steady and subordinate client—is really its prop and lifeblood, its *raison d'être*!

The anxiety was over the colonial other's "bewildering" behaviour which did not appear as legible as in the past. If it provoked a feeling of the loss of grip over "the other" it also had something of an unnerving impact on the sense of self. There was fear that the "fat days of Lancashire were over."[42] It was expressed in tetchy, exasperated remarks about the colonial market: "Frankly India so far has been disappointing."[43] It was suggested that she might have "burnt her fingers"[44] in holding back with firm orders: "Calcutta was a particularly bad sinner in this respect. Bombay was not very much behind, with Karachi a good third."[45] There was worry that this meant "competition, menace, a threat" from the "greatest of outlets for Lancashire" which would "put in jeopardy its supremacy."

In this respect, *Textilia* saw matters almost exclusively in terms of a return to the pre-war, imperial pattern of trade. It

was keenly aware that "up-country India had been swept clean of cloth and starved of yarn."[46] Why the delay in placing orders? It marked the limits of its response. Many factors were involved in the tardiness of Indian buyers—whether colonial British or native—which are not at issue here. The striking thing is that throughout the journal there is no hint of the swelling resistance in India to dependence on Britain—a movement which, ironically, was making Lancashire cloth and yarn the very issue of struggle.

Notions of Britishness touched on in *Textilia* were mainly in the "masculine mode." Audley Gunston's cover design dramatizes this. An argosy laden with materials and garments stands safely at anchor. From it a man carries forward fabrics and offers them, ritual fashion, to "woman"—pictured as an ideal, classical nude with attendants. The two activities involved seem to be centred in the masculine, or at any rate initiated from its standpoint: the seafarer's business of gathering and bringing back exotic cloth and the issue of constructing the "feminine" by dressing it up, fashioning it, condense into one.

The image seems to capture the journal's overriding concern with the sphere of trade and trading: textiles and the feminine become signs of a male-centred exchange and turnover of commodities. By depicting the business of obtaining textiles and its usage as very much in the hands of men the image suggests a linking of sexual place, position and power. The division it implies seems to be between "masculine" obtaining of materials through trade, putting them to "manly" use as necessities, at the service of "woman": this is set off against the "feminine" receiving of textiles, displaying them as part of the spectacle object.

It is a scene of relationships carried through in no small measure in other pictures on the theme of "textile goods and exchange" reproduced in the journal. The Gunston cover design shares much the same ground of ideas and attitudes as Lord Leighton's *Phoenicians Bartering with the Ancient Britons*.[47] The field encompasses the dramatic Derry and Toms' advertising image on the subject. The journal notes,

"The scene represents the Port of London, where are gathered together merchants from four quarters of the globe, laden with the choicest fabrics, the most costly furs and exquisite textiles that their countries produce for the adorning of women and beautifying of the home."[48] Across the spectrum of representation—fine art to advertising images—the turnover of textiles commodities seem to be depicted in and through the image of woman, the consumer-spectacle.

With the journal's emphasis on the sphere of textiles exchange and consumption, the Viyella advertisement it almost regularly featured as its back cover may seem unusual in showing women in the act of textile production. But it is also phrased to evoke a sense of the glamorous, exotic spectacle object—women exhibiting cloth and themselves "as if only to themselves." Beyond this double-edged image, *Textilia* reveals little about the sexual division of labour and its coding in the sphere of production.

In *Textilia's* pronouncements on taste and its orders—through which it signalled notions of difference of culture, class, nation and ethnic provenance—we see a condensed version of those oppositions which characterize its wider reflections on Britishness. "Each nation's taste is different, each demands a different line of design—Africa, on the Gold Coast requires more brilliance than the sea-girt islands of Japan." The view, however, was not so much part of an open pluralism of taste as a fixed stereotyping of difference based on market demands.[49]

It marked out something like a universal ground of fine taste—"educated taste." This centred on a rather rough and ready distinction between garish, brilliant colour as sign of "less educated, provincial, crude taste," and "softer, muted colour as that of fine taste." It is not unlikely the view reflected, in broad terms, dominant norms of colour and taste of Britain of the day. It was evoked in the face of workers' "tasteless" high spending on costly silks. If the aim was to give guidance on good taste it was no less to regulate buying, to steer it out of the "elysium of luxury goods" towards more sober, mainstream textiles on the market.[50]

In these respects, *Textilia* seemed to conform to the old orders of taste. But it was not completely sealed off from the new, as may be noted in its reaction to the Mayor of Brighton's criticism of the English as "the most inartistic nation on the face of the earth." "In our homes, our furniture, decorations, pictures and ornaments are all hideously ugly. All middle class and working class homes throughout the country want refurbishing."[51] The journal seemed to demur before the sweeping, almost Vorticist ring of his views. But it called for a positive response to the simpler, cleaner line of the modernist style coming into vogue—away from the "old stodgy standard of Victorian taste."

The switches of focus from traditional to modernist orders of taste are part of the overall double movement of the journal's discourse. It also depended on the particular area of textiles on which it was commenting. At one end, a conservatism of taste: matter of fact acceptance that little could be changed with straw hats, "the boater design,"[52] or the desire to catch up with Parisian *haute couture*, sign of established fine taste. At the other, an incipient modernist taste: rejection of muted colours associated with the old world in favour of colour suggestive of the "brass band with more stridency than tune," a taste for the vibrant, easygoing, dissonant, for experiment, futurism and modernity.[53]

One item captured the sense of these switches: government promises to put aside cloth for something like mass-produced, reasonably-priced suits. From the outset the project appeared to get bogged down by delays, diversions of promised material, high prices. *Textilia*'s last issue comments on the innovative scheme's failure; the trade and its customers are urged to report unfair prices to the Committee on Profiteering.[54]

The idea of constructing a textiles world based on "standardization and concentration"—mass-produced goods and special items, ready-made and one-off, made-to-measure clothes—appeared to have to come to grief. The standardized suit, recalling Penelope's incomplete shroud, turns up as a pre-eminent signifier of the unfinished product of modernity—"new order Britishness."

Gandhi's *Wheel of Fortune*: 1918–22

Who has denuded India? The question reverberates through the Gandhi texts centered, not unlike Textilia, on the desire to remake the world of textile-making. The latter serves as both practical instrument and metaphor for "Swaraj"—the remaking of India, of something like an Indian identity quite independent of British rule and outside the network of colonial subordination.[55]

The stripping of Draupadi replays itself in the actions of the modern denuders of India who strip her of wealth and assets. Gandhi identifies them as representatives of the colonizing power, Messrs Bosworth Smith & Co. and the O'Briens and native agents, the Shree Rams and the Maliks. He links them with the insolent power of men who "lift women's veils with their walking sticks," to peer at them as if they were commodities—disrespect and violation no less than that suffered by Draupadi.[56]

The tone seems unusually sharp—he is responding to the British shooting of unarmed Indians at Amritsar in April 1919. The backdrop is the jittery reaction of the colonial authorities to the Russian Revolution's impact on agitation for home rule. The moment is the aftermath of the Great War. The "Mahabharata," a figurative expression in many Indian languages, had come to mean literally the "Great Conflict."[57] In this sense, we might say, the Gandhi texts speak to "the time of the modern Mahabharata."

His focus is on the unequal relations of the imperial system. It has brought poverty, "a famine of cloth in India."[58] At one end, prosperity in "Lancashire" developed with protective laws: at the other, pauperism with the indigenous textiles industry run down and reduced to consumer, client status. Indians had themselves come to believe that cloth could not be manufactured in India, that they were at the mercy of imports. They had been "amputated in a figurative sense"—crippled, rendered into a state of dependency.[59] Gandhi's allusion is to the trauma of East India Company rule, of control

over textile production sometimes enforced by mutilating workers, by chopping off their fingers.

How do the colonized break the bonds of dependency? Gandhi saw only part of the answer in "Swadeshi"—the boycott of British cloth. To give up foreign clothes is "to decline to wear the badge of slavery."[60] But could this be anything more than an aggressive desire to punish "the English"—a sign of weakness?[61]

For Gandhi the post-colonial self could not be forged in a clear-cut instant by simply negating the colonizing other: independence, self-determination were not so much ready-made states of being and mind as a self-creating process on the part of the colonized—a struggle to awaken new capabilities and qualities in themselves no less than in the colonizer. A mutually transforming, binding project, a "sacrificial quest"— they redefine themselves and the colonizer without feeling the latter could be simply bypassed.

Gandhi grounds the search in homespun—the "rudimentary" mode of textile-making, but something not out of people's reach, even the poor. They, above all, would need to experience through spinning and weaving a sense of what it might mean to do things for themselves, to stand on their own feet. Gandhi put great store on it as a practical-symbolic mode for shaking off the sense of dependency, for grasping the idea that deliverance from colonial subjugation lay in their own hands. He is thus wary of mill-loom, machine-made cloth not because of a backward-looking glorifying of artisanal modes. It is because he assesses it, in the circumstances, as the less effective instrument for undoing the structures of colonial power.

He codes the homespun/mill-made divide thus: the former has a potential for activating the mass of people into making of cloth—drawing them into the arena of reforging themselves and their energies, of rethinking identities and subjectivities. Mill-made cloth, on the other hand, no matter how "native" in origin, remained a product churned out over their heads: it tended to leave relationships of subordination and dependency largely intact.

Gandhi is also aware that to opt totally for mill-cloth would be to hand over to the colonizers the lever of a "machine blockade" of native mills. It would mean stepping out of the old order of dependency on foreign cloth only to step into the new one of dependency on imported technology and machinery.

Homespun/mill-made—signs of counterposed economic systems and politics? "Capitalists do not need popular encouragement," Gandhi notes dryly, in associating mill-cloth with a rising class of native industrialists, entrepreneurs and merchants.[62] Their aspirations, however movingly expressed "in the name of the nation and independence," amount to stepping into the colonizing power's shoes.

Homespun, at the other pole, he links to the making of a people, their coming to awareness in personal ways of fresh connections and contacts which cut across caste and class in new co-operative communities.[63] In this sense it serves as a critical gloss on the prevailing system of textiles production. Where mill-made cloth signals a consolidating of corporate forces, hand-spun, based "anarchically" in individual desire and demand, comes to signify resistance.

But is it "manly" activity?[64] The question is put by Swadeshis not at ease with the spinning and weaving regime Gandhi recommends for men and women alike. It seemed radically at odds with accepted ways of being men and women, with received ideas about "virile labour" and "women's activity," productive work time and leisure time.

Gandhi suggests a kind of "de-feminizing" of the textile-making terrain, displacing its traditional axis of sexual position and power. He seeks to shift it into a space where it might be seen more as a sexually indifferent practice, where it might become "as graceful for either sex as music"[65] —something like an unmotivated sign system, an abstractive notation all the more flexible for that for constructing sexual identities in fresh ways.

A sexually indifferent "gracefulness," the sense of stepping out of the state of dependency towards cooperative living—

Gandhi pictures the post-colonial self as a site of transformation where the orders of taste come to be turned inside out. People would have to consider revising their sense of fashion and feeling for cloth textures. It would involve training themselves to revalue the lowly, subordinate product of homespun, to see "art and beauty in its spotless whiteness," to appreciate its soft unevenness.[66] It would mean cultivating a different textiles sensibility altogether—an aesthetic more responsive to elements of the raw, native, vernacular.

"Will the nation revise its taste for Japanese silks, Manchester calico or French lace and find all its decoration out of hand-spun, hand-woven cloth, that is, Khaddar?"[67] Gandhi is responding to reports sent in by women's groups on debates and discussion over tastes, fabric textures, a new textiles sensorium.

The activist Sarladevi writes from a Swadeshi meeting at Sialkot attended by 1,000 women: they are sorry she has given up costly fine silks for a heavy, coarse, homespun white sari. She answers that it is easier to bear than the weight of helpless dependence on foreign manufactures however apparently fine and light.[68] Her sari impresses more than her speech: as with Draupadi, it stands out as the signifier pre-eminent.

Arachne—"Genre débordé"?

Athena or Arachne? In one of his *Irish Tracts*, Swift sides with the latter in the name of "colonized Ireland." In another, no matter its doubtful and suppositious status in the Swift canon, he sides with the former in the name of "colonizing England." Each stance comes to overrun its own borders into the other. An "undecided" space opens up.

Swift recounts the Arachne story in *A Proposal for the Universal Use of Irish Manufacture in Cloaths and Furniture of Houses etc. Utterly Rejecting and Renouncing Every Thing Wearable that comes from England* (1720).[69] "From a Boy, I always pitied poor Arachne," he confesses. "I could never

heartily love the Goddess, on account of so cruel and unjust a sentence." He likens it to the even more painful sentence of English exploitation of Ireland: "for the greater Part of our Bowels and Vitals is extracted, without allowing us the Liberty of spinning and weaving them."

Swift speculates on a boycott of materials and yarns not grown in Ireland or made there. Would that all "silks, velvets, calicoes and the whole lexicon of female fopperies" were excluded in favour of Irish stuffs. He suggests a "firm resolution by Male and Female, never to appear with one single shred that comes from England." Would Ireland then stand her own feet, this land where "the faces of the Natives, their manner and dwellings" spoke of "universal oppression"?

His counter-tract *A Defence of English Commodities Being an Answer to the Proposal for the Universal Use of Irish manufactures...etc.* (1720),[70] portrays Arachne as ungrateful, guilty of presumption and pride. Her sentence is seen as fair, as a warning against the ill-consequences of her putting her trust in herself, of contending with superiors. The stress is on the old woman's advice to Arachne: to accept her subordinate position, to obey so that the blessings given to her might not be revoked. Swift's arguments on her behalf are seen as misleading—a topsy-turvy interpretation in which he makes "Madness pass for Wisdom and Wisdom for folly."

It calls into question his account of the downtrodden, "native Irish." "They have been chastised by England with great severity; if they shared Arachne's fate it was for the same crime— Madness, Pride, Presumption." But it claims the punishment had its creative, transforming side, eliciting from them skills and sensibilities for a new world. "They have been metamorphosed not into spiders but Men—transformed from savages into reasonable creatures, delivered from a state of nature and barbarism, and endowed with Civility and Humanity."

If we have a striking picture of the violent, wounding induction of the colonized to modernity it is a double–edged one. Fiercely corroding as this force its, it is paradoxically creative: it brings into being conditions in which the colonized come to

reforge themselves as identities in a modern world.

The Swift tracts tend to leave us less sure about imagining power as a dominating force radiating outwards from a focal, colonizing source. We are alerted to the possibility of its being something like a two way, destructive/creative process—even when "the one" seems to be calling all the shots. The idea of stepping out of the "state of dependency" would not be easily grasped without taking this field of interconnectedness into account.

Swift's eye for elements of this intertwined relationship of demand/response is keen: "biass among our people," he notes, "is in favour of things, persons, and wares of all kinds that come from England." They admire English things and are attached to them, desire for foreign textiles not easily shed off—an issue not unfamiliar to Gandhi in the Indian setting. To interpret such desire simply in terms of abject dependency and collusion, as artificial and false needs, seems limiting, brittle, not least belittling. It is better to see here a field of needs and wants in interplay: they mutually define, mould and elaborate one another, often taking on a momentum of their own.

The discourses of both *Textilia* and Gandhi are not unaware of this and have to reckon with it. Their constructions of "Britishness" or "Swaraj" come face to face with a world-system of interlinking needs and wants, symbolized by the Lancashire/India connection, and, wittingly or not, are conceived in its terms.

In the post-war setting of avant-garde textile practice, by "Arachne's space" would be signalled something less than the absolutely separate and totally autonomous and something more than it. At any rate, not simply a self-enclosed space with clear-cut, fixed boundaries demarcated in straight opposition to that of Athena's. We would have to imagine it as approaching a condition not unlike that "state of débordement" with which Derrida rethinks genre:[71] a marking out of borders with their spoiling, a spilling out and beyond them, a taking into itself "its outside and other"—Athena's space.

Judy Chicago's *Mother India* is a principal landmark in this textiles field. It situates itself squarely in Arachne's space—terrain on the "other side of male-order" from where it launches its powerful critique of the actual subordination of women, the devaluing of the female body and childbirth in institutions of Indian life and living. But in drawing Athena's gaze into itself can we say it manages to turn it inside out and displace it—to make it speak about, even against, itself? Or does it simply replicate its way of seeing? A Eurocentric gaze at the heart of a feminist critique and at odds with it—deadlock of insight and blindness?

The Chicago piece stages itself through Katherine Mayo's *Mother India*[72]—a controversial report, at a high point of the Swaraj movement, on the condition of women in India, on Gandhian action for change. The Mayo work does battle with the Mother India of tradition and "obscurantism." The myth had been remobilized in the "Bande Mataram"—Hail Mother India!—movement against colonial rule. She sought to combat the forms it took in native practices attending women's health care and childbirth, to cut through the latter's "superstitious world" in the name of progress, humane medical knowledge.

The female "child-fabric"—how it is rent and ripped by the force of the Indian male-order—is the focus of Mayo's moving account of Indian women.[73] Her story is devised through figures and images which share not a little with Orientalist narratives of the colonized other. She documents shocking, unspeakable conditions. But the more harrowing the data the more everything tips over into an Orientalist fable of exotic brutalities and horrors.

Through vivid anecdotes and vignettes, a spell-binding tale of bizarre habits, practices and morals emerges which is no less "factual" for that. In querying Mayo's sources, Wyndham Lewis was to call attention to this phenomenon. It makes his critique of *Mother India* significant for our review of Athena's gaze if in other ways it simply expresses the imperial male's embarrassed defence of the "great Indian people" against the "suffragette outsider."[74]

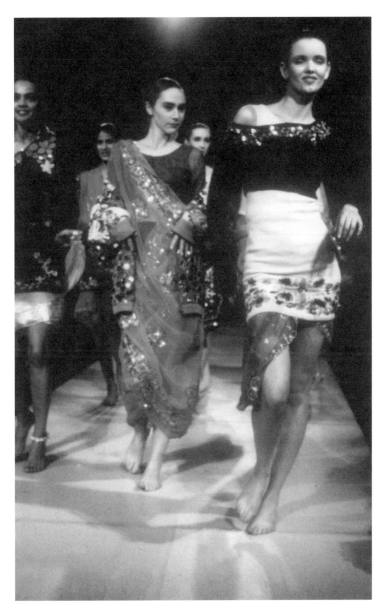

Ethnic Look, St. Martin's fashion show, 1988.
Photo: courtesy Ian Paggett.

If Mayo's insights were crucial they were also not easy to dissociate from a sense of the Western medical gaze as invasive, punitive. We see something of a collision between a traditional symbolic ordering of divisions between pure/polluted and a modern, "literal," clean/dirty hygienic code. As systems of representation they seem utterly closed off to each other, incommensurate: we reach something like an epistemic barrier.

Chicago's own focus on the "hygienic body" tends to replicate this framework. As such it seems at one with the period's forceful assertion of this stance, with Naipaul's troubling double-edged, sanitizing scan of the Indian body.[75] She notes that the hospital system for childbirth might be a questionable blessing for modern Indian women.[76] For a moment it seems she is leading up to opening a gap for a critical review of the gaze; the moment seems to slip by.

Chicago voices far more explicitly and strikingly the politics of "stepping out of dependency" than Mayo. But her desire to take "an enlightened, compassionate" view of the "Indian other's world" suggests less of that self-reflexive element with which the latter accounted for her forthright, plain-speaking and brisk "truth-telling." Mayo was putting together "living facts of India today"—however problematical such an enterprise might be. Its equivalent, a sense of the "living facts" of the post-colonial contemporary condition of women in India, appears to be the missing—at least unnegotiated—dimension of the Chicago world.

Hence the work's repetition of an array of received "sensationalized" scenes: arranged and child marriage, infanticide, sati, purdah and the like. Mayo speaks of midwives inserting balls of hollyhocks roots into the uteruses of women in labour.[77] The Chicago piece pictures them in the "Birth Scene" probing the woman's body with a whole hollyhock stem— a raising of the horror stakes, a heightening turn not out of keeping with the Orientalist mode. The decorative elements add not a little to this sense of stereotyping.

A sense of the static, unchanging "other" comes to be reaffirmed. The tendency is for the grand received text of the

Eastern world of "self-inflicted sorrows" to re-install itself. Perhaps even quite against its intentions, the piece veers towards depicting the other unremittingly as victim. It is as though everything is seen through Athena's gaze—as a world waiting to be uplifted and in which the "other" cannot speak and must be spoken for.

Against this force, to make room for this voice, Chicago tries to allude to "stepping out of dependency" by means of strips of mirror-worked Gandhian homespun. The device is perhaps too muted to mark itself off as critical, counterpointing inflection against the rest of the representation. In staging a tableau on the suffering of Indian women the Chicago piece gets inexorably caught up in an eyeball to eyeball encounter with the "Athena vision": the showdown tends to leave it somewhat transfixed by it, even captive to it.

Mayo had confronted the grand mythologies of feminine power, "Mother India" goddesses, with the desperate condition of women in India of the day. The Chicago piece, ironically, tends to take up her diagnosis and to institute it as a negative, fixed mythology. We sense little of the condition of women in the India of Chicago's day.[78]

It is as if a half-century of the story of Indian women— signposted by the popular post-independence film *Mother India*, which had such an impact across the decolonizing world, picturing a woman's and a people's struggle "to step out of dependency"—should go missing. Its upshot is to vacate the field for the unintercepted sway of Athena's gaze, blunting the vigorous sense of exposé which inspired the piece.

"Ethnic, ethnic everywhere," observes Katherine Hamnett, commenting on the late 1980s fashion textiles craze for the "Ethnic Look."[79] Its lexicon is derived from elements of "tribal raffia work and dress," references to colonial clothing, "ethnic design, motifs and decoration," pop synthetic sari fabrics, "folk-kitsch" materials, "native embroidery, bead and sequin work and stitchery." These collage into some topsy-turvy statement about "self as the other—at least, some blurring of the received demarcating lines between them. But does the

Eurocentric gaze gain a further lease of life in this masquerade, in the guise of the "Ethnic Look"?

Does the latter simply mime and endorse the former, as a straightforward mirroring and celebrating of Eurocentric textile-fashion-costume constructions of otherness? The heightened manner in which it stages its borrowed and lifted elements suggests otherwise. In parading them in a larger than life register it tends to open up a self-reflexive gap between "source and cited version," "original and copied item."

Hence the air that everything has been "expressed to the second power"—whether they are quite placed in quotation marks or not. In uneven ways the elements come to be rendered in an ironic mood. Each item—fabric, texture, threading, stitching, pleating, motif, design, imagery—is mimicked in a version which sets it all askew enough for new inflections and tones to be marked. Is it in the "Ethnic Look" that Athena's gaze is met, splintered, deflected—its codes brusquely scrambled?

Arachne's genre, where everything surges beyond its borders and overruns it in an endless referring to something other than itself may be contrasted to the self-referring character of the modernist conception of genre. At least, to the version which came to post-war pre-eminence with Greenberg.[80] For him the modernist genre, *par excellence*, involved a reductive, involuting process—a paring down by each art of the medium to its essential qualities.

The stress is on each art alluding back to the logic of its own idiom and shadowing it, divesting itself of every element of the "extra-pictorial." It amounts to a sense of the strict autonomy of each art practice—an underlining of firm boundaries and borders between them. Everything in this view of genre is driven by a self-enclosing force: to use Greenberg's words "the arts, then, have been hunted back to their mediums, and there they have been isolated, concentrated and defined."

Amongst the many reasons for this purist conception of genre, we need mention only one: "the threat" to fine art's autonomy posed by both "art in the service of politics" and the spectacular growth of mass culture forms. Strictly

defined, genre was part of a holding operation against this dynamic of dissolution. It aimed at stanching the outward flow of representation, out of its received generic confines, at curbing tendencies towards the flattening out of differences between artistic practices.

Greenberg recalled not only Lessing's Enlightenment project of defining the classic, clear-cut spheres of each of the arts against what was seen as the medieval confusion of the arts, their undifferentiated mix.[81] He echoed Babbitt's rearguard project which had appeared with high modernism. Babbitt was against the "effeminate" mixing and blending of the arts into one another in a "mélange des genres." Against their "restless striving away from their own centres toward that doubtful periphery where they pass over into something else" he sought to assert a more strict, "manly" division of the arts, "genre tranché."[82]

The "uneven undecidedness" of Arachne's genre might be seen as placed both between the world of "genre tranché" and that of a "mélange des genres"—and beyond them. Between the former's manly power, its strict demarcations and steely divisions and the latter's "effeminate" force, its yielding, submissive lines—and beyond them in something like a sexually indifferent terrain? Avant-garde textiles practice thus begins to map out an inside/outside space. An "edginess"—it cites established genres and their edges even as it cuts across and beyond them.

We would perhaps have to remind ourselves that it is not, therefore, so much a matter of elevating it from its "subordinate" place in the hierarchy of art practices, of legitimating and adding it to the official list of genres. This would be to see things simply in terms of extending the list—as if the idea were to equal or top the breathtaking range of art genres recognized in the *Kama Sutra* and *Sukraniti*.[83]

It is rather that it throws out of joint the list itself, its ordering of the arts. As a genre of "boundaried boundarilessness" it marks that protracted exit out of the modernist landscape of genres into the post-modern scene of art practices. This

uneven passage might be signposted by Magdalena Abakanowicz's invention of the "Abakan genre" which spans the years 1964-75. Hanging forms, genre between wall and floor, a "débordement" in which all genres are played and deferred, the series is perhaps best summed up by the piece *Abakan—Situation Variable*.[84]

The two orders of genre sketched by Derrida are centred on the issue of borders.[85] They might be related to the "edgy matter" Ruskin made of the borders embroidered by the Goddess and the Lydian needlewoman. A law of genre based on purity—clear demarcations of a practice's edges and boundaries. We might liken this to Athena's trim-leaved olive of peace border: measured interval, decisive, crisp outlining. It suggests a manly territorializing force constantly staking its ground, hemming in things, patrolling its frontiers to find out what belongs inside and what outside. A regulating, self-enclosing drive keen to ensure, to use Chicago's words, that "borders should not be wonky."[86] Against this, is Derrida's counter-law of genre based on contamination and impurity in which everything belongs by not belonging, scene of the undecided, unsteady. We might liken this to Arachne's border of ivy leaves with its "wanton running about everywhere," hither and thither—a dispersing, incontinent force, "genre débordé," to use Derrida's words, a "fabric of traces."[87]

NOTES

1. John Ruskin, *Complete Works* (London: George Allen, 1905) pp. 371-80.

2. Ovid, *Metamorphoses* (Cambridge: Harvard University Press, 1977) vol. 1, lines 1-145, pp. 289-99.

3. Roland Barthes, *The Fashion System* (New York: Hill and Wang, 1984) p. 42.

4. Gilles Deleuze, *Différence et répétition* (Paris: Presses Universitaires de France, 1968) pp. 36-7.

5. J.J. Winckelmann, *Reflections on Painting and Sculpture of the Greeks (1756)* (London: Scolar Press, 1972) pp. 160-1.

6. J.J. Winckelmann, *History of Ancient Art* (Boston: Marston, 1881) vol. 1, p. 162.

7. G.W.F. Hegel, *Aesthetic (1835)* (London: Clarendon Press, 1975) pp. 322-47.

8. Ruskin, p. 347.

9. Roger Fry, *Last Lectures (1933-4)* (Cambridge: Cambridge University Press, 1939) pp. 150-69.

10. Edward Said, *Orientalism* (Harmondsworth, Middlesex: Penguin, 1987) pp. 1-28.

11. Jean François Lyotard, *The Postmodern Condition* (Manchester: Manchester University Press, 1984) pp. 15-27.

12. Michel Foucault, *The Order of Things* (New York and London: Tavistock Publications, 1970) p. xv.

13. Fredric Jameson and Stuart Hall, *Marxism Today* (September 1990) pp. 28-31.

14. J. Clifford, *The Predicament of Culture* (Cambridge: Harvard University Press, 1988) p. 182.

15. Ibid., p. 256.

16. Ortega y Gasset, *Velasquez, Goya and the Dehumanization of Art* (London: Studio Vista, 1972) pp. 101-2.

17. Theodor Adorno and Max Horkheimer, *Dialectic of Enlightenment* (London: Verso, 1979) pp. 43-80.

18. Walter Benjamin, *Illuminations* (London: Fontana, 1970) p. 95.

19. Jacques Derrida, *Margins of Philosophy* (Sussex: Harvester Press, 1982) pp. 209-20.

20. Homer, *Odyssey* (London: Clarendon Press, 1932) Book XXIV, lines 114-50, pp. 496-7.

21. *Mahabharata* (Bénares: Indian Press, 1915) Chapter on Sabha Parva.

22. Marcel Duchamp, *The Green Box (1915)*. M. Sanouillet and E. Peterson, *The Essential Writings of Marcel Duchamp/Marchand du Sel* (London: Thames & Hudson, 1973) pp. 62-8.

23. Ibid., p. 43.

24. Ibid., p. 36.

25. *Textilia* (An Informative Journal of Textilian Industry and

Commerce), London, 1918-20.

26. M.K. Gandhi, *The Wheel of Fortune* (Ganesh, 1922).

27. *Textilia*, no. 1, vol. 1, July 1918, p. 2.

28. *Textilia* (Woollens, Cottons, Silks etc.); *Linen* (Organ of the Linen Trade); *British Lace* (Journal of British Lace, Embroidery & Curtain Trade); *Hosiery and Underwear; British Clothier; British Glovemaker; British Hatter.* With the April 1919 issue *Textilia* took under its wing *The British Spinner* and *The Carpet Maker.*

29. Ibid., no. 4, vol. 1, April 1919, p. 232.

30. Ibid., no. 1, vol. 1, July 1918, p. 2.

31. Ibid., no. 1, vol. 1, July 1918, p. 2.

32. Ibid., no. 2, vol. 1, July 1918, pp. 2-5.

33. "Story of the Sailor Suit," no. 1, vol. 1, July 1918, pp. 33-92; "Story of Hosiery," no. 1, vol. 1, July 1918, p. 93; "History of Hats," no. 1, vol. 1, July 1918, p. 98; "History of Lace," no. 3, vol. 1, January 1919, p. 127, no. 4, vol. 1, April 1919, p. 257; "History of Gloves," no. 3, vol. 1, January 1919, p. 146.

34. The first featured Mrs. Henry Wood, "Novelist of the Glove Trade," with reference to her novel *Mrs. Halliburton's Troubles*, no. 1, vol. 1, January 1919, pp. 143-6; the second Mrs. Gaskell, "Novelist of the Cotton Trade," in a discussion of Mary Barton, no. 4, vol. 1, April 1919, p. 185.

35. Vermeer's *The Lace Maker,* no. 2, vol. 1, October 1918, p. 76; Rembrandt's *The Syndics,* no. 1, vol. 1, July 1918, p. 7; Hals' *Man with Glove,* no. 1, vol. 1, October 1918; p. 86; Velasquez's *Las Hilanderas and Lady with Fan and Gloves,* no. 1, vol. 4, April 1919, p. 209; no. 2, vol. 1, October 1918, p. 85; Van Dyck's *The Embroidery Age,* no. 3, vol. 1, January 1919, p. 135; Titian's *Man with Glove,* no. 3, vol. 1, January 1919, p. 144; Lord Leighton's *Phoenicians Bartering with the Ancient Britons,* no. 4, vol. 1, April 1919, p. 214; Moore's *Blossoms,* no. 2, vol. 2, October 1919, p. 155. Only the Irish linen industry engravings and Spenser-Pryse's *The Workers' Way,* no. 3, vol. 2, February 1920, p. 207, go against the grain of the myth thus woven.

36. *Textilia,* no. 1, vol. 1, July 1918, p. 2.

37. Ibid., no. 1, vol. 1, April 1919, p. 50.

38. Ibid., no. 4, vol. 1, April 1919, p. 51.

39. Ibid., no. 3, vol. 1, January 1919, p. 127.

40. Ibid., no. 4. vol. 1, April 1919, p. 3.

41. Ibid., no. 1, vol. 2, July 1919, p. 3.

42. Ibid., no. 4, vol. 1, April 1919, p. 233.

43. Ibid., no. 1, vol. 2, July 1919, p. 12.

44. Ibid., no. 3, vol. 2, February 1920, p. 241.

45. Ibid., no. 2, vol. 2, October 1919, p. 135.

46. Ibid., no. 3, vol. 1, January 1919, p. 162.

47. Ibid., no. 4, vol. 1, October 1919, p. 137.

48. Ibid., no. 1, vol. 2, July 1919, p. 90.

49. Ibid., no. 2, vol. 2, October 1919, p. 137.

50. Ibid., no. 1, vol. 1, July 1918, p. 55.

51. Ibid., no. 1, vol. 2, July 1919, p. 34.

52. Ibid., no. 4, vol. 1, April 1919, p. 289.

53. Ibid., no. 3, vol. 2, February 1920.

54. Ibid., no. 1, vol. 1, July 1918, p. 17; no. 2, vol. 2, October 1919, pp. 222-3; no. 3 vol. 3, February 1920, p. 313.

55. Gandhi, pp. 8-14.

56. *Young India,* 7 July 1920, p. 29.

57. The Spenglerian grand cycles of conflict and decline in which D. Tagore places Western civilization and the Great War in his introduction to the Gandhi texts adds to the sense of a modern *Mahabharata* (pp. i-xii). See also A. Besant, *The Great War* (Theosophical Publishers, 1899). Gandhi explicitly tied the wheel (chakra) to the symbolism of the Gita section of the *Mahabharata* (*Young India,* 20 October 1921), pp. 93-6.

58. Gandhi, p. 11.

59. Ibid., pp. 24-5.

60. Ibid., p. 45 (*Young India,* 6 July 1921).

61. Ibid., pp. 2-5.

62. Ibid., p. 20 (*Young India,* 18 August 1920).

63. Ibid., p. 54 (*Young India,* 16 July 1921).

64. Ibid., p. 78 (*Young India,* 10 November 1921).

65. Ibid., p. 12.

66. Ibid., p. 8.

67. Ibid., p. 6.

68. Ibid., p. 27 (*Young India,* 7 July 1920).

69. Jonathan Swift, *Irish Tracts (1720-3)* (Oxford: Basil Blackwell,

1948) vol. IX, pp. 15-22.

70. Ibid., pp. 269-77.

71. Jacques Derrida, "Living on Borderlines," *Deconstruction and Criticism,* RKP, 1979, pp. 75-176 and "The Law of Genre," *Glyph, 7,* 1980, pp. 202-32.

72. K. Mayo, *Mother India* (London: Jonathan Cape, 1935) pp. 76-98.

73. Ibid., p. 51.

74. W. Lewis, *Paleface* (London: Chatto & Windus, 1929) pp. 289-300.

75. V.S. Naipaul, *India: A Wounded Civilization* (London: Deutsch, 1977).

76. Judy Chicago, *Birth Project* (New York: Doubleday, 1985) p. 180.

77. Mayo, pp. 80-3.

78. Even though she mentions three works on post-war India (1985, p. 231).

79. L. White, "The Empire Strikes Back," *Vogue,* no. 6, vol. 153, June 1989, p. 168. Also see *L'Image,* no. 2, Summer 1989, pp. 42-3.

80. Clement Greenberg, *Towards a Newer Laocoon, the Collected Essays and Criticism,* vol. 1, 1939-44. (Chicago: University of Chicago Press, 1988) p. 88.

81. G. Lessing, *Laocoon* (1766) (Indianapolis: Bobbs-Merrill Publishing, 1977).

82. I. Babbitt, *The New Laocoon* (Boston: Houghton Mifflin, 1910) pp. viii, 159.

83. Vatsyayana, *Kama Sutra* (Taraporevala, 1961), pp. 75-80; Sukracharya, *Sukraniti* (Manoharlal Publishers, 1975), pp. 156-60.

84. *Magdalena Abakanowicz* (Chicago: Museum of Contemporary Art, 1983) pp. 45-50.

85. Derrida, *Margins of Philosophy,* pp. 201-10.

86. Chicago, p. 133.

87. Derrida, "Living on Borderlines," p. 82.

IV. RECONSIDERING TRADITION AND HISTORY

The Unravelling
of History:
Penelope and
Other Stories

Ruth Scheuing

Perceptions of mythological figures shift throughout history and reflect how we, as a society, ascribe value to certain behaviour. As a whole, stories from classical Greece and Rome promote values that support patriarchy. Nevertheless, individual accounts challenge our assumptions about past cultures. I will address the intersection between actual stories about weaving and the way in which history is told and retold.

My focus for this paper are three characters in early Greek myths: Penelope, Arachne and Philomela. Their weaving enabled them to assert their own wills against a dominating power structure, for which they were either punished, maligned, misrepresented or, even worse, forgotten in historical records. They all used weaving as a language to communicate—in each situation, weaving is more strongly connected to storytelling than it is to domestic needs.

All media are charged with their own history. Many artists who use textiles have attempted to use it as a "neutral" medium, similar to any other in the visual arts. But material implications continue to affect the work and how it is perceived. It is

important to analyze what influences readings of textile art in order to establish a critical context for discussing works on a conceptual level. The rise of the Fibre Art movement during a modernist era initiated great exuberance, but also resulted in a split between textiles and its history and social place. Today, within postmodern and feminist discourses, textiles has an interesting role to play, and the consideration of its historical role is relevant. Because it is primarily women who are involved in the production of textiles, implications of this challenge reach outside the strict confines of a textiles dialogue, as they reflect attitudes of women and toward women and their activities.

Textiles are part of everyday life, each in its own distinct manner. Some provide for physical needs only, some contribute to rituals or religious activities and, in many instances, textiles communicate power and status, as well as political, social and cultural allegiances. Western culture, with its division into high art and craft, has tended to similarly contextualize all textiles.

My investigation into textiles began with the following quote by Roland Barthes:

> *Text* means *Tissue*; but whereas hitherto we have always taken this tissue as a product, a ready-made veil behind which lies, more or less hidden, meaning (truth), we are now emphasizing, in this tissue, the generative idea that the text is made, is worked out in a perpetual interweaving; lost in this tissue—this texture—the subject unmakes himself, like a spider dissolving in the constructive secretions of (her) web. Were we fond of neologisms, we might define the theory of the text as an hyphology (hyphos is the tissue and the spider web).[1]

The representation of goddesses as weavers or spinners exists in many cultures. They are "Spinners of the Thread of Life" and "Weavers of the Tapestries of Life and Death"[2] and also "Goddesses of Fate."[3] Spinners appear as powerful, and sometimes helpful, sometimes dangerous witches in fairy tales. Today, in contemporary science fiction, writers enter

metaphorical tapestry to alter past events.[4]

The early Greek period is a time of transition in which the male pantheon dominated by Zeus consolidated its power over earlier belief systems, and weaving, as a goddess's attribute, had become suspect. I wanted to find out how the value system that has become the foundation of Western culture was established.

Although I did not initially see her as a heroine, Penelope became a pivotal figure who I now think of as a real person, an artist, a weaver and a friend.[5]

> **Penelope** My power as a woman and weaver emerged as I worked not by consciously thinking of it.... I simply concentrated on the task: the doing by day, the undoing by night, in never-ending rhythm. This gave me focus and discipline to continue year after year... the creation of beauty and the undoing of it. Both (are) equally challenging, a changing story, a changing weave, forever new, forever undone.[6]

Penelope's palace was invaded by numerous suitors, who demanded that she choose a new husband from among them. She said that she would do so after finishing her weaving and she stalled them for three years by weaving in the daytime and unweaving her day's work each night. Odysseus, her husband, had been gone for twenty years, ten of them spent in the Trojan War and another ten years at sea, in treacherous water, cursed by the gods. During this time Penelope waited and reigned in his stead. Her action or non-action has been interpreted in many different ways throughout history. In more ancient myths, her name means "she who tears out threads,"[7] connecting her with the ancient powers who controlled destiny by weaving threads, the Goddesses of Fate. Her refusal to cut the final thread or finish the work led to the unspoken assumption that she controlled the life of her husband. Her actions seem less heroic than Odysseus's, but she persevered without bloodshed while Odysseus "solved" things quickly and brutally by slaughtering all the suitors.

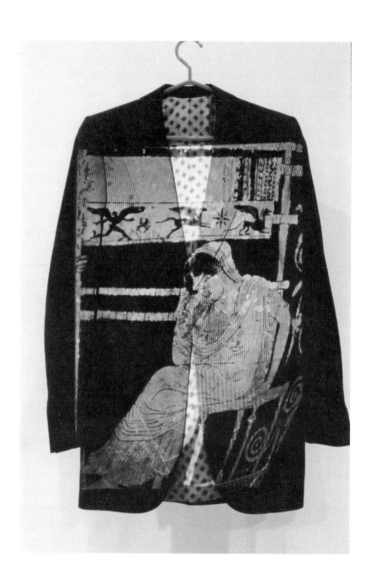

Ruth Scheuing

Penelope (detail), 1991.

Projected image on altered man's suit.

Photo: courtesy the artist.

Homer describes Penelope and her work as follows:

> Here is one of her tricks: she placed her loom,
> her big loom, out for weaving in her hall,
> and the fine warp of some vast fabric on it.
> ... so every day she wove on the great loom—
> but every night by torchlight she unwove it,
> and so for three years she deceived the Akhaians.[8]

Penelope lived during the Bronze Age, a period associated with shifting roles between women and men. The legends from this time are pervaded with powerful female figures, such as Clytemnestra, Hecuba, Andromache and Penelope.[9] Women such as Penthesilea, Helen, Cassandra, Antigone, Electra, Medea and Phaedra have powerful and tragic roles, although they may not accurately represent everyday life for all women.[10] But they do demonstrate characters who make decisions and who use personal power to achieve their goals.

Penelope became the model of the faithful Christian wife. Robert Greene's 1587 poem "Penelope's Web," is subtitled "wherein the Christall Myrror of faeminine perfection represents those vertues and graces which more curiously beatifies the mynd of women... namely Obedience, Chastitie and Sylence."[11] In Greene's story, Penelope tells several long, moral and entertaining tales to the women who surround her while they all weave, illustrating these "ideals" for women's behaviour. As a subtext, we get the impression of an educational rather than domestic setting.

Penelope is not the only weaver in *The Odyssey*; in fact several women challenge and help Odysseus and most of them are weavers who live independent lives and make their own choices: Io, Calypso, Circe, Helen, Arete, the Sirens and of course Athena. The goddess Io gives Odysseus the veil that saves him from drowning:

> Do what I tell you,
> Shed that cloak, let the gale take your craft,

and swim for it ...
Here: make my veil your sash; it is not mortal;
you cannot, now, be drowned or suffer harm.[12]

Calypso and Circe are both weaving when Odysseus and his men arrive; both are powerful women, one a goddess, the other a nymph. They reign on their own islands and challenge or seduce travelling heroes. Both likely wove a few spells into their webs. Circe who turned Odysseus's men into swine is introduced here:

> They heard the goddess Circe. Low she sang
> in her beguiling voice, while on her loom
> she wove ambrosial fabric sheer and bright,
> by that craft known to the goddesses of heaven.[13]

> Divine Calypso, the mistress of the isle, was now at home.
> ... in her sweet voice, before her loom a-weaving,
> she passed her golden shuttle to and fro.[14]

When we meet Helen in *The Iliad*, she is weaving a tapestry depicting the Trojan War. It has been suggested that all the scenes that the narrative that follows comes from her tapestry, that she is the weaver/author of the whole story.[15]

> She (Iris) found her weaving in the women's hall
> a double violet stuff, whereon inwoven
> were many passages of arms by Trojan
> horsemen and Akhaians mailed in bronze-
> trials braved for her sake at the argod's hand.[16]

Other women weave in Greek mythology to assert their positions. Often, they use their power more overtly than Penelope and are punished for it. But they choose weaving to give voice to their ideas.

Arachne is generally remembered as the mortal woman who challenged Athena to a weaving competition and subsequently

produced the finest piece of weaving. She was punished by Athena for this and transformed into a spider. But what did Arachne weave, to deserve such treatment? Ovid, in *Metamorphoses*, tells the story of Arachne, describing, in vivid detail, her tapestry which contained twenty-one instances of "seductive deceptions," or rapes, committed by the Olympian gods. It is important to point out that he describes them very much as deceptive actions:[17]

> Arachne, of Maeonia, wove at first
> The story of Europa, as the bull
> Deceived her, and so real was her art,
> It seemed a real bull in real water
> ... and she wove Asterie seized
> By the assaulting eagle; and beneath the swan's
> White wings showed Leda lying by the stream.[18]

Athena weaves a tapestry that represents the symbols of her power that gave her name, rather than Poseidon's, to the city of Athens. When Athena sees Arachne's work:

> Minerva (Athena) could not find a fleck or flaw—
> Even Envy can not censure perfect art—
> Enraged because Arachne had such skill
> She ripped the web, and ruined all the scenes
> That showed those wicked actions of the gods
> And with her boxwood shuttle in her hand,
> Struck the unhappy mortal on her head.[19]

"Arachnology" is a term created by Nancy Miller in response to Barthes' use of "hyphology."

> By arachnology, then, I mean a critical positioning which reads against the weave of indifferentiation to discover the embodiment in writing of a gendered subjectivity; to recover within representation the emblem of its construction.[20]

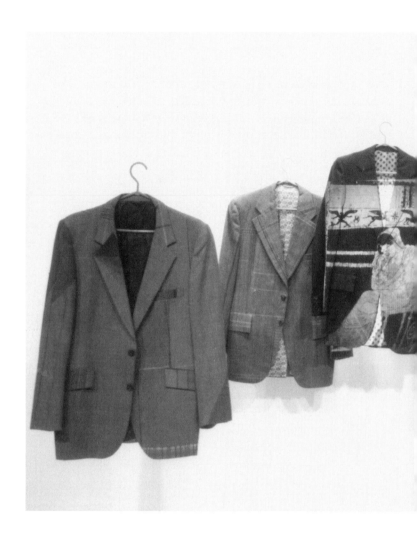

Ruth Scheuing

Penelope, 1991.

Altered men's suits with slide projections
and soundtrack, 365 x 150 x 90 cm.

Done in collaboration with composer Marc Patch.

Photo: courtesy the artist.

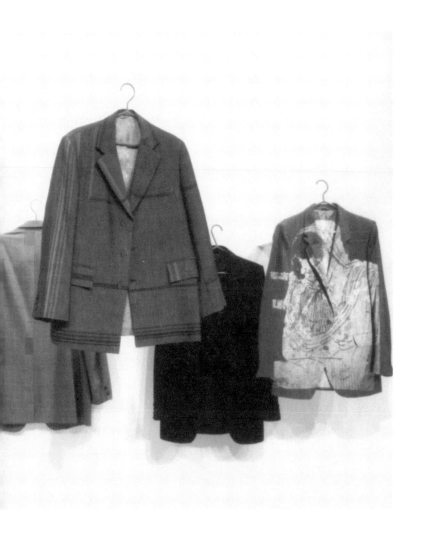

Arachne began as a woman weaver of texts, but punishment transformed her; she was rendered voiceless, her body destined to weave webs. The communicative power of her weaving was removed and she is remembered only as a spider; her story is forgotten or ignored by history.

Philomela's story shows an act of silencing overcome through weaving. Thereus, her sister's husband, raped Philomela and afterwards cut out her tongue to silence her. So Philomela weaves her story into a coat to tell her sister of this horrible act. Such a simple domestic "meaningless" activity easily passed the scrutiny of her jailers. Her sister understood her message, saved her and together they avenged Thereus.

> What could Philomela hope or do?
> ... Prevented flight and mutilated, she
> Could not communicate with anyone
> ... Spreading the Thracian web upon the loom
> She wove in purple letters on white cloth,
> A story of the crime: and when 'twas done
> She gave it to her one attendant there
> And begged her by appropriate signs to take
> It secretly to Procne. She took the web
> She carried it to Procne, with no thought
> Of words or messages by art conveyed.[21]

Today we do not hear these stories: it is as if these acts of defiance did not exist and Philomela, Arachne and Penelope remain muted. Feminist critics such as Nancy Miller and Patricia Joplin Klindienst have explored the idea of women using weaving as language to tell their stories, as a tool to obtain control over their own destiny. Weaving is more than a symbol for language, as Miller and Joplin argue, it is also a symbol for the gendered nature of language and a means of resistance. Patricia Joplin Klindienst makes this point in an article entitled "The Voice of the Shuttle is Ours":

In the middle we recover the moment of the loom, the point of departure for the woman's story... revenge, or dismembering, is quick. Art, or the resistance to violence and disorder inherent in the very process of weaving, is slow.[22]

Philomela refuses her status as mute victim.... When she transforms her suffering, captivity, and silence into the occasion of her art, the text she weaves is overburdened with a desire to tell. Her tapestry not only seeks to redress a private wrong, but should it become public, it threatens to retrieve from obscurity all that her culture defines as outside the bounds of allowable discourse, whether sexual, spiritual, or literary.[23]

These three stories demonstrate how greatly accounts of weaving differ from perceived stereotypes. Philomela communicated privately in a secret language with her sister, but she also communicates to us today through her weaving. Arachne, by comparison, expressed her ideas to a large public of her contemporaries, but today we get only a diminished version. She is presented as vain, or proud or the silent spider, and the narrative content of her tapestry is largely ignored. Penelope used the process as an act of defiance. The content of her weaving seemed secondary, but the mystery remains: Did she reweave daily the same images or patterns or did she make changes? The suitors certainly did not notice any changes. Penelope was discovered only because one of her women helpers told the secret. Today such subtle changes in a tapestry may still go unnoticed—it is therefore crucial to create situations, as Penelope did, to suit individual needs.

NOTES

1. Roland Barthes, *The Pleasure of the Text* (New York: Hill and Wang, 1975) p. 64.

2. Buffie Johnson and Tracy Boyd, "The Eternal Weaver," *Heresis*, pp. 64-68.

3. Erich Neumann, *The Great Mother*, Bollingen Series 47, translated by Ralph Manheim, (New Jersey: Princeton University Press, 1991) pp. 226-239.

4. Piers Anthony, *With a Tangled Skein* (New York: Ballantine Books, 1985).

5. I started to dismantle the fabrics of men's business suits as literal, physical "deconstructions" of a patriarchal symbol. By cutting and pulling out individual threads I could alter existing pattern structures and replace them with my own, often decorative designs. The invisible manner in which these textiles communicate became visible. This subtle, subversive act was influenced by Penelope's "stalling" tactic.

6. Ruth Scheuing, *Penelope*, text from a performance in collaboration with composer Marc Patch, 6th Biennale de la Tapisserie de Montreal, 1991.

7. Paul Kretschmer, *Penelope* (Anzeiger der Akademie, 1945) p. 80.

8. Homer, *The Odyssey*, translated by Robert Fitzgerald, (New York: Anchor Books Doubleday, 1963) book 24, lines 130-140.

9. Sarah B. Pomeroy, *Goddesses, Whores, Wives, and Slaves: Women in Classical Antiquity* (New York: Schocken Books, 1975) p. 17.

10. Pomeroy, *Goddesses*, pp. 94-119.

11. Robert Greene, "Penelope's Web", 1587. *Life and Complete Works in Prose and Verse*, Vol. 6 (New York: Russel & Russel, 1994).

12. *The Odyssey*, book 5, lines 337-42.

13. *The Odyssey*, book 10, lines 220-23.

14. *The Odyssey*, book 5, lines 65-67.

15. Homer, *The Iliad*, translated by Pope, book 3, lines 125-30. This is a very agreeable fiction, representing Helen weaving into a large veil or piece of tapestry, the story of the Trojan War. One might believe that Homer inherited this veil, and that his *Iliad* is only a narrative based on Helen's admirable piece of art. (Dacier)

16. *The Iliad*, book 3, lines 125-130.

17. Later depictions of rape, particularly in Renaissance paintings, become an excuse for the depiction of naked women being manhandled or bravura depictions of painted flesh.

18. Ovid, *Metamorphoses*, translated by More, (Francetown NH: Brewer M. Jones Co, 1978) book VI, line 105-112.

19. Ibid, book VI, lines 13-136.

20. Nancy Miller, "Arachnologies: The Woman, the Text, and the Critic" in *Subject to Change: Reading Feminist Writing*, Nancy Miller, ed., (New York: Columbia University Press, 1988) p. 80.

21. Ovid, book VI, lines 575-587.

22. Patricia Joplin Klindienst, "The Voice of the Shuttle Is Ours" in *Stanford Literature Review 1*, (Spring 1984), pp. 46-48.

23. Ibid, p. 43.

Crimes Against Nature

Neil MacInnis

I am light-headed, my heart is pounding. I am in the Textile Department at the Art Institute of Chicago, viewing eighteenth-century French embroidered-silk waistcoats. The research assistant has informed me that I am not to touch the pieces. I wonder why it is that more boys my age aren't also interested in these French silk delicacies, which are as good as any difficult puzzle in physics or the workhorse of an engine found in a 1960s Volvo station wagon. Several pieces in the collection affect me so strongly I feel as though I might vomit in excitement or faint before their lovely presence. I want to consume them, their flesh to become my flesh, as though every ounce of their colour and luminosity could be deployed to sate some lifelong yearning inside me.

It must have been the indisputable gorgeousness of French Rococo silk woven textiles that first excited and gratified the visual appetite of my mind's eye. But I might also have been attracted to their illustrious history knowing that the mastery of sophisticated hand-craftsmanship demonstrated in these textiles has seldom since been rivalled. Certainly, one is denied a truly Rococo experience without the benefit of viewing them in their original architectural settings, *in the flesh*. Both the effervescent palette and gardenesque vitality sparkle today as brightly as they must have two hundred years ago. Only by feigning gross ignorance can the indulgent viewer enjoy a

strictly pleasurable encounter with these alluring but difficult textiles. This is not to say that certain attributes of Rococo textiles are not occasionally appreciated, though in the general public's consciousness they tend too readily to elicit disdainful sentiments including charges of corruption, cruelty, indulgence, frivolity, decadence, waste, excess and, as we shall see later, absence, denial, dishonesty and perversity. What could be more justifiably worthy of contempt within the current social order than the empty and useless frivolity of self-indulgent beauty for its own sake?

I wish to examine why the act of sodomy and its accompanying, sexualized but shamed organ, the anus, have come to represent the bodily site at which repression/oppression is perpetrated through the practices and policies of religious, judiciary, governmental and societal institutions. This preliminary investigation is intended to bring forth insights concerning the problem that hate-crimes present for constituents of various Queer communities in both urban and rural settings across North America. When considering the volatile debates between the liberal left and the conservative right, regarding such basic civil rights issues as discrimination on the basis of sexual orientation, the debates must be grounded in an historic framework. Such a framework would expose the means by which rhetorical systems have been constructed, systems that have ultimately sanctioned violent acts against persons because they are perceived to be Gay/Lesbian/Dyke/Queer/Transgender, etc.

The premise of this text postulates a series of links, even fictitious links if necessary, in order to triangulate the complex histories of textiles, sexualities and technologies. French Rococo textiles constitute a poignant genre against which to speculate about an historically informed reading of certain contemporary subjects. The official dismissal of the Rococo period and its cultural production, typical of much twentieth-century art historical discourse, resonates with other subjects in which a rabid moral contempt or snide indifference also succeed to squelch efforts toward more serious examination. The parallel use of language that condemns both the Rococo *and* homosexuality is certainly more than merely coincidental.

How appropriate it is, then, to entertain a discussion and an examination of certain aspects of contemporary Queer sexuality in view of the flamboyant and dynamic aid provided by the example of French Rococo silk woven textiles.

A hole is the site. The site of the hole may be known, or it may be forgotten and difficult to name. The site of the hole conceals a darkness and in this darkness I am not able to see, nonetheless I may know that I am within it. The hole that does not speak, that will not tell a story. The hole that does feel, nonetheless. It is through this hole that I may come to worship, and through which I may be sacrificed. Persecuted. Martyred. Ostracized. Into this hole my defiled corpse will be thrown. Into the dark, not to be seen, not to be heard from, forgotten and buried. The well of denial, deep and cold, treacherous and merciless. The hole has become a proscriptive site, a locus of male heterosexual virginity. Why is this shamed hole the scapegoat for such brutal crimes committed against the name of Sodomy? Crimes that can never be reconciled with the inconspicuousness of this organ's anatomy, its virtual innocence. I am pitted against nature, the original site of my voluptuous sexuality.

Only recently having been classified by police and government as a category of hate-crime, statistics demonstrate an alarming and increasing incidence of violence perpetrated on persons because they are perceived to be gay, lesbian and transgendered. Of course, the assignation of recognizable identities to gays and lesbians in a social context plays a primary role in the process of singling-out through which we become the targets of hate-crimes. Prior to the early 1990s, the prevailing sentiment among administrative bodies working on behalf of municipal police forces, provincial, state and federal court systems and emergency wards in hospitals was that the abuse, harassment and murder that gay people have been subjected to, *goes with the gay lifestyle*. Which is to say that the "gay lifestyle" is known for its perversity, self-indulgence, excess, corruption of nature, brutality, exploitation, decadence, heathenism and risk. Perpetrators of hate-motivated murders often believe their crimes fulfill a

valuable service to society. A majority of these perpetrators are middle class, white males under the age of twenty-one. If they are indicted for their crimes, they are often granted lenient sentences and sometimes they are not prosecuted at all. Using the defense of "homosexual panic," lawyers who represent them claim that violent behaviour is a normal heterosexual male response to the threat posed by the sexual invitation that the company of a homosexual male naturally implies.

> **Detroit, MI.** On March 9, 1995, Scott Amedure was shot twice in the chest with a 12-gauge shotgun at point-blank range in his suburban mobile home, three days after the taping of a segment of the nationally syndicated *Jenny Jones* television show. The topic program was "secret crushes." Amedure's killer, Johnathan Schmitz, was the man who appeared with him at the taping and was surprised at being the object of Amedure's attraction. In his statement to police, the killer said, "He's gay, but I'm not... That's why I did it. I went on the *Jenny Jones* show and [he] called me a crush. I didn't know it was a guy and that's why I killed him." (Triangle Foundation)

Like the aristocracy of eighteenth-century France, who engaged in a scandalous yet popular roster of strategies and rituals in pursuit of their frequent, esteemed sexual liaisons and intrigue, today a formulaic or definitive expression of sexuality remains elusive. So popularized was sex during the Rococo (despite the use of discretionary coding in public discourses), philosophers of the period designated pleasure and love as the most exalted of human endeavours. Concurrently, the French aristocracy abandoned their faith in Christianity and God, instead embracing models of Deism and Nature as systems through which to exercise philosophical inquiry. It was also during the eighteenth century in Europe that the profession of law was increasingly disentangled from the jurisdiction of the churches, while its site of practice became increasingly identified with that of the state. The phrase, "homosexuality is a crime against

nature," attributed to eighteenth-century British jurist William F. Blackstone, was popularized in England, where society had been technologically jump-started in advance of its French rival. The inspiration for Blackstone's profoundly influential and equally paradoxical truism was nurtured for centuries in biblical doctrine based on very few actual citations, such as those perhaps mistakenly cited in the story of Sodom and Gomorrah, or as in some of the prohibitions listed in Leviticus:

> If a man lies with a male as with a woman, both of them have committed an abomination; they shall be put to death, their blood is upon them. (Leviticus 20:13)

What is more apparent in the subject matter depicted in Rococo textiles, furnishings, decorative treatments, sculptures and paintings than the subject of Nature itself? And what is Nature but the effusive and colourful display of systems and organisms whose flourishing livelihood may suddenly be annihilated by the random effects of one force on another? Long considered decorative *and* meaningless, the symbolic value of subject matter represented in much of the Rococo period's artworks signified an anti-classical response to the long-standing academic tradition of Christian and allegorical art that had been popular since the Renaissance. The Rococo was condescendingly named after that form in nature so variously deployed in its representational and decorative schemes—that of the shell, or *rocaille*. Most art of the period, whether painted, sculpted or decorative, reflects an obsessive preoccupation with an infinite variety of heart-felt sentiments wrought from the irresistible titillations of desire. The French aristocracy, for whom these interiors were designed, enacted in them the social mechanics of entangled relationships through which games of sexual pursuit and social intrigue came to fruition. Since Nature itself had replaced God as the location from which an exploration of spiritual meaning would take place, so these interiors would serve as the indoor manifestations in which Nature was invited to exert her

powerful and intoxicating influence over their occupants.

The contradictory and conflicted problems that histories of sexualities raise are neither more nor less a challenge for today's thinkers than for those of the Rococo period. The Marquis de Sade, an exemplary figure against which to further examine this conjunction of Rococo debauchery and postmodern hate-crimes, is well known today in the West, yet seldom read. As expressed in de Sade's copious *oeuvre*, the author's proclivities (at any rate, the author's fantasy) for sexually perverse violent dramas, as well as his maniacal repertoire of manipulations for controlling victims, are located all over the map that we call sexual orientation. It was the Marquis de Sade, after all, who theorized that the essential act of Nature is murder, since the essence of Nature itself is abomination and brutality. The viewer may be startled to observe the premonitory aesthetic of patterning in Rococo textiles, grotesqueries whose spilling, lunging and curling flora strike an alarming similarity to the patterns formed by the organs of eviscerated corpses, the victims of sexually violent murders. Subsequently, industrialization and the modernization of medicine encouraged the proliferation of surgically examined and internally exposed human bodies, remanifesting the public's interest in this type of fantastical imagery.

Humbolt, NB. John Lotter and Marvin Nissen have been charged with the three execution-style homicides of Teena Brandon (a female to male transgendered person) and Brandon's friends Lisa Lambert and Philip Devine, on the night of December 31, 1993. Brandon had passed as a man and dated girls in the small Nebraska town before being "outed" as a female by local authorities. After the outing, Brandon was kidnapped and sexually assaulted by Lotter and Nissen; however, local police refused to arrest either man for the well-documented assault. A week after reporting the rape, Brandon and the friends with whom he was staying were murdered. After the murder, Lotter and Nissen were belatedly charged with the abduction and rape. Local officials have refused to consider the case bias-motivated

and have publicly referred to the victim as an "it." (New York City Gay and Lesbian Anti-Violence Project)

It is estimated that the average person, upon reaching the age of high school graduation, has witnessed 13,000 real or simulated deaths and more than 100,000 acts of violence on television. It is not surprising, then, that some of the most difficult and socially charged debates under discussion today include disagreements concerning the representation and exhibition of sexually explicit visual material or material that depicts or documents violent acts of behaviour. Contemporary S/M practice problematizes our expectations about this relationship between sexuality and violence (or, pleasure and pain) because the axiomatic function of consensual agreement allows its constituents to engage in a stylized expression of so-called violent behaviour. Negotiations facilitate a bond of trust upon which the desired exchange unfolds within agreed-upon boundaries, thus constituting the means by which many S/M practitioners secure a mutually satisfactory scene. S/M practice resonates deeply outside its sub-cultural context, challenging and confusing a broader non-participating public who cannot distinguish between it and non-consensual violent crimes.

The carnage of a gory murder goes a long way toward reminding citizens that danger is promised should they commit a forbidden, punishable act or by being in the wrong place at the wrong time. Eighteenth-century France, contrary to its English rival, demonstrated a significant statistical decrease in the incidence of officially sanctioned, brutal public mutila- tions and executions perpetrated on homosexuals charged with the crime of sodomy. The nineteenth-century bourgeoisie, whose evolution was strongly rooted in the previous century, promoted a less tolerant agenda regarding sexual relations. Unlike their aristocratic predecessors, and with rising economic status and its commensurate share of power, they sought to re-establish a formulaic but vague morality. Their legacy is a history of legalized persecution that continues to legislate sexuality to this day. The attitudes of the new bourgeoisie

were informed by an earlier and more familiar model developed from Christian traditions and biblical examples with which they were more comfortable. The insistence upon Godly-styled procreation as the real purpose of sex may have resulted from both a general public fear of decreasing numbers in population counts and/or a philosophical and spiritual rigidity that better served the single-mindedness often required for an individual to rise from one class to the next during hard economic times.

Butthole. Fuckhole. Poopshute. Ramhole. Cornhole. Shitter. Asshole. Boy pussy. Glory hole. Anus. Rectum. Manhole. Scat shack. Pokehole. Fuck that hole. Fuck it good. Fuck it hard. Shove that cock up my ass. Pump it. I want your cock deep inside me. Pound my hole. Ram it. Fuck that hole. Fuck it good. Keep going, yeah. Fuck me hard. I want you to shoot your load inside me. Work that hole. Fuck it good. Fuck that hole. Eat it. Greek me. Lick it. Fuck it. Eat it. Fuck me. Fuck it. Fuck me. Fuck me.

Numerous motifs that were popularly depicted during the Rococo period survive today, having assumed an ironic usage as culturally animated signifiers in certain areas of social trafficking. Wreaths, once commonly used to celebrate crowning achievements, ritualized the joy of victory or the promise of love, are now regularly seen in both funerary rituals and settings. Bows, sashes, garlands, palls, urns and obelisks all remain active through continued use, also in the funerary realm, popularized as such during the Victorian era. Even the faddish phenomenon of tattooing and piercing evokes images of shoppers flocking to purchase the latest powdered wigs or have their faces painted with stars, moons and hearts. The stifling abundance of trappings that mark the commodifying obsession with which love and leisure were enculturated during the Rococo established a precedent for what is now a similar contemporary preoccupation. Where almost anything floral has come to stand for a perversely limited version of femininity and sentimentality, the strategy of decorative flora was fully employed in Rococo textiles to create some of the most dynamic and harmonious compositions executed in European

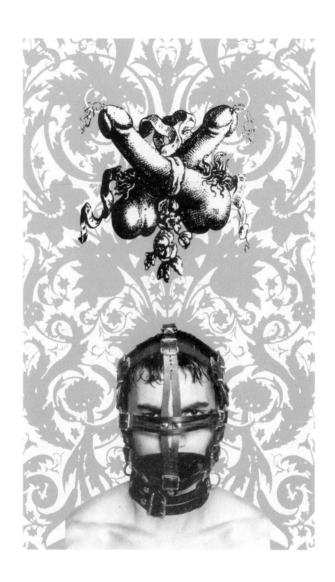

Neil MacInnis

Crimes Against Nature, 1998.

Digital media, 5 x 7".

Photo: courtesy the artist.

pictorial history. The design and creation of Rococo decorative textiles constituted a "fine art," usually produced by the labour of skilled middle class artisans, and as such were worn and esteemed by both males and females of the middle and upper classes, as well as by those people employed to serve them. Enhancing sartorial rites of beautification, Rococo textiles provided an essential tool for the ritualistic practice and perfection of the period's most fashionable entertainments. Since the aristocratic class had been increasingly stripped of its governmental and militaristic responsibilities at the hands of an ever-growing bourgeoisie, their fanatical commitment to a protocol of intricate social choreographies satisfied the need for a sense of purpose. Their alienation from the French public was further exacerbated when Louis XIV relocated the French court to Versailles, outside of Paris, away from the centre of swiftly changing urban development.

The popularity of cross-class social events seen in molly houses and at masquerade balls constituted a widespread phenomenon during the eighteenth century. While molly houses usually catered to a newly formed and publicly self-identified gay male clientele, notorious for their transvestism and effeminacy, masquerades were attended by people of all sexual persuasions. Encounters initiated at masquerades often spilled over into local city parks, under the cover of darkness where one might frolic undetected later in the evening. Meanwhile, the emergence of molly houses effected considerable influence on the development of a distinct society of homosexual individuals who were socially and publicly motivated, particularly by their sexual interests. Eventually the popularized effeminacy of molly house patrons and the debauched attendees of the masquerade, including its celebrated homosexuals, became confused in the minds of the bourgeoisie with the excesses of the aristocracy. Even heterosexual men who openly expressed their sexual interests came to be regarded as effeminate, like women, accused of over-indulgence in the frivolities of love and pleasure. Dressing up was so widespread a practice, particularly

among the French, that many surviving narratives relate the stories of both men and women who passed as their transgender peers for reasons spanning a range of purposes from pleasure to business.

I am a pansy-faggot. I am a fleurette. I am a pussy boy. I am a fee-fee. I am a radical faerie. I am a fruit. I am a gear-box. I am a nelly queen. I am a nancy. I am a Queer. I am a fucking faggot. I am a fibre-fag. I am a pervert. I am a social deviant. I am sick, deranged, possessed by the devil. I am damned to hell. I am a drag queen. I am androgynous. I am weak. I am a sissy. I am a ninny. I am a brain. I am a girl. I am a boy. I am not a man. I am not a real man. I am butch. I am trade. I am chicken. I am a tappette. I am a bottom. I am a top. I am trash. I am a cock and ball-torturer. I am a piss-freak. I am a cock-sucker. I am a dyke, if I had a cunt. I eat shit. I am a child molester. I am (my own) hairdresser. I am creative. I am sensitive. I am well-groomed. I am one in ten. I am different.

Having enjoyed enormous popularity in eighteenth-century France, pornographic literature was printed and disseminated among an audience of unprecedented size. *Romans érotiques* (novels), and erotic images both depicted an array of events, acts, personages, mythical figures, narratives and oddities. Myriad variations on the themes of coupling, trios and orgies were popular. Pornographic images often depicted highly stylized arrangements of decorative systems incorporating sexualized motifs. The highly satirical novels and images contributed to the development of the modern concept of the individual, who was both their subject and reader. Pornographic novels were the domain of a leisured class who not only had the time and the education necessary to read them, but also the social autonomy required to indulge in their enthralling contents without the threat of recrimination. It is not surprising then that many Rococo images contain provocative scenes that arouse embarrassment and disdain even today. Clergy, as notoriously corrupted then as they are purported to be today, are seen in disturbing exchanges that challenge boundaries of acceptable human behaviour. Other

period images illustrate historical interpretations of mythical and heraldic figures such as "flying penii," similar to those seen in earlier sculptural examples from Greek and Roman antiquity. Motifs such as the penis in flight, so frequently represented in the eighteenth century, evoke the lore of archaic agrarian societies in which practitioners cut off their genitals as a gesture of worship, a sacrifice to Mother Earth.

> **Chicago, IL.** On December 18, 1993, a transvestite was stabbed thirty to forty times in his bathtub by a man he had picked up and brought home. The perpetrator cut off the victim's penis and shoved it in his mouth. After being arrested, he claimed that he was upset to find that the victim was really a man. (Horizons Anti-Violence Project and Cook County State's Attorney's Office)

As discussed in the case of the decorative arts, moralizing language that services a history of discourses addressing this pornographic material is intended to incite the impulse to censor rather than to emphasize the transgressive potential engendered in these genres of representation. The increasing popularity of Rococo pornography predates important later trends, especially with the advent of photography and the significant factor that pornography constitutes an important component of photography's early and developing history. While the trappings of the Rococo are identified today as the cumulatively excessive property of a corrupt class, so they also constitute the last significant stage of hand production before industrialization, marking a basic repertoire in which may be seen a preliminary inventory of modern society's possessions and aspirations. The success of molly houses and masquerade balls, in addition to the increasing ability to rapidly reproduce images, texts and objects, began to play an important role in the formation of distinct groups of people who were represented by and participated in the production of these identity-shaping materials. The complex link that associates the homosexual in popular consciousness with the textile practitioner may appear to be a superficial sexual

stereotype. There is, however, a verifiable history of homo-
sexual textile practice as there are certain professions
popularly associated with figures known to be homosexual.
Additionally, there are problems raised when considering the
presence of a large male workforce employed in the clothing
trade, for example, as was the case until the time of the
industrial revolution during which "fashion" came to be
regarded, in the modern sense, as a distinctly *feminine* pur-
suit. Consequently, the social perception of those men working
in what would become high fashion, who might not have
been homosexual at all, was subjected to an increasingly
effeminized identification. While female fashion maintained
its ethos and practice of innovative decorative adornment
contrasted with *décolletage* and exemplified by centuries of
leading French tastes, male clothing progressed toward
simpler garments that streamlined an outer covering for the
body and gave their wearer greater freedom of movement
without sacrificing the integrity of an overall visual and
structural aesthetic. Male *tailoring* developed as a distinct
practice from the processes afforded through industrialization,
increasingly dictated by more conservative British influences.

> Ungay Gay, 23, WM, serious, thoughtful, disgusted by the effemina-
> cy and crudeness of other gays, is looking for another intelligent
> WM who feels the same way. Interests include: Bach, Dostoevsky,
> Asimov. (Appearing in the personals section of *The Chicago
> Reader*, weekly classified advertisement, 1995).

Contemporary categories of sexuality may be interpreted by
linking their relation to textile production and technological
developments in the realm of print media, photography, film,
video and now digital imaging. The increasingly cheap, efficient
and high-quality production and reproduction of images since
the invention of the printing press has promulgated identifiable
categories of sexualities and communities of people who define
them accordingly. Not only were key figures in the history of
the development of computer technology homosexual (Alan

Turing, Charles Babbage and Ada Lovelace), but the technology of textile manufacture itself shares a discernible set of mathematical principles and mechanical developments in common with that of computer technology. Some of the greatest Rococo textiles were executed on draw looms that were manually operated by two weavers, one of whom carefully selected the pattern warp threads while the other treadled and threw the shuttle. Jacquard's revolutionary invention in weaving, developed in the eighteenth century but not perfected until about 1820, uses the same principle as draw-loom technology but mechanizes the labour of the second weaver through the use of punch-cards, allowing the automated production of large, complex, polychrome, imagistic repeat units. Applications in state-of-the-art scientific research within the textile industry continue to dominate the pursuit of creative exploration utilized in weaving technology today. The meaning and influence of these innovations and their accompanying technologies of production play an important role if we are to imagine how the construction of sexualities and gender roles also relies on textiles and textile-based practices. In addition, historical influences resulting from the migration of skilled workers, changes in the demographics of class in rural and urban areas and continual debates concerning the morality of sexuality all inform this relationship between textiles, technologies and sexualities.

Latex garments have excited my interest in all things black and shiny, exemplifying a contemporary textile of sorts. I am fascinated by the contradictory, impractical and fetishistic uses of Latex fashions when compared to its origins in clothing that served basic, functional needs. Latex is a form of bondage. It is about holding things in, tightly, and keeping other things out, warmly. I am constantly reassured by the perpetual squeezing of Latex. It makes me stand up—straight. A recent adventure in Latex took place in New York, where I was visiting friends. I wore a black tank sporting red racing stripes and shorts with a detachable codpiece, both in Latex, as well as black jump boots and heavy, grey wool socks with bright red stripes. Oh yeah, I also wore my big-ass black slave-collar, a souvenir from IML '95. We decided on

a club in the slowly reviving meat-packing district just south of
John's house. Soon after we arrived, a scene ensued. I was tied
down, seated on a chair with my hands behind my back. As John
pissed on me, a third boy forced my mouth open with his hands
and stuffed his big cock inside. A crowd gathered to watch. John
and the other boy slapped me around a bit. Both of them pissed
on me for what seemed like hours. Occasionally, John and I nego-
tiated the scene through quiet exchanges.

The art of constructing social spaces in which sexuality,
clothing and architecture are fully integrated, engulfing not
only the entire body but also the psyche, typifies both Rococo
practices as well as those of contemporary Queer sub-cultures.
Rococo and current S/M fetishistic practices share numerous
attributes, including; the attentive observance of a costuming
trade in which custom-built garments are designed for indi-
vidual bodies; the codification of love and desire through an
intricate and highly ritualized protocol; and the creation of
specialized architectural sites that are both decorated as well
as activated for use, particularly as fantasy spaces that contain
a sexual charge. Additionally, the element of spectacle plays a
central role in support of a costume's social use and value
in locations such as these. Like other sorts of Queer cultural
production, S/M has spawned a proliferation of private, secret
clubs, illegal back rooms and censored visual materials, all
of which have catered to the specific needs of an historically
persecuted community. The essential role of photography, in
addition to other media, ultimately succeeds in binding
itself with constructions of sexuality through documentary
representations that depict practitioners from these alternative
communities. It is ironic that many of these censored images
represent a conflicted and contradictory history that is
characterized either by an incidence of shocking revelation,
on the one hand, or grotesque denial and erasure, on the
other. In many instances, as in the case of fashion, the camera
has been employed to capture images that record the sexual-
ized presence of clothing on the body, or, as in the case of
pornography, images that depict the sexualized absence of

clothing from the body.

Taxonomic distinctions govern the complex frontier of human sexualities, especially social practices involving specific uses of textiles as in dress and interior architecture, and are codified in their contemporary mode as a result of the success enjoyed by British industrialists in the nineteenth century. The British propagated their puritanical attitudes (read: anti-French) while dominating European and world economies, infusing the technological impetus with a sense of moral virtue, an influence that continues to exert itself today in both textile manufacture as well as the textile arts. The pageantry of the French Rococo and subsequent responses to it, therefore, have played an essential role in the formation of modern and contemporary constructions of the Homosexual/Gay/Queer/Male. Textiles and sexuality are both informed by the conditions of habituated practice, wherein cultural artifacts and social interaction facilitate a meaningful history of use, through sensory experience located in the body rather than through visual perception alone. The inability of popular theories to account for the importance and influence shared by textile and sexuality-related technologies is, in part, due to the absence in these discourses of discussions that identify the complex role of the tactile and its pre-visual location in the development of the human psyche. Because the driving force behind the industrialization of textile production rests with its ability to infinitely be mechanically reproduced, thus eliminating the role of "handwork," textiles must be evaluated in the same history of development and cultural use that is attributed to related technologies.

The invisibility conferred by heterosexual orthodoxy, constructed as the coalescence of religious, judicial, social and economic sanctions, further problematizes these absences and incidents of erasure. Beliefs that once prohibited the development of what is now the unconditional Queer social demand for legal recognition and public acceptance have begun to deteriorate. That the homosexual in society is feared

as an aberration of the social order, a perversion of humanity, an undeserving recipient of human rights, or an unnatural species in Nature, betrays an inherent resistance to reconciling an appreciation for what may be unconventional with the impulse to approach new technologies without succumbing to destructive ends. The pending approval of legislation that will regulate sexuality-specific human rights in many regions suggests a tremendous promise toward the reconstruction of certain histories, allowing new and changing expressions of sexuality to continue to emerge.

Skanda

Kiku Hawkes

The language of textiles is vivid and mysterious, an evocative etymology of ancient knowledge and tradition. Woven into each piece are loyalties and love, political upheaval and intrigue, beatitude and passion. Listen to the sounds.

Tulle, taffeta, gauze, organza, percale, pique, linen, triple mousseline

It is said a princess of China spirited silkworms and mulberry leaves out of the country when she was sent to wed the Shah of Persia—a treasonous act against the whole of the Middle Kingdom.

Raw silk, damascene silk, charmeuse, peau de soie, faille, silk ghazar

Carol Browner, head of the United States Environmental Protection Agency in the 1980s, spoke of protecting the "fabric of the country" during her confirmation hearings. As the only woman ever appointed to the United States Federal Reserve Bank Board, she protested skyrocketing interest rates in the early eighties, and spoke of the "fabric of the country" being torn asunder through the introduction of neoconservative monetary policies. Reflecting on the responses of

her (male) co-workers, she said, (to paraphrase):"None of them sew. They never understood the metaphor, that once a piece of fabric is ripped, it can never be made whole again."

Calico, kettlecloth, gingham, muslin, lawn, homespun,
linen, hemp

The king's three sons are sent to find a maiden who weaves fabric so fine it can be drawn through a ring. The fabric for the emperor's new clothes were woven to reveal a truth. Women note in journals what they wore during critical junctures in their lives.

Rayon, dacron, orlon, lisle, nylon, twill, flannel, felt

When I was a little girl, I sat on the floor beside my mother while she sewed, as she once sat with her mother. This is how we learn. On some days I sat sewing doll's clothes, on others I sorted through the button box, arranging the little treasures of gilt and plastic and mother of pearl in piles and rows. My mother's little black Singer, emblazoned with a golden sphinx and copperplate scrolls, was like a mechanical cornucopia bringing forth school clothes and dance recital costumes. There were mother-daughter circle skirts made of red felt and trimmed with white reindeer appliquées (and a scrap for the doll), a plaid box-pleated skirt with H-shaped suspenders, and a decade later from the same scant yardage a plaid mini-skirt.

Pins, scissors, tracing wheel, tailor's chalk, a red cotton,
pin-filled tomato at the wrist, the pattern laid out on the
carpet while the children slept

Somewhere between the very first First-Day-of-School dress and the very last Last-Day of-School outfit was a turquoise silk party dress with spaghetti straps and a bouffant skirt, to be worn with dyed-to-match silk pumps, and if the summer evening grew too cool, a little white eyelet jacket lined with

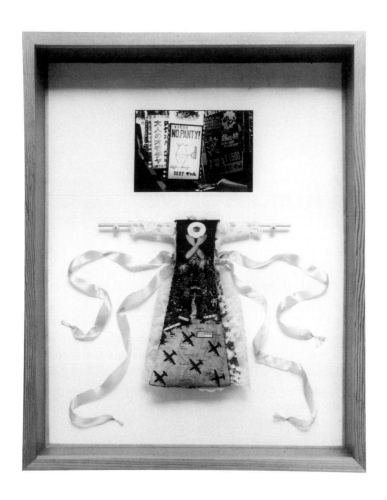

Kiku Hawkes

Flight from Shinjuku: Costume for the Character of the Warbride, 1986.
Mixed media: selenium-toned black and white silver gelatin print,
handcoloured photo linen, lace ribbons, glass fronted fir cabinet,
43 x 53 x 10 cm.
Photo: courtesy the artist.

matching silk. This was a dress of great promise to heal unrequited love and ease teenaged melancholy. Photographs reveal a splash of brilliant colour and a silver starburst of braces veiling a shy smile. Thus armoured, I went to the dance.

Slip stitch, cross stitch, blanket stitch, hem stitch,
satin stitch, running stitch, felling stitch, buttonhole stitch

Destiny comes from the latin *destino* meaning that which is woven or fixed with cords and threads. A dress with its formal elements of colour, shape, line and balance creates an icon that defines woman, deciding what to show and what to hide and placing her into a specific time, place and class. Scarlett O'Hara tore up the olive velvet draperies to woo the man and to save her plantation.

Panne velvet, brushed velvet, cut velvet, velveteen with tassels

The transmission from mother to daughter has survived through millennia, but was dramatically altered by developments in textile production machinery during the late 1700s. Previously, fabrics were made one piece at a time in the home, as were most other household items. Goods once made on the rural farms could now be manufactured cheaply and in greater abundance in the factories. The industrial revolution caused people to migrate to the cities for waged labour in factories. Mothers and daughters still sat side by side as they worked, but their relationship had changed.

Inca loom, Jacquard loom, drawloom, backstrap loom, rods,
heddles, treadles

The pattern started in Great Britain, the centre of new mechanical prowess, only to spread during the concurrent development of territorial expansion and colonization. Raw materials were exported from countries renowned for their rich textile culture. Machine-produced fabrics were returned

to their country of origin as finished goods, which rapidly undermined indigenous traditions. In India, during the struggle for independence, Mahatma Gandhi advocated a boycott of foreign goods and a return to village handicrafts. He wore *khadi* (homespun cotton) and adopted the spinning wheel as the symbol of protest. The Turning of the Wheel evoked ancient Vedic imagery and recalled India's long history. The spinning wheel was commemorated as a symbol on India's flag after independence, connecting the past to the future.

Spindle, distaff, carders, skeins shuttles, bobbins, spools

The spinning wheel, the wheel of life and *dharma* (Sanskrit for "the way" or "the law") suggest the web and its maker, the spider. Fragments of ancient associations between the spider and textile arts are scattered throughout the world. In India the spider is both the virgin Maya, the spinner of fate and illusion, and Kali-Uma, the crone or symbol of death. Ix Chebel Yax, born after her mother, the Mayan moon goddess Ix Chebel, watched a spider spin a web, taught mortal women the skills of loom and spindle and how to colour threads with resources from the land. She is Sussistanako (Spider Woman) of the Pueblo and Navajo, who created the people from black, red, white and yellow clays and to each she attached a strand of her web to connect them to herself throughout their days.

Point d'esprit, bobbin-net, Alesçon lace, blonde lace,
bridal lace, bone-work lace

Few traces of this long and subtle history remain. In a sewing basket filled with antique embroidered ribbons, I keep a paper packet of needles, Nickel-Plated Atomic Brand Needles, found in a thrift shop. Printed on the front cover, a cheerful man in a blue suit and porkpie hat straddles a rocket. Behind him, a bright young modern woman, in a brief dress, hat and heels, sits and waves. Her ankles are crossed and her knees carefully tucked to one side. Yellow fire streams from the rocket, arcing

over scattered stars. Inside a score of needles pierces thin,
coloured foil embossed with the pattern of a spider's web.

*Skanda, from the Sanskrit, means a complex of activities
necessitating continual transformation.*

Death and Deterrence

Bruce Grenville

Sleep, oh! sleep, my pretty little fellow,
rocked by the movement of thy mother's hand;
rest and refreshment, tender and supporting
come from the cradle and its gentle rhythm.

Sleep, ah! sleep, in the grave's soft embraces,
still 'neath the protection of thy mother's arm,
all thou could'st hope for, all thou could'st ever have
lies within the circle of that warm, loving clasp.
Franz Schubert, *Wiegenlied*

There is very little in the world that allows us to acknowledge
the body of a child. Bodies, especially in their abstract state,
are generally large and mature. They are the subject of directed
events and established plans, they are a product of the social
world. But the body's vulnerability, in its various forms, is
best comprehended in the body of a child. Children's bodies
move with a rhythm and intent that speaks of their unmediated
desires. They make no effort to distinguish between the real
and the imagined, between interiority and exteriority. An
adherence to the Cartesian duality of mind and body only
comes later, with the accession of language and the entry of
the child into the symbolic order.

Today, children seldom die: they are bound to the world by technology, held firmly in its rationalizing embrace. When death comes, it is understood as a failure of technology, an inexplicable gap in the logic of its defence. In a seemingly impossible turn of events, the language of medicine and the language of the military coincide around death. For both, death is understood to come in a moment of weakness, the catastrophic collapse of a defensive position which can no longer be guaranteed by its technological apparatus. Here the failure of an artificial heart has the same immediate and totalizing effect as the failure of a radar defense system.

In her recent work, Barbara Todd has sought to bring about a different understanding of contemporary culture by proposing a seemingly improbable link between military security, domesticity, mortality and the body. Todd's *Security Blanket: A Child's Quilt (32 missiles, one bomb)*, 1988–89, stands at the centre of her recent work, for it is the child's vulnerability in the face of nuclear war that brings a horrifying clarity to the language of warfare. If contemporary warfare is based on logistics—the ability to deliver the maximum payload to a specific site with the greatest speed—then it is no longer a question of superior military intelligence, but of brute force and speed.

In Todd's quilt, the cumbersome and stout "Fat Man" nuclear bomb, which was dropped on Hiroshima, is surrounded by the sleek and speedy missiles of contemporary warfare. The emblematic images drawn from the pages of *Jane's Weapons Systems*, a pictorial reference book for state-of-the-art military hardware, are applied to the quilt's surface using traditional appliqué technique. The intent is to force a double reading of security and to create a conflict between traditional notions of military security and domestic security. Significantly, this conflict finds its locus in the body of the child which is the nominal subject of the quilt.

Todd's *Security Blanket (14 suits, 5 aircraft, 1 bomb, 25 missiles)*, 1986–88, is the earliest work in the exhibition and in many ways establishes the principal characters in her

narrative. The fourteen miniature business suits represent big business and its role in the perpetuation of the Cold War. These are interspersed with emblematic images of military aircraft and the "Fat Man" bomb laid out in a five-by-four grid. A decorative border of missiles surrounds this central grid. In her later quilts, Todd supplanted the literal image of the business suit by using woolen suiting cloth as the principal material for all elements of her quilts. In this way, the pervasive and insidious impact of big business and patriarchy was economically acknowledged.

Todd's interest in combining traditional quilting techniques and patterns with unconventional subject matter culminated in two works which took the American B-2 Stealth Bomber as their subject. *Security Blanket: B-2 Stealth Bomber*, 1989–90, and *Wild Goose Chase: B-2 Stealth Bomber*, 1991, are dark and malevolent works. The barely perceptible shift between figure and ground echoes the covert character of her subject, for the B-2 was developed by the American military to avoid enemy radar by cloaking its form.

The B-2 offers an exemplary instance of the principal of deterrence. Proponents of deterrence advocate the development of increasingly sophisticated military hardware. In an extraordinary leap of logic they propose that the superiority of their hardware will deter the enemy and therefore ensure peace. Such rationalization allows the military and the government to maintain a warlike status with regard to the acquisition of hardware, while avoiding the controversial issue of civilian and military deaths. War, then, is everywhere and nowhere at once. Within this scenario the B-2 is the ultimate deterrent— it is virtually invisible and therefore is potentially everywhere, all of the time.

Death, too, takes on a very specific meaning within a culture of deterrence, for the principal of deterrence begins from the proposition that the potential for instantaneous death is also everywhere, all of the time. Within the postmodern world we have lost our understanding of death, seeing only its finality and closure. The continuity of life and death has been displaced

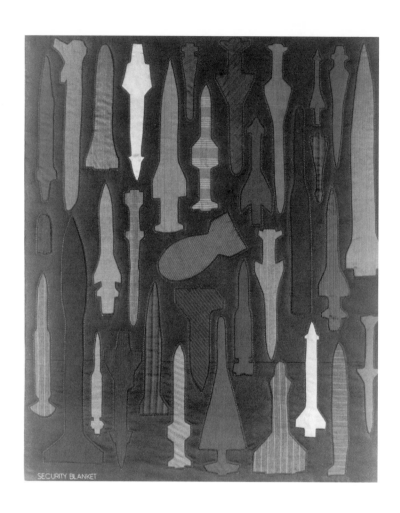

SECURITY BLANKET

Barbara Todd

Security Blanket: A Child's Quilt, 1988-89.

Wool, cotton 197 x 157 cm.

Collection: Canada Council Art Bank.

Photo: John Dean.

by a binarism that pits the living against the dead and the powerful against the powerless. Death is no longer recognized as a condition of being, but as a strategy of deterrence and a denial of being. In claiming that "God is dead," Nietzsche invited us to consider whether "the question of God" had disappeared from contemporary consciousness. One might ask the same question of death itself—for it appears that "the question of death" has disappeared from our consciousness.

In later work, Todd has shifted her attention from an ironic commentary on Cold War paranoia toward a melancholic contemplation of life and death. *Funeral Blanket*, 1992, combines Todd's continuing interest in the representation of military hardware with an emergent interest in images and symbols that speak to human mortality. In this instance, Todd has quilted a number of spiral shapes onto the open central panel. These spirals are traditional symbols of life. They speak of a passage through time and space. So, too, they acknowledge the circularity of life and rehearse the process of death. *Funeral Blanket* shifts the discourse away from questions of security and deterrence toward mortality and the complexity of relationships. If the earlier *Security Blankets* recognized the anxiety of a parent faced with the prospect of bringing a child into the postmodern world, then the current work mounts a compelling challenge to that fear. Death rightfully remains a dominant presence in this work, but now it is an image of death inexorably intertwined with life.

Sleep and death are often confused, especially in the mind of a child. They listen too closely to our euphemisms, imagining that sleep somehow gently folds into death and death into sleep. Barbara Todd's *Coffin Quilt*, 1991–92, compounds this conceit, blurring the distinction between sleep and death, blanket and shroud, containment and continuity. The rigid geometry of the interlocking coffins is softened by the spiral overlays which blur their edges and disrupt their singularity. This dark and absorbing quilt returns us to the body of the child, freed from the paranoid grasp of deterrence and logistics, but nevertheless bound to its own mortality.

Barbara Todd seeks to blur those distinctions which have come to delimit our comprehension of life and death in the late twentieth century. Cold War politics and postmodern culture have constructed a representation of mortality in which death is nothing more than a sign of absence. The *desaparecidos* of Central and South America and the invisible casualties of the Gulf War are the logical consequence of a worldwide system of warfare that seeks to maintain the principals of deterrence. Against this monolithic presence Todd offers the body, and specifically, the body of the child—awkward, sentimental and frighteningly vulnerable—a mortal body.

for Jack, born July 28, 1993, died November 29, 1993

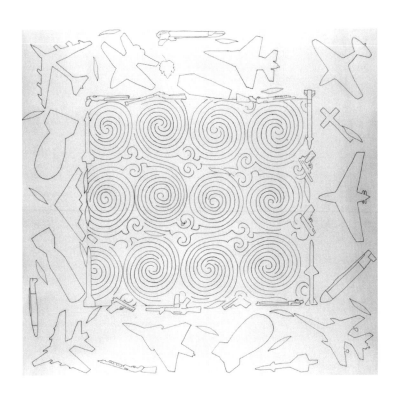

Barbara Todd

Funeral Blanket, 1992.

Ink on vellum, 93 x 86 cm.

Photo: Nelson Vigneault.

Contributors

Editors

Ingrid Bachmann is an artist whose activities include a studio practice, curatorial projects, writing and collaborative ventures. Recent projects include *Knit One, Swim 2, Nomad Web: Sleeping Beauty Awakes*, an interactive network installation, and *Speaking Sites: Dialogue, Ingrid and Plato*, a participatory installation in New York. She has written for numerous catalogues and art magazines. Curatorial projects include *Re-Inventing the Box* (with Shawn Decker), *Poke Out Her Eyes and Other Stories* (with Kai Chan) and *The Politics of Cloth*. She was Visiting Artist at The School of The Art Institute of Chicago, 1995-98, and is currently Professor in the Studio Art Department at Concordia University in Montreal.

Ruth Scheuing is an artist who works with textiles and clothing, exploring their implications as language, myth and communication. Her works have been widely exhibited in solo and group exhibitions internationally, including *Empty Dress* organized by ICI, New York, and *Corpus* by the Mendel Gallery, Saskatoon, and the 8th International Tapestry Triennial in Lodz, Poland. She currently coordinates and teaches in the Textile Arts Program at Capilano College in North Vancouver. Her writings have been published in *Ars textrina, Feminist Art Criticism: Critical Strategies*, edited by Katy Deepwell, London, UK, *Semiotexte*, New York and *Inversions*, a Mawa publication, Manitoba. She received the 1996 Chalmers Award in the Crafts.

Writers

Renee Baert is a critic and curator living in Montreal. She has written for numerous catalogues, journals and art magazines including *C Magazine*, *Parachute* and *Screen*. Her writing appears in several anthologies and she is the editor of *Territories of Difference*. Her most recent curatorial projects are the touring exhibitions *Alison Wilding: Territories* and *Trames de mémoire*.

Bruce Grenville is Senior Curator at the Vancouver Art Gallery. He is the former Toronto editor of *Parachute* and has written for *Vanguard*, *Canadian Art*, *Artscribe* and *Queen's Quarterly*. He has been Curator at the Mendel Art Gallery, Saskatoon, and Senior Curator of the Edmonton Art Gallery. He has organized many exhibitions, including *Mapping the Surface: The Process of Recent Toronto Sculpture*, *Active Surplus: the Anti-Graceful*, *Allegorical Procedures in Recent Canadian Painting*, *Corpus*, *The Alberta Biennial of Contemporary Art and New Science*, and was coordinator of *The Post Colonial Landscape*, a four-year series of exhibitions and special events that examined the land and its representation within the colonial and postcolonial state.

Kiku Hawkes is an award-winning artist and photographer. Her work reflects her interest in history, anthropology and design. In her most recent exhibition, *Tales from the Village*, she constructed costumes combining textiles with hand-coloured photographs. She is a also a lecturer at the Emily Carr College of Art and Design in Vancouver.

Stephen Horne is an artist and writer living in Montreal. He is a founding editor of *Harbour* magazine with Lani Maestro and *Burning Editions* with Maestro and Andrew Forster. He teaches a seminar on art criticism at Concordia University and is an Associate Professor at the Nova Scotia College of Art and Design. His writing has been published in *Vanguard*, *C Magazine*, *Harbour*, *Parachute* and *Flash Art*.

Jo Anna Isaak is a writer who lives in New York. Her most recent book is *The Revolutionary Power of Women's Laughter*, published by Routledge Press. She is the author of *The Ruin of Representation in Modernist Art and Text* (1986) and has written for various magazines including *Art in America*, *Artforum*, *Art History*, *Art Journal*, *Art Monthly*, *Arts Magazine*, *Heresies*, *Parkett*, *Parachute* and *Vanguard*.

Janis Jefferies is Study Head: Textiles and Programme Leader: Postgraduate Textiles, Visual Arts Department, Goldsmiths' College at the University of London. She is a member of the Foundation Board and joint coordinator of the education group of the European Textile Network (ETN) and Advisory Board member of the International Tapestry Network (ITNET). She is a theorist and artist who has been instrumental in developing a critical discourse in textiles since the late 1970s and is a frequent contributor to *Feminist Art News*, *Textile Society Journal*, *Crafts* and *Textile Forum*. She has been involved with the Tapestry Triennial in Lodz, Poland, and the Lausanne Biennial, Switzerland.

Sarat Maharaj is a Professor at Goldsmiths' College at the University of London, England. Born and educated in South Africa, he was given refugee status in Britain. His avant-garde studies such as *The Duchamp Effect* (MIT, 1996) are inseparable from his work on cultural translation, textile practice, multiculturalism and difference including *Global Visions* (Kala Press, 1993), "'A Falsemeaning Adamelegy': Artisanal Signatures of Difference after Gutenberg" (Sydney Biennial, 1997) and a prose-poem, "Besides, it is always others who die for a student who died of AIDS" in *Familiars: Art Projects of Hamad Butt* (INIVA/John Hansard Gallery 1996).

Robin Metcalfe is an independent critic, curator, writer and broadcaster working in Halifax, Nova Scotia. He has written extensively on art, craft and gay politics for over fifty periodicals in six countries, including *Vanguard*, *The Body Politic*

and *Arts Atlantic*. He is currently preparing a collection of essays on the politics of the gay male body.

Neil MacInnis is an artist and weaver who seeks to reactivate the medium of textiles to provide a social context in which communities, in particular the gay community, can express their identities and tell their stories. He is a lecturer in the Fibre Department at Concordia University in Montreal. His writings have been published in *The City Within* and *Seismographes*.

Mireille Perron was born in Montréal, Québec, and now lives in Calgary, Alberta. Since 1982, her installations have been shown in solo and group exhibitions in Canada, the United States, France, Italy and England. Her work uses embodied storytelling and is dedicated to the circulation of crucial desires. It explores the connections between feminism, culture, art and art history, technology and science. She has also written and published essays on a variety of subjects related to representation. Her recent work includes an artist book, *Anecdotal Waters or the Drifting Nomads*, co-authored with Paul Woodrow, *Index of Intents ou elle à la vague à l'âme*, an installation at the crossroads of medical, sensual and personal imagery, and *The conversion of Père Version*, a piece of ficto-criticism co-authored with Lorne Falk in the Cyborg Handbook. She presently teaches at the Alberta College of Art and Design.

Sarah Quinton is an artist and writer who works at Toronto's Museum for Textiles as Curator of the Contemporary Gallery. Recent curatorial projects include *Small World*, 1998; *Fancy* 1996; and *Textiles, that is to say*, 1995, co-curated with John Armstrong. Quinton has written catalogue essays for an exhibition of work by Japanese artist Yasufumi Takahashi (Mercer Union, Toronto, Ontario) and for *In Search of Paradise*, an exhibition of work by Toronto artist Kai Chan, at the Library and Gallery, Cambridge, Ontario.

Debra Sparrow and her sisters, Robyn Sparrow and Wendy Grant-John, have been instrumental in reviving Salish weaving at Musqueam since 1986. Their visions of weaving are integrated into a spiritual life that reflects traditional values and methods of weaving inherited from their ancestors. Their work is used in traditional ceremonies and is represented in numerous private and museum collections including Phil Fontaine, Grand Chief of the Assembly of First Nations; the Museum of Civilization, Ottawa; the Glenbow Museum, Calgary; the Museum of Anthropology at the University of British Columbia; Paramount and Disney Studios; and the Vancouver Airport. Their work was a part of *Topographies: Contemporary Art in British Columbia*, Vancouver Art Gallery, 1997.

Nell Tenhaaf is an artist and writer whose work is focused on computer imaging technologies in art and in the biosciences. She co-coordinated and conceived the *Bioapparatus*, a conference, residency and publication, exploring the cultural and political implication of new technologies. Currently she is Professor at York University in Toronto.

Anne West is Adjunct Professor for the Department of Graduate Studies at the Rhode Island School of Design in Providence, Rhode Island. She works closely with art and design students to help them map the intelligence of their work. As a curator since 1979, she has coordinated and presented exhibitions of various media for galleries and museums throughout Canada. She holds a doctorate in art and media studies from the University of Toronto.

Diana Wood Conroy has a B.A. in Archeology from the University of Sydney, and a Doctor of Creative Arts degree from the University of Wollongong, New South Wales, Australia, where she is a Senior Lecturer in the Faculty of Creative Arts. Since 1993, she has participated in major survey shows of Australian textiles, including *Crossing Borders*, USA tour, 1995–96; *Below the Surface*, Goulburn Regional Gallery,

Australia tour, 1996–97; and *Origins and Perspectives: Australian Textiles*, Lodz, Poland, 1998. She writes on issues of contemporary craft and archeology, and has been Team Manager/Artist-in-Residence at the Paphos Theatre Excavation in Cyprus with the University of Sydney, 1996, 1997, 1998.

Credits

"Death and Deterrence" by Bruce Grenville was originally published by the Southern Alberta Art Gallery in Lethbridge, Alberta, 1993, as part of a catalogue for the exhibition *Barbara Todd: Security Blankets.*

"Embodying Subjectivity" by Stephen Horne was originally published by Articule Gallery and Burning Editions, Montreal, May 1995, as a catalogue essay for the exhibition *Justice in the Flesh.*

"Who's 'We,' White Man?" by Jo Anna Isaak was originally published in *Parkett* Number 34 in collaboration with Ilya Kabakov and Richard Prince, December 1992.

"Autobiographical Patterns" by Janis Jefferies first appeared in *Surface Design Journal*, Volume 21, Number 4, Summer 1997.

"Arachne's Genre: Towards Inter-Cultural Studies in Textiles" by Sarat Maharaj was originally published in the Journal of Design History, Volume 4, Number 2, 1991; reprinted by permission of Oxford University Press. Previous versions were presented in the form of an address to the Arts Council of Great Britain in September 1989, and a paper for the "Textiles Today Symposium" held at Bradford University in April 1990. Maharaj thanks Tag Gronberg for help with research.

"The Unravelling of History" by Ruth Scheuing, was originally presented as a paper at the conference "Feminist Art in the 90s" in London, UK, 1992, and published as "Penelope or the Unravelling of History" in *New Feminist Criticism: Critical Strategies*, edited by Katy Deepwell, published by Manchester University Press, 1995.

"A Journey" by Debra Sparrow was presented at the "Making a Place for Tapestry" conference organized by BCSTAR (British Columbia Society for Tapestry Arts) in Vancouver, 1994, and published as part of the conference transcripts in 1995.

"Mary Scott: in me more than me" by Nell Tenhaaf was originally published by the Edmonton Art Gallery in *Mary Scott: Recent Work*, 1993.

"Weaving Out Loud" by Anne West was originally published as a catalogue essay in *Weaving Out Loud: Sandra Brownlee*, published by the Museum for Textiles, Toronto, 1995.

"An Archeology of Tapestry" by Diana Wood Conroy was originally published by BCSTAR (British Columbia Society for Tapestry Arts) in Vancouver, 1995, as part of the transcripts from the conference "Making a Place for Tapestry."

Also available from YYZ Books